THE IMPRESSIONISTS

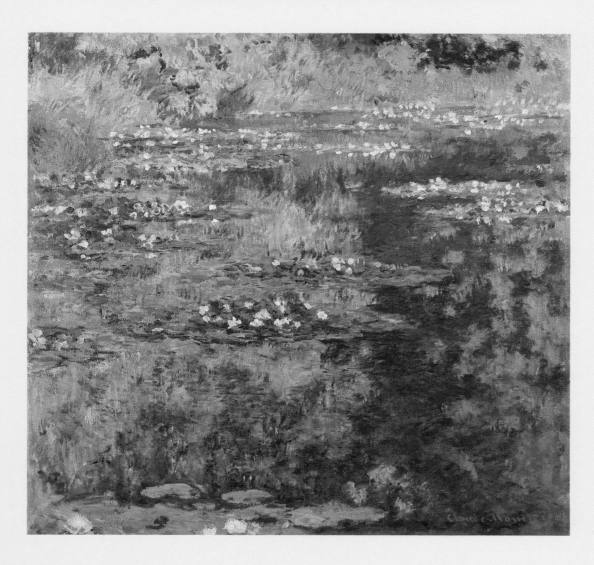

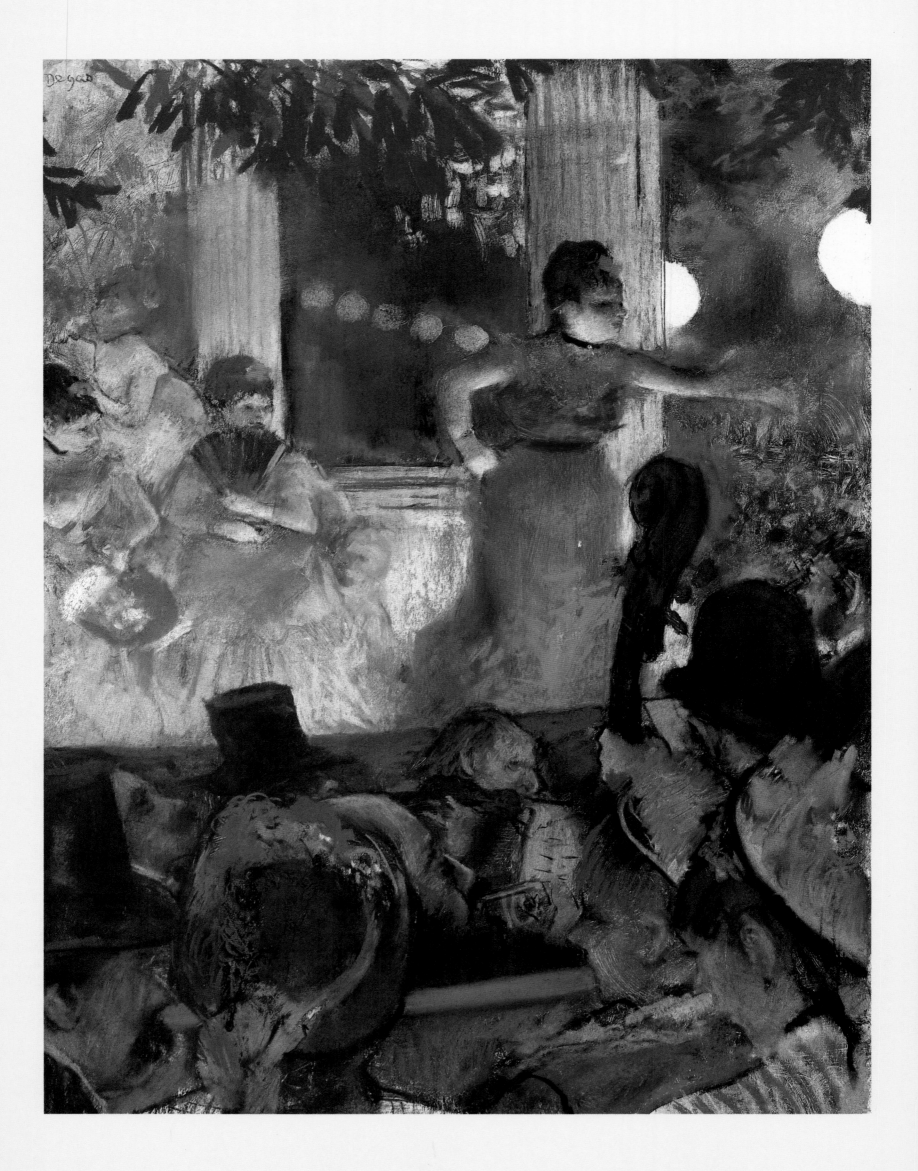

gardless of their status as either professional or amateur artists, and the exhibition spaces were determined by drawing lots. But most importantly, the society and its exhibitions were completely separate from the official Salon system and made the exhibitions a show place where artists could sell their works directly to the public.

When the first show closed in May 1874, the press had already introduced the public to the label Impressionism. The name was first used by a journalist Louis Leroy in an article published in *Le Charivari* on 25 April 1874 titled 'Exhibition of the Impressionists.' In the article Leroy used the word firstly with reference to the works by Pissarro, Sisley, and Monet, in particular Monet's *Impression, Sunrise*, and then went on to comment:

Now take Mlle Morisot. That young lady is not interested in reproducing trifling details. When she has a hand to paint, she makes as many brushstrokes lengthwise as there are fingers and the business is done. Stupid people who are finicky about drawing a hand don't understand a thing about Impressionism, and great Manet would chase them out of his republic.

The reference to Manet is important as it indicates that among the art-conscious press and public at least, there appeared to be a coherent group of painters who, although they never issued a group manifesto or statement, shared certain things in common, including a possible leader in Manet, a role no doubt forced on him because of the publicity which had surrounded his own painting *Déjeuner sur l'herbe* in 1863.

The typical visitor to the exhibition at Nadar's studio, however, would have found it difficult to isolate the features which we now see as common to the Impressionist style: there was no sense of a unified approach to either subject matter or painting style. On the one hand Monet exhibited many landscapes painted directly from nature, while Degas' paintings emphasized the studio-based nature of his work. In addition to paintings of

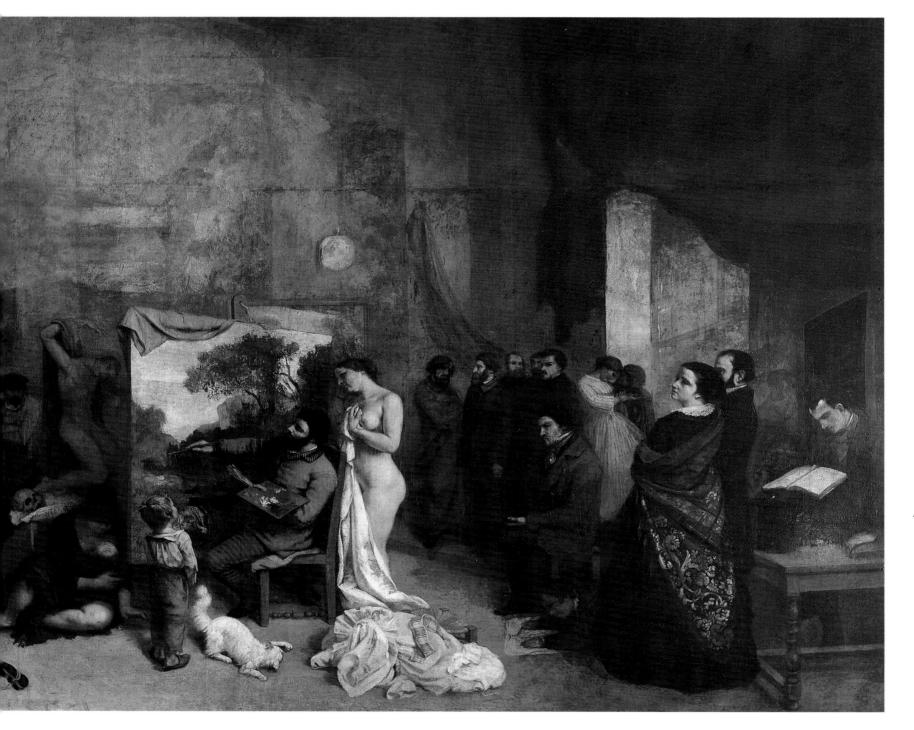

Below: These maps show the areas of Paris and northern and southern France where French and foreign Impressionist painters were most active.

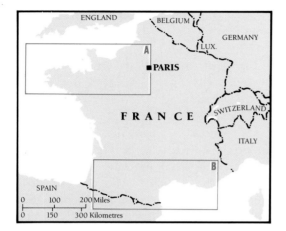

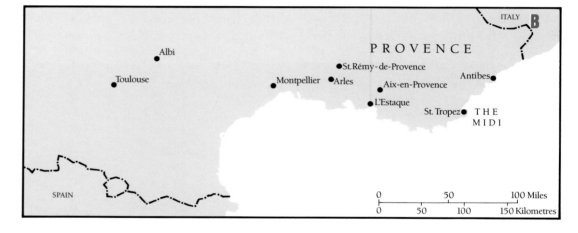

modern subjects there were also on display paintings that were interpretations of historical and religious events and even some animal portraits by Comtè Ludovic-Napoléon Lepic. Nevertheless, the landscape painters and the figure painters were united in their aim to take up the call of the poet Charles Baudelaire (1821-1867) for paintings of modern life. This call for a distinctly modern sensibility was first articulated in Baudelaire's Salon review of 1845 and was repeated and refined in his critical writings until his death. The Impressionists were to respond with their attempts to paint the modern world in the most appropriate manner, thus allowing each artist to follow his or her own individual path.

Many of the ideas and practices of the Impressionists had been around in the early years of the century: out-of-door oil studies had been made by the Neoclassical painters like Pierre-Henri de Valenciennes who had been an inspiration to artists like Corot. Valenciennes had also written a treatise on perspective which Camille Pissarro recommended to his son Lucien. Even more substantial influences, and acknowledged by the Impressionists, were the works of artists they admired, in particular Constable, Delacroix, the Dutch landscape painters, Corot, the artists working near Barbizon, Boudin and Jongkind, Courbet, and Manet.

Some of the Impressionists' attitudes had their roots in Romanticism: the dislike of too formal or overworked paintings and the notion of the artist as an independent man at odds with official, accepted opinions and constantly searching out and exploring the new and unknown.

To varying degrees the new art of the Impressionists was supported in the critical works by men such as Emile Zola, Edmond Duranty, and Joris-Karl Huysmans, whose writings expressed the idea of the city as an appropriate and valuable subject for modern art. In twenty years Paris itself had grown into the first truly modern urban center and many of the Impressionist visions come directly from the experiences of the city, its suburbs and surrounding landscape.

Despite the seige of 1870 and the subsequent ravages of the Commune, Paris had become the cultural capital of Europe. For the most part this was due to the efforts of Baron Haussmann (1809-91) who ruthlessly and efficiently rebuilt entire sections of the city mainly (though not exclusively) in the western section of the Right Bank. He created a network of 50 kms (31 miles) of boulevards (which made the building of barricades by the citizens difficult and made the rapid deployment of troops possible) which provided the setting for Parisian 'life of the streets', where cafés, restaurants, theaters, music halls, and brothels provided entertainment to suit every taste and purse of the growing population.

In the course of the century the population of Paris had more than doubled, largely due to the influx of people from the provinces and surrounding countryside and assisted by the expansion of the railways. Paris was at the center of the rail network and by 1870 was the terminus of ten lines, helping to make the capital the world's greatest manufacturing city with nearly ½ million workers employed in its various manufacturing industries. The railway stations were the new cathedrals and it is not surprising that Monet should paint both Rouen Cathedral and the Gare St Lazarre. This station stimulated the growth of the Batignolles area which became favored by the Impressionists in their early stages of development and also offered access to the surrounding countryside and promoted the growth of weekend retreats such as Argenteuil, Pontoise, and Bougival as well as giving access to the Channel ports and coastal resorts. While the new city and suburbs furnished the subject matter for the Impressionists, reflected in the pages of Zola's novels could be seen the affluent bougeois Parisian society which emerged in the second half of the nineteenth century and that provided the majority of the patrons of the new art.

There was also at this time in France a growing fascination with science. From the middle of the century for painters and writers alike, the phrase 'the true' was replacing 'the beautiful' as a term of praise. The founder of the philosophy of Positi-

Below right: The Pont de l'Europe, seen here from the Gare de Lyon, was a popular 'modern life' subject with several of the Impressionists, including Caillebotte (pages 44-45).

Bottom: The boulevard des Capucines is typical of the broad boulevards created by Baron Haussmann in his vast rebuilding of central Paris in the late 19th century.

vism, Comte, had assigned prime importance to what was either factual or was the product of direct observation – a distinct parallel with Impressionist aims. But although painters before Georges Seurat did not make any systematic efforts to make their art conform to scientific rules, some of the new scientific discoveries must have come to their attention in the many popular booklets and pamphlets that began to be published all over France. Cézanne's mother and sister for example were subscribing to the *Gazette des Beaux-Arts* in 1865, at the time when Charles Blanc was writing his articles on color. Cézanne's own interest is revealed in notes about the articles scribbled on one of his drawings for the *Apotheosis of Delacroix*. Naturally the greatest impact of science on painters was in the field of optical research, particularly the constitution of colors and the structure of light. Numerous developments at the time include those of Bunsen and Kirchoff around 1855 in connection with the spectrum and between 1854 and 1862, the works of Arago and de Fresnel on the polariscope. The scientist usually associated with the Impressionists theories of color is the French chemist Eugène Chevreul (1786-1889). Following his appointment as director of the dye-house of the Gobelins tapestry factory in Paris, Chev-

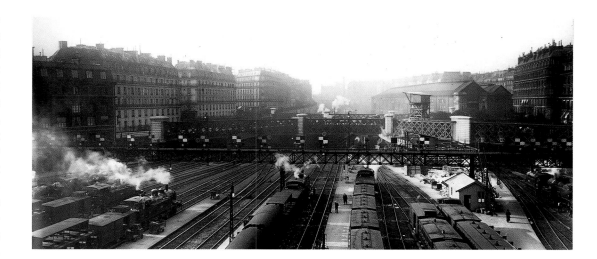

reul began his research into color harmonies and produced his most important books *De la loi du contraste simultané des couleurs et de l'assortiment des objets colorés* (1839) and *Des Couleurs et de leur application aux arts industriels à l'aide des cercles chromatiques* (1864). Chevreul's principal thesis was that colors in proximity influence and modify each other. He also observed the effect of 'negative afterimage,' where a single color seems to be surrounded by a faint 'halo' of its complementary color (eg a red spot on a white ground will seem to tint the background green). Chevreul also investigated 'optical mixture': in his experiments with woolen

threads, he found that two strands of different dyes appear to have a single color when they are seen together from a distance. The Impressionists were to be greatly influenced by Chevreul's science-based discoveries: there is evidence that Monet, Pissarro and later Seurat had first-hand knowledge of his works. It was Chevreul's theory of optical mixture which would lead the Impressionists to tint shadows with colors that were complementaries of the color of the object which was casting the shadow. Furthermore, Chevreul's theories led them to place colors on the canvas so that beyond a certain distance the viewers eye mixed the two

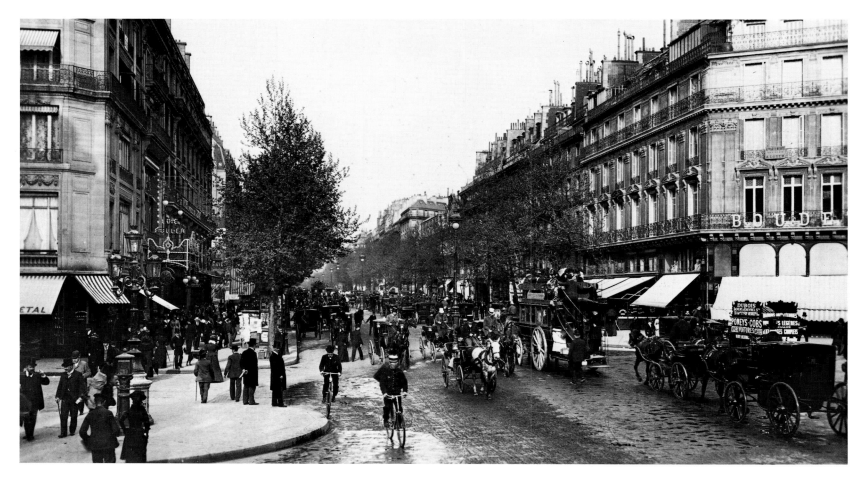

Introduction

Right: Paul Durand-Ruel (1832-1923), seen here in old age, was the first dealer to buy significant numbers of the Impressionists' works.

Below: Frédéric Bazille, who was killed in the Franco-Prussian war in 1870, painted this portrait of his friend Renoir in 1867.

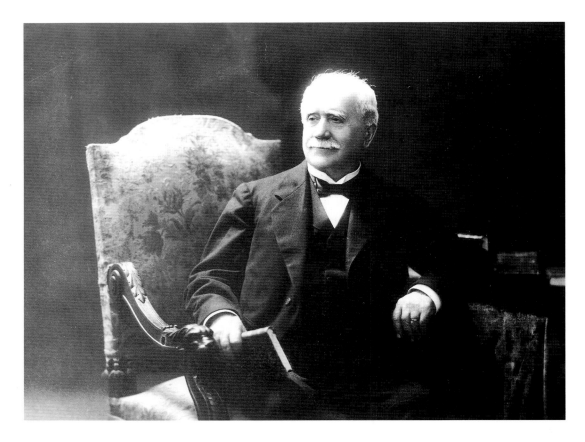

imitating Courbet's use of the palette knife, a technique which Renoir gradually abandoned in favor of a more finely crafted, painted finish. In spite of intercessions by Daubigny who admired Renoir's work, all his entries were rejected by the Salon juries in 1866 and 1867. Sometimes too poor to buy paints, Renoir was often helped by the generous Bazille and a good friend Jules le Coeur.

Le Coeur and Renoir had mistresses who were sisters, the daughters of a country postmaster called Tréhot. Renoir's affair with Lise Tréhot lasted for eight years and she became the model for at least 15 of Renoir's paintings including *Diana the Huntress* and *Bather with Griffon*, both of which betray the influence of Courbet in

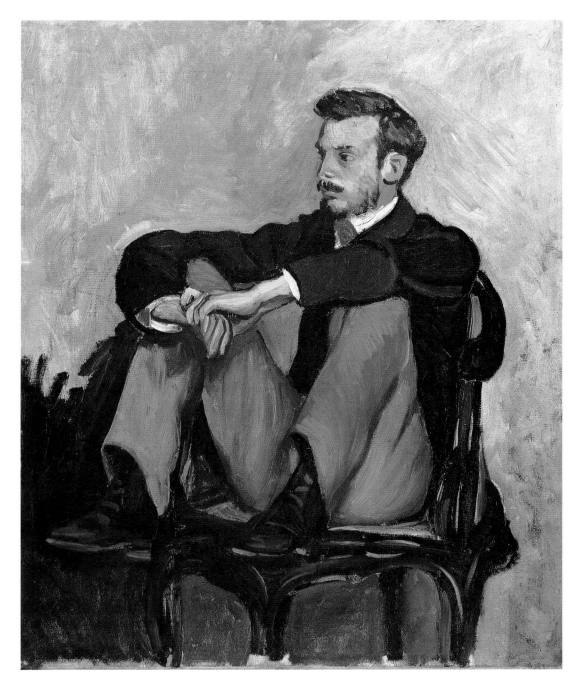

the modelling of form. Salon success did follow in 1868 and the following year saw him and Monet painting the atmospheric effects of light and water at La Grenouillère, a popular bathing spot at Bougival on the Seine. Out of this close friendship and painting partnership (the styles of the two painters at this time are nearly indistinguishable) Impressionism gradually grew. It was at Bougival that both Renoir and Monet made their discovery that shadows were not black or brown, but were in fact colored by their surroundings. It was there that they began to use pure unmixed colors (particularly the three primaries and their complementaries) and there that they banned blacks, browns, and earth colors from their palettes. In their attempts to capture the sensations of movement and changing light both began to handle paint more freely allowing their broken brushstrokes to be visible.

Commercial success came to Renoir in 1872 when Durand-Reul started to buy his works. This was followed the following year by purchases by the collector Théodore Duret, who also had remarkable portraits of himself painted by Manet, Whistler, and Vuillard. A relative of Courbet, Duret was involved in the Impressionists' discussions and supported them in his writings. In 1878 he also published *Les Peintres Impressionistes*, a short account of the movement. His later writings include comprehensive studies of Whistler and Manet.

Renoir took part in the first Impressionist exhibition in 1874 and in three subsequent ones, but he was not really an enthusiastic member of the group. Unlike his friends he disliked theoretical discussions about art and said he was forced to break

Right: *A Studio in the Batignolles (Manet's Studio)* by Henri Fantin-Latour. From left: Scholderer, Manet, Renoir, Astruc, Zola, Maître, Bazille, and Monet.

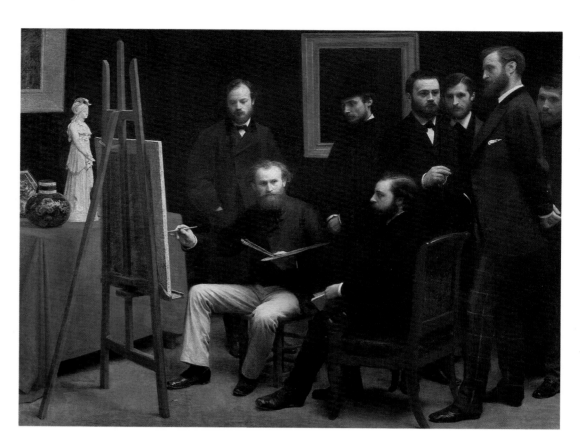

with many of his friends because they argued so late into the night that they were unable to get up the next day to paint. Furthermore, unlike many of his colleagues, by this time Renoir had built up the wealthy and supportive backing of a number of patrons: Victor Chocquet, the Charpentier and Berard families, as well as Duret and Durand-Ruel.

During the time that Renoir and Monet were painting together, they were often joined by their friend Alfred Sisley. At first, like the other Impressionists, Sisley was influenced by Corot, Courbet, and Daubigny, but by 1870 he was adopting a much freer manner and began to follow his friends' lead in using Impressionistic techniques, clear colors, and chromatic divisions. But unlike Renoir and Monet, Sisley rarely ventured into figure painting but confined himself almost exclusively to landscape scenes that were to become characteristic of the Impressionist movement as a whole. From his early admiration of Corot, Sisley retained a passionate interest in the sky which nearly always dominated his paintings. A somewhat diffident person Sisley did not promote himself in some of the ways his fellow Impressionists did and it was only in the last years of his life that he achieved something of the recognition that was due to him.

One artist who was to participate in all the Impressionist exhibitions and was one of the mainstays of the group was a woman: Berthe Morisot (1841-95). The daughter of a wealthy civil servant Berthe and her sister Edma were taught painting and drawing by Joseph Guichard. Guichard was also a friend of Courbet and Berthe was introduced to him in 1861. Throughout her early development as an artist the influence of Courbet was to be a dominant one. With Corot Morisot also worked at the Ville d'Avray, a town near St Cloud, and with Corot's pupil Cudinot she painted at Auvers and Fontainebleau where she met Daumier, Daubigny, and Antoine Guillemet. Despite an interest in landscapes, Morisot often concentrated on scenes of the domestic life around her: her sister beside a cradle, women sewing or at their toilette.

In 1868 she was in the Louvre copying a painting by Rubens when she was introduced by Fantin-Latour to Edouard Manet. Manet became an admirer and Morisot posed for a number of his paintings, notably *The Balcony* (1869). In turn Morisot encouraged Manet in his move towards

plein-air painting, while his influence on her work is evident in such paintings as *The Artist's Sister Edma and their Mother* (1870) (which was in fact retouched by Manet).

Their strong relationship was however upset in 1869 when Manet became preoccupied with Eva Gonzáles (1849-83) who was to become his model and only pupil, much to the chagrin of Morisot. Manet and Morisot were however reconciled and eventually Morisot married Manet's brother Eugène in 1874. The same year, at the first Impressionist Exhibition, Morisot exhibited several works including the now-famous *The Cradle* (1873). She continued to provide a social and inspirational center for the Impressionists: each Thursday she would entertain Degas, Monet, Caillebotte, Pissarro, and Whistler as well as writers such as Emile Zola and Stéphane Mallarmé.

By the end of 1869 all the major Impressionists knew each other well and Monet and Renoir had begun to paint in the technique which, when fully developed, would come to characterize Impressionism.

One of the meeting places of the Impressionists was the Café Guerbois on the rue des Batignolles (later the Avenue Clichy). The café, which was close to Manet's studio, was to become a sort of headquarters for discussions among the artists, and the close relationship between many members of the group is demonstrated in several group portraits: Henri Fantin-Latour's (1836-1904) *A Studio in the Batignolles' Quarter* (1870) shows Manet at work in the company of Renoir, Bazille, Monet, and Zola. The group was to be disrupted however by the outbreak of the

Franco-Prussian War. Monet and Pissarro were in London, with Monet traveling on to Holland in 1871; Renoir had little opportunity to paint since he was conscripted into a regiment of cuirassiers; Degas and Manet were in the artillery. Berthe Morisot remained in Paris and sent letters describing life in the city under seige by balloon to her sister, and, tragically, Bazille was killed in action.

After the war prospects seemed a little brighter for the Impressionists and many were able to sell their works at relatively high prices. But the Salon of 1873 was hostile to their work and once again a Salon des Refusés was set up. The same year Monet revived the idea of holding a group exhbition that was entirely independent of the official Salon. For this, Monet received surprisingly enthusiastic support from Edgar Degas (1834-1917), despite the fact that he had never been completely in favor of plein-air painting and refused to be identified with the Impressionists. At first the plan was to invite some of the older masters to exhibit – artists such as Corot, Daubigny, and Courbet. But this idea was abandoned when some of the older artists agreed with Corot, who was totally against the idea of showing with the Impressionists. Financial wrangling was settled by Renoir's suggestion that each painter contribute one-tenth of the proceeds from any sales to a group fund, while Degas suggested that established artists who were deemed 'acceptable' to the general public – Boudin, Stanilas Lépine and Giuseppe de Nittis (1846-84) – should be invited to exhibit. Pissarro appealed successfully to Degas and Monet to include paintings by Paul Cézanne, and Berthe Morisot, who had always been successful in the official

Below: This photograph which once belonged to Degas reveals that the sometimes unnatural-looking poses of his bathers were, in fact, based on actual models' poses.

Salon, ignored her mentor Manet's advice and exhibited with the Impressionists. Those who refused to show works included Tissot, Fantin-Latour and Legros. Over 165 works were shown and ten paintings by Degas were the largest number of works by an individual artist. They included scenes of dancers, horse races, and beaches. Degas was, more than any other of his Impressionist colleages, absorbed by the human figure and only marginally concerned with landscapes and nature. Rather than color, Degas was more interested in draftsmanship and line. A concern with different media and constant technical ex-

plorations led Degas into a wide variety of works; as well as sculpture he was a keen photographer and used many of his photographs of ballet poses and unusual viewpoints as compositional aids for his paintings. With the help of Pissarro and the American artist Mary Cassatt (1844-1926), all of them influenced by Japanese examples, Degas also experimented with printmaking techniques.

It has been said that Degas came close to Impressionism only in the 1890s in his large-scale pastel works, but he himself always insisted he was not an Impressionist. By the third exhibition in 1877 when

most of the other artists who had displayed the characteristics of Impressionism that had given rise to the term had resigned themselves to the label, Degas continued to oppose it.

While Degas'· greatest contribution to the movement was his originality in composition, it must not be overlooked that he also benefitted the Impressionists by introducing them to Mary Cassatt and her American connexions.

The daughter of a wealthy Pittsburgh businessman, Cassatt studied at the Pennsylvania Academy of Fine Arts in Philadelphia before traveling extensively in Europe and settling in Paris in 1874. That year she had a painting accepted at the Salon and in 1877 she met Degas, with whom she was to be on close terms throughout his life, and whose art and ideas were to have a considerable influence on her own work. Following her introduction to the Impressionist circle Cassatt took part in their exhibitions in 1879, 1880, 1881, and 1886. Additionally, Cassatt was a great practical support to the movement as a whole: as well as providing direct financial support she helped to promote the works of the Impressionists in America. By persuading her brother Alexander to buy works by Manet, Monet, Morisot, Renoir, Degas, and Pissarro, she made him the first important collector of Impressionist works in America. When they were exhibited in mixed shows in the USA her own works were well received by the critics and greatly contributed to the acceptance of Impressionism in America.

From Degas, Cassatt developed an interest in scenes of everyday life, but like Berthe Morisot, she inclined toward domestic rather than urban scenes. Later in the 1890s, largely as a consequence of the exhibition of Japanese prints held in Paris, Cassatt's work became more boldly defined and her colors cleaner and clearer. The exhibition also encouraged her investigations in printmaking and her works in this area are among the most impressive of her generation.

The years between the first Impressionist exhibition in 1874 and around 1881 are generally regarded as the period of 'High' Impressionism and is best represented by the paintings of Renoir, and to a lesser extent by those of Sisley and Monet.

It was Renoir who was largely responsible for a sale of Impressionist works that took place at the Hôtel Drouot auction house and who gradually introduced the

Right: This delicate drypoint, etching and acquatint by Mary Cassatt reveals both her debt for various compositional devices to Japanese woodblock print artists, and her mastery of printmaking processes.

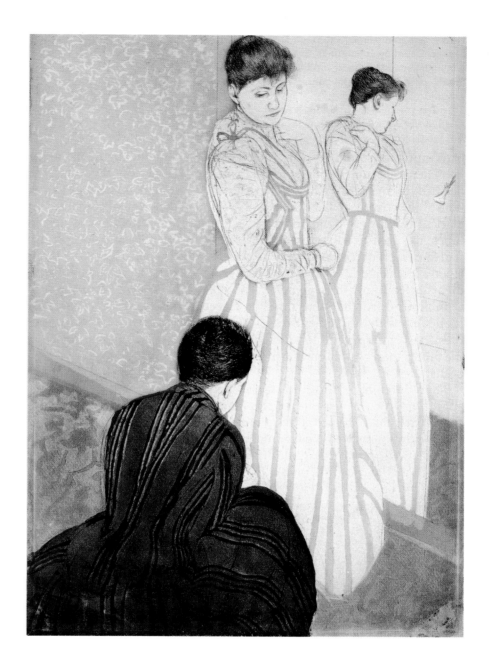

patron and collector Victor Chocquet to the group. In addition to commissioning portraits from Renoir and Cézanne, the Chocquet collection, which already contained works by Delacroix, Daumier, Corot, and Courbet, was to grow to contain 32 works by Cézanne, 11 each by Renoir and Monet, 5 by Manet and 1 each by Pissarro and Sisley. In 1876 Renoir was to meet an even more important patron, Georges Charpentier (1846-1905), whose family was to become the subject of no less than five portraits. At the informal salons kept by Charpentier's wife, Renoir was to meet members of fashionable Parisian society: Yvette Guilbert, Edmond de Goncourt and the young diplomat Paul Berard who was to become Renoir's host on numerous occasions at the family estate in Normandy.

In spite of growing acclaim, Renoir was by no means financially secure but was still in a better position than his friend Monet, whose art had yet to find wealthy admirers. In the winter of 1875 Monet was painting snow scenes at Argenteuil; the next year he showed some of his La Grenouillère paintings at the second Impressionist exhibition. Then he began his series of paintings depicting the Gare St Lazarre railway station.

In 1878 Monet's friend and sometime patron Ernest Hoschedé (1838-90) became

Below: An unusual double portrait of around 1883 of *Gauguin* by Pissarro and *Pissarro* by Gauguin.

Below: Manet's portrait of *Emile Zola*, Naturalist novelist and champion of the young Impressionist painters.

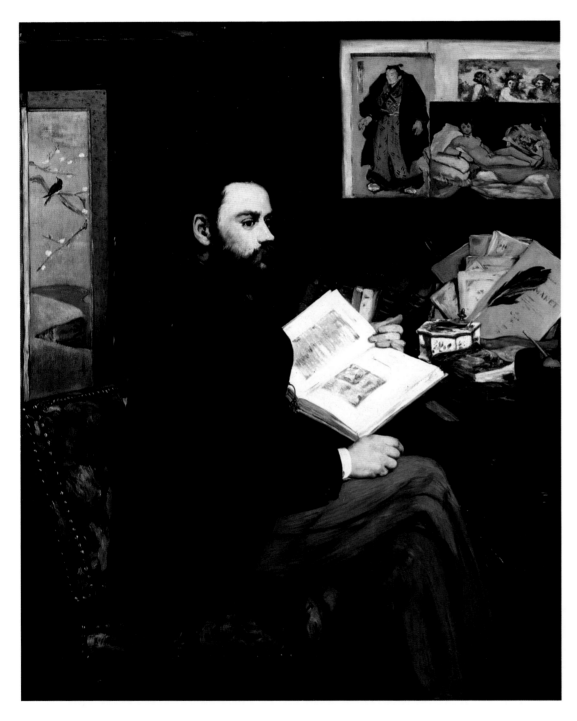

Only in England and America would critics continue, either in praise or in condemnation, to consider Impressionism as a unified movement.

While English artists like Constable and Turner undoubtedly contributed to the evolution of Impressionism, the English art public were not to give a favorable reception to contemporary French painting. The first of the Impressionists to visit England was Manet who arrived in London in 1868. Then, during the Franco-Prussian War between October 1870 and June 1871, Monet, Pissarro, and Sisley arrived and painted several views of the city. Monet continued to be a frequent visitor staying at the Savoy Hotel three or four times between 1899 and 1904 while he painted his series of views of the River Thames. Pissarro was also in London around the same time and was working on views of Kensington Gardens, Hyde Park, Charing Cross Bridge, and Hampton Court Palace. In 1871 Sisley painted his view of Charing Cross Bridge and returned three years later to paint a series of views of Hampton Court. In 1881 Sisley was back in England, this time working on the Isle of Wight (which had also been a favorite holiday resort of Berthe Morisot and her family in the mid 1870s) and later spent several months in Wales.

Between 1870 and 1875 Durand-Ruel, who had fled France during the war, rented a gallery at 168 New Bond Street where he held a series of exhibitions which included works by Manet, Monet, Pissarro, Sisley, and Degas. It was not until 1883 however, when a much larger and better advertised exhibition took place at Dowdeswell's Galleries, also on New Bond Street, that the first serious impact of Impressionism on English critics and collectors occured. The exhibition, which included seven paintings by Degas, three by Manet, seven by Monet, two by Cassatt, three by Morisot, nine by Renoir, and eight by Sisley, was the first in England to attract a good deal of attention from the British press.

On the whole the Impressionist paintings were again fulfilling the role of a 'succès de scandale': one contributor to *Punch* urged visitors to look in at the gallery because the exhibition was so 'horrid funny.' In general the paintings were condemned for paying too much attention to landscapes and too little to the human figure which was deemed a more worthy and more 'noble' subject for artists.

Nevertheless, it appears that before Durand-Ruel had closed his first gallery in 1875, he had sold seven paintings by Degas to a man referred to as 'The Tailor of Brighton,' a Captain Henry Hill. Another early British collector was a botanist and bleach-factory owner from Lancaster, Samuel Barlow, who in the early 1880s had acquired four paintings by Pissarro. The English painter Walter Richard Sickert (1860-1942) had also bought a number of paintings by Degas. There were others in England like James Abbott MacNeil Whistler (1834-1903) and John Singer Sargent (1856-1925) who owned works by the Impressionists, but this was due largely to friendship rather than an active policy of acquisition.

Whistler in fact went further in promoting both his own work and those of his colleagues in France by founding the International Society in 1898 and persuaded Cézanne, Renoir, Sisley, Degas, and Pissarro to exhibit. In all, between 1870 and 1900 there were some 16 exhibitions in London which showed the works of one or more of the Impressionists.

Despite the formation of the New English Art Club in 1886, whose original intention was to join English 'sentiment' and 'feeling' with French painting techniques, the overriding British point of view towards Impressionism was expressed by Sir George Clausen, an active member of the Club, who said that some of the Impressionist works, in spite of their beauty, were:

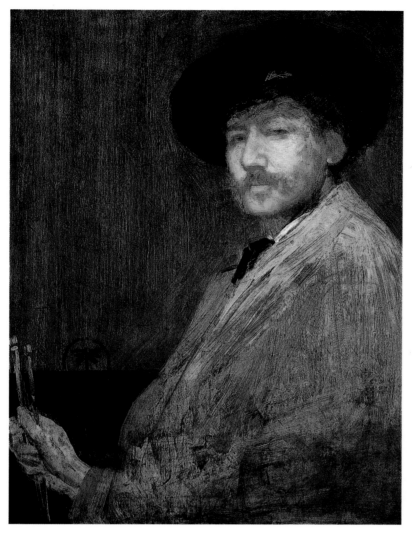

Left: Whistler *Self-Portrait*, 1872.
Whistler, although born in the US, lived from the
age of 19 in France and Britain.

Below: Theodore Robinson (left) lived in France
for many years and was a close friend and
neighbor of Monet at Giverny.

used to descend on Giverny in the 1890s, often to the annoyance of Monet and his neighbors. Robinson was also interested in the relationship between painting and photography: several of his paintings are direct translations of photographs and it is possible that he encouraged Monet's interest in the subject, since around this time Monet had two darkrooms constructed at Giverny. On his return to America in 1892, Robinson spent his last four years of his life teaching, painting, and promoting the Impressionist style in America.

One of the most publicized and colorful figures of the art world in the nineteenth century, Whistler, went to study art at Gleyre's studio in 1855. An early champion of 'Art for Art's Sake,' Whistler was also one of the first to acquire an interest in Japanese art, something that was to become a consistent element in his paintings. In 1887 he and Monet traveled together to England. After the orientalized paintings of the 1860s, Whistler was to concentrate primarily on portraits and cityscapes which he called 'Nocturnes' or 'Arrangements.'

His influence was to spread not only to other American painters like J Alden Weir

disgusting and violent, and it is questionable if, after all, this method is as true to nature as the older convention of painting, where the effect is less brilliant but more restful.

But there were painters within the New English Art Club – Sickert, Sargent, Laura Knight (1877-1970) and even at times Augustus John (1878-1961) – whose works demonstrate the influence of Impressionism in their color, brushwork, and immediacy of observation.

On the whole the British painters' allegiance to Impressionism was slight but it was viewed by the critics as being better than the French version, as the English painters were less 'extreme' and chose 'nicer' subjects! While it is true to say there was no true Impressionism in Britain, there was an 'impressionistic' school.

The first contact between the Impressionists and the United States occurred when Degas visited New Orleans in 1872, a visit he documented both in his correspondence and in the painting *The Cotton Office, New Orleans*. Further contact with the Paris art scene were made by expatriate artists such as Cassatt, Whistler, Sargent, and Theodore Robinson (1852-1896).

Robinson first studied at the National Academy of Design in New York and went to work in France in 1877. He became a close friend of Monet, whose style he partly imitated and with whom he worked a great deal at Giverny. It has been suggested that Robinson in many ways was responsible for the hosts of American students who

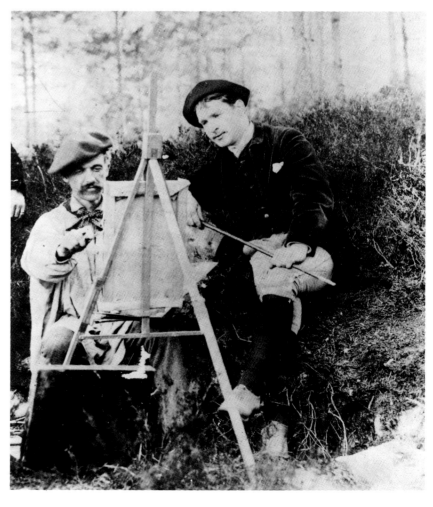

Right: The American John Singer Sargent made a successful career for himself as a portrait painter in Europe as well as in the United States.

Below: J Alden Weir, a prominent figure in the American art establishment, used his position to promote the work of struggling younger artists.

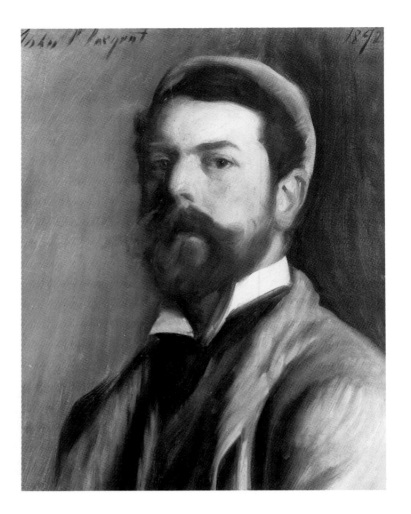

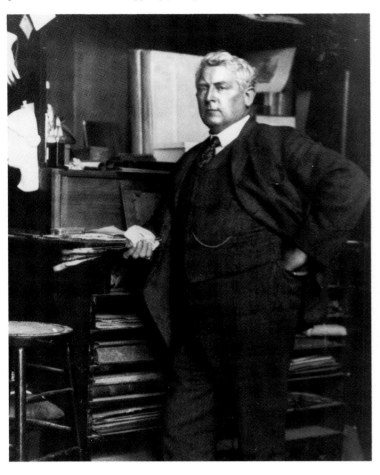

Right: Self-portrait etching of Childe Hassam whose work is the most 'French' of all the American Impressionists.

Below: Although John H Twachtman's work was admired by his fellow artists he did not enjoy wide popular acclaim.

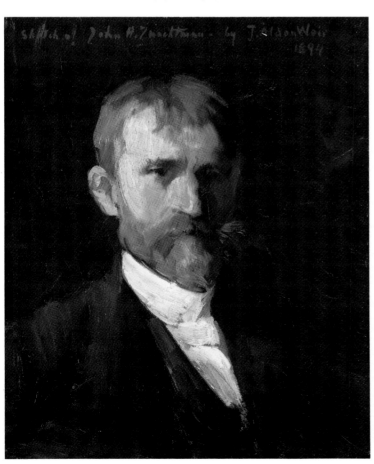

Summer Scene, 1869

Oil on canvas
62¼×62½ inches (158.1×158.9 cm)
Courtesy of The Fogg Art Museum,
Harvard University Art Museums
Gift: Mr and Mrs F Meynier de Salinelles

It has been suggested that Bazille was not a true Impressionist partly because he died in 1870 before the first Impressionist Group Exhibition and before the use of small vibrant touches and the divisions of tone became general among the group, and partly because of his own classical tendencies. While there is an undeniable debt to Manet's *Déjeuner sur l'herbe*, Bazille's *Summer Scene* reveals his interest in academic art. Like Degas, yet unlike the other Impressionists, Bazille used the traditional method of preparing pictures by a series of drawings and studies from nature, frequently using the motif of a riverside landscape. While he simplified and ordered these preliminary studies, he still painted the final picture in the open air, something Degas did not do. In a letter of 1868 Bazille wrote: 'I should like to restore to every subject its 'weight and volume, and not only paint the appearance.' This was something that later Degas, Renoir, and the Post-Impressionists succeeded in doing, developing a new pictorial language to express modern life in a classical and monumental form.

FRANK BENSON

American 1862-1951

Calm Morning, 1904

Oil on canvas
44×36 inches (111.8×91.4 cm)
Courtesy, Museum of Fine Arts, Boston
Gift of Charles A Coolidge Family

This painting shows Eleanor, George, and Benson's second daughter Elisabeth, fishing off the shore of their island home. When exhibited in 1905, a reviewer praised the painting for being 'well composed, full of light with excellent atmosphere and distances.' Benson commented, 'Few appreciate that what makes them admire a picture is the design made by the painter. If the design is pleasing the picture is good,' no matter what the subject. Characteristic of Benson, the composition and space of *Calm Morning* are rigorously plotted. Despite the flattening high horizon, Benson expands the sense of space beyond the picture's edges by orienting each child's face in a different direction. Other devices subtly create an illusion of depth; gradually diminishing in scale, the boats trace a zig-zag as they recede into space, and the colors of the b oats progressively become cooler, suggesting the effect of haze on distant objects.

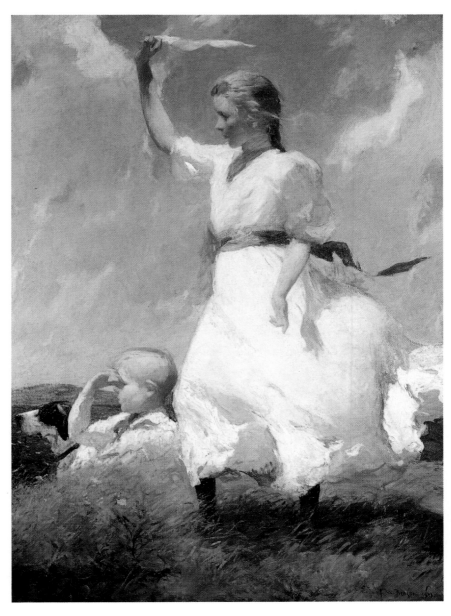

The Hilltop, 1903

Oil on canvas
71×51 inches (180.3×129.5 cm)
Malden Public Library, Malden,
Massachusetts

The best-selling painter of the Boston Impressionists, Benson here depicts his daughter Eleanor, his son George, and the family dog on a hill top, one of his favorite motifs (and one that had also been used by Monet in *Woman with a Parasol, Turning Right*). The landscape itself was the area around Benson's summer home at Wooster Farm on North Haven Island, Maine. The farm was on a hundred yard spit of land with views back to the mainland and out to other islands. While the scene appears spontaneous, it was in fact carefully composed: notice how the movement of Eleanor's handkerchief is repeated by her blue sash and the billowing hem of her skirt is echoed in the cloud above. Benson often worked up his paintings in the studio from a series of watercolor studies made on the spot. George's gesture of his hand to his eyes also reappears in many of Benson's works, notably *Sunlight* (1909) where Eleanor is once again depicted on a hilltop, silhouetted against the sky.

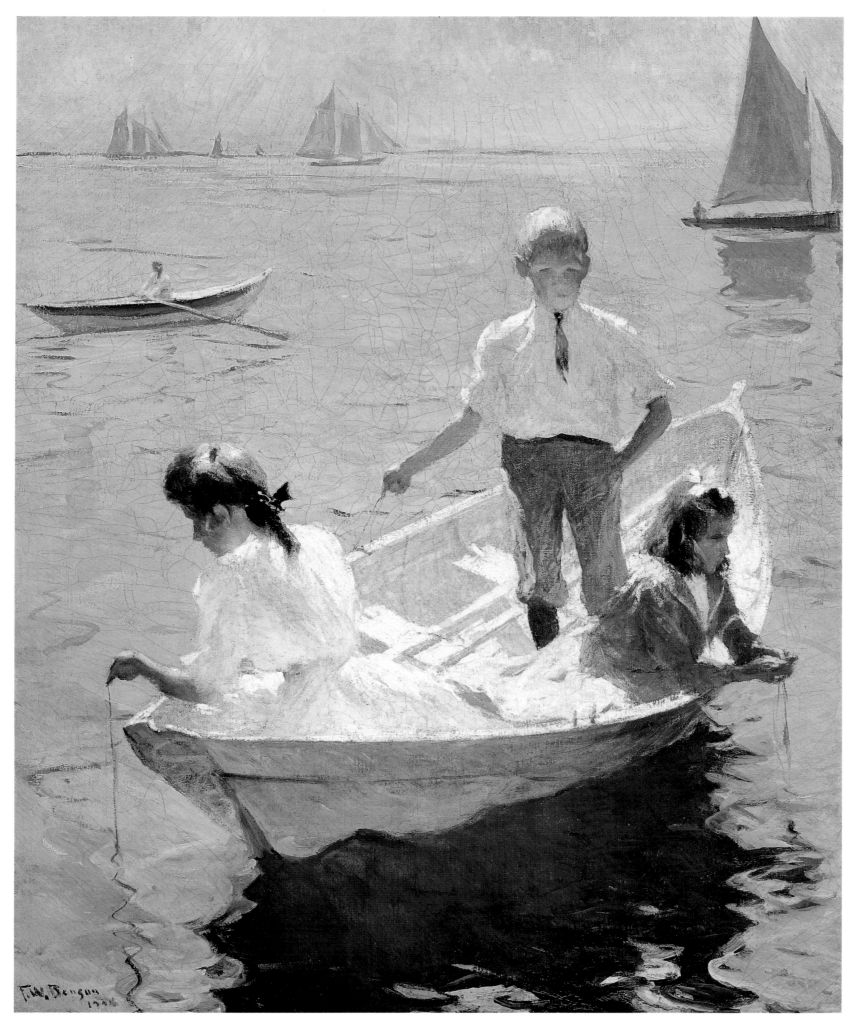

EMILE BERNARD
French 1868-1941

Breton Women with Umbrellas,
1892

Oil on canvas
31½×41 inches (80×105 cm)
Musée d'Orsay, Paris

Bernard was a painter and critic who was to play an important role in the later development of Impressionism, especially in relation to the works of Gauguin and Cézanne. Bernard studied painting under Fernand Cormon (1845-1924) who ran an atelier in Paris and counted among his pupils van Gogh, Gauguin, and Toulouse-Lautrec. During the winter of 1887-88 Bernard, van Gogh, and Toulouse-Lautrec started to develop the technique of cloisonnism which involved the use of heavy black outlines and flat areas of dense color. At the same time Gauguin's work was beginning to show similar stylistic tendencies towards simplification. In his earlier encounters with Gauguin, Bernard felt they had little in common, but in 1888, encouraged by van Gogh, Bernard visited Gauguin in Pont-Aven, Brittany, and despite large differences in age and temperament, the two succeeded in forming a strong working relationship which led to the production of outstanding paintings including Gauguin's *Vision after the Sermon* (page 96) and Bernard's *Breton Women in the Meadow*. Bernard's use of flat areas of color, the suppression of modeling, and decorative treatment of the Breton costumes so impressed Gauguin that he took the painting with him to Arles where van Gogh made a watercolor copy of it.

Three years later when Gauguin was set to leave for Tahiti, he was acclaimed by critics as the undisputed genius of Symbolism and Bernard's own crucial contribution was entirely overlooked. While there is no doubt that Bernard broke new ground in his youth, none of his later works ever achieved the excellence of his early paintings, but his articles about Cézanne and van Gogh, whose Paris exhibitions he arranged in 1893, went a great distance in establishing the reputation of these artists.

In *Breton Women with Umbrellas*, painted four years after his collaboration with Gauguin, Bernard returned to the theme of Breton women gathered in a meadow. In the painting, four women are represented in traditional Breton costume while a fifth wears contemporary dress. While less flat and schematic than his earlier works, the treatment of the landscape using parallel brushstrokes reflects his growing admiration for Cézanne's works and the stiff poses are reminiscent of Seurat's *Sunday Afternoon on the Island of the Grande Jatte* (page 194).

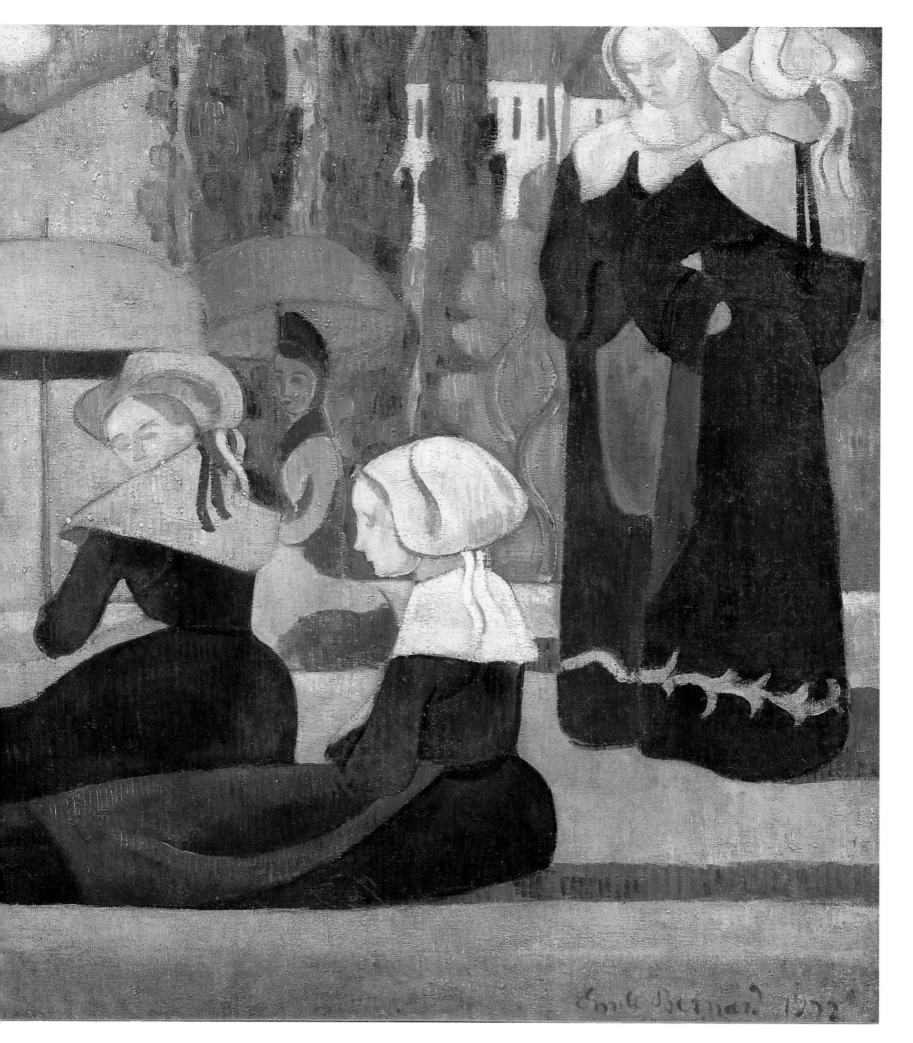

PIERRE BONNARD

French 1867-1947

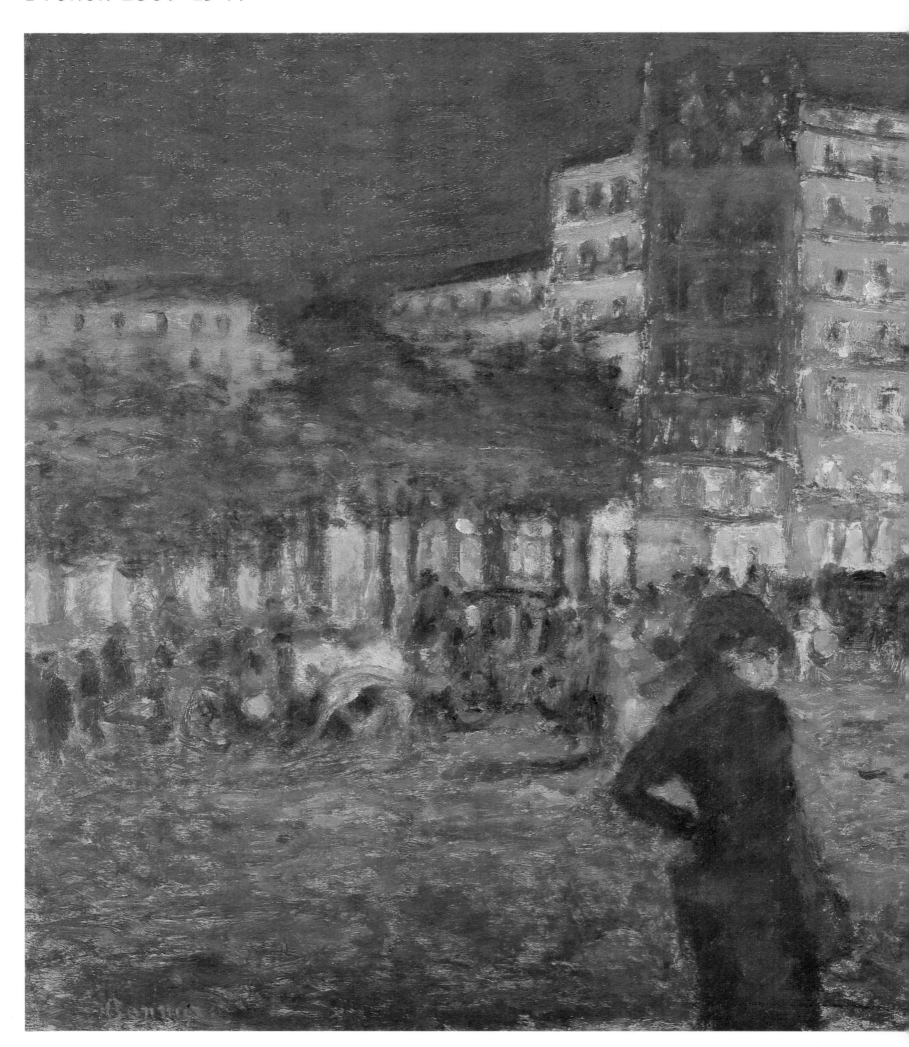

Place Pigalle at Night, c. 1905-8

Oil on wood panel
22¾×27 inches (58×69 cm)
Yale University Art Gallery
New Haven, Connecticut
Gift of Walter Bareiss, BA 1940

Bonnard did not begin his career as an Impressionist: he belonged to the generation of artists who came to the fore in the 1890s having learnt a great deal from the Impressionists and from Gauguin. In the 1890s, influenced by Gauguin and Japanese art, Bonnard's aim was mere decoration. By around 1900 he was moving toward a kind of Impressionism, paying more attention to nature, color, and light and assimilated into his own style some of the technical methods of the Impressionists: lighter tones, more subtle color relationships, and short, fractured brush strokes.

Place Pigalle was at the heart of Paris's entertainment district and was noted for its café-concerts, brothels, and circuses; Bonnard treats the subject as a nocturnal cityscape. Although Pissarro had undertaken one or two views in his series of paintings of the Paris boulevards, the city at night had been of little interest to the Impressionists. This theme was to come to the fore at the turn of the century in the paintings of Bonnard as well as in the paintings of a newcomer to Paris, Pablo Picasso.

EUGENE BOUDIN

French 1824-98

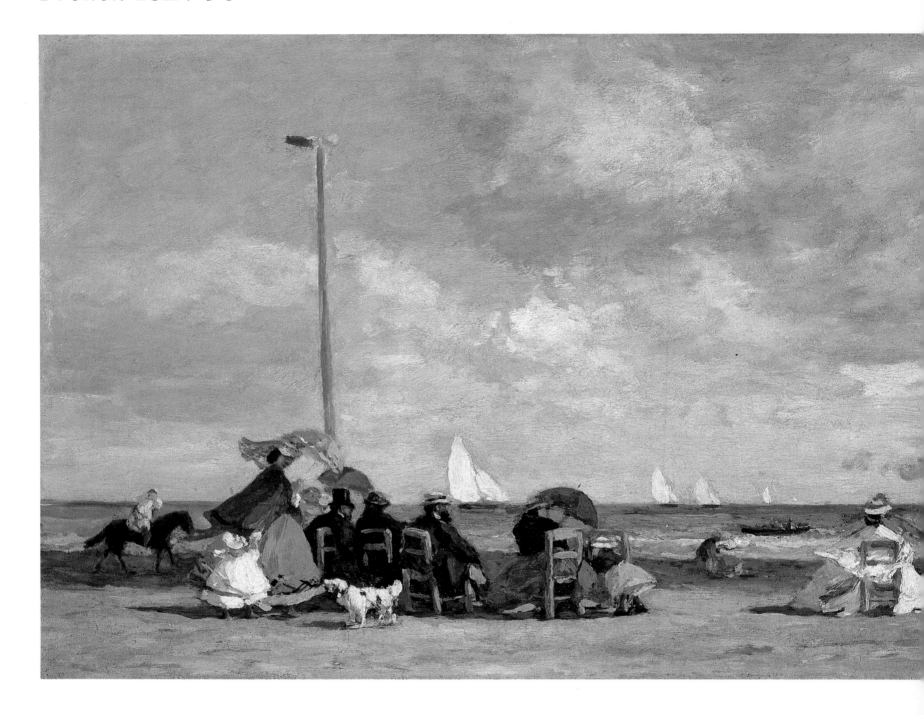

The Beach at Trouville, 1864-65

Oil on wood
10¼×19 inches (26×48 cm)
National Gallery of Art, Washington DC

'My eyes were really opened and I finally understood Nature. I learned at the same time to love it.' So wrote Monet after meeting Boudin in Le Havre in the late 1850s. For Monet, and for the Impressionists as a whole, the influence of Boudin, who spent virtually his entire working life on the Normandy coast, was seminal.

Born in Hornfleur, Boudin was self-taught and at the age of 20 opened a framing and printselling shop which specialized in the works of the numerous painters who visited and worked at Le Havre. Among his clients were the painters Troyon and Couture who recommended Boudin for a scholarship at the Ecole des Beaux-Arts in Paris around 1859. While in Paris Boudin started to paint pictures *en plein air* in the countryside surrounding Paris, but it was at Trouville, Le Havre, and Deauville that Boudin found all he needed to occupy him for a lifetime of painting.

He pointed out to the young Monet: 'Everything that is painted on the spot has always a strength, a power, a vividness of touch that one doesn't find again in one's studio.' His example of *plein-air* painting alone would have been a major contribution to Impressionism. But throughout his career, Boudin was also concerned with the atmosphere, the nature of light, and the transcience of visual sensation which would make him a source of inspiration for the younger generation of painters.

Another aspect of Boudin's work which brought him close to the Impressionists was his belief that the ordinary, urban middle-class people were just as worthy a subject as picturesque peasants or heroes. In 1868 Boudin wrote to one of his friends in Le Havre:

The peasants have had painters who have specialized in painting them: men such as Millet, Jacques, Breton and that is a good thing . . .

but quite honestly, between ourselves, don't these middle-class men and women walking along the pier to the setting sun also have a right to be fixed on canvas, to be brought to life? . . . This is a serious argument, and I think it is irrefutable.

In the *Beach at Trouville*, Boudin presents us with the image of middle-class Parisians huddled in informal groups and braced against the Channel winds, while at sea a number of yachts are racing.

JOHN LESLIE BRECK
American 1860-1899

Garden at Giverny, c. 1890
Oil on canvas
18¼×22 inches (46.4×55.9 cm)
Daniel J Terra Collection
Terra Museum of American Art, Chicago

Massachusetts-born Breck studied first in Munich and then at the Académie Julian in Paris before going to Giverny where Monet was working and where he had an un-fulfilled love affair with Monet's step-daughter Blanche. Access to Monet greatly influenced Breck's technique and choice of subject matter: the garden either with or without figures which gave many of the Impressionists the opportunity to explore the effects of light on colors. The garden was also a new subject matter, previously painted only as a minor aspect of house or estate portraits. A gardening revival in the 1880s in Europe and the US led to an interest in paintings of gardens. Some of the paintings that Breck sent back to Boston where they were exhibited in Lilla Cabot Perry's studio (Perry was another fine painter who had also lived next door to Monet in Giverny and a painting by her still hangs in Monet's bedroom) were among the first American Impressionist paintings to be seen in the city.

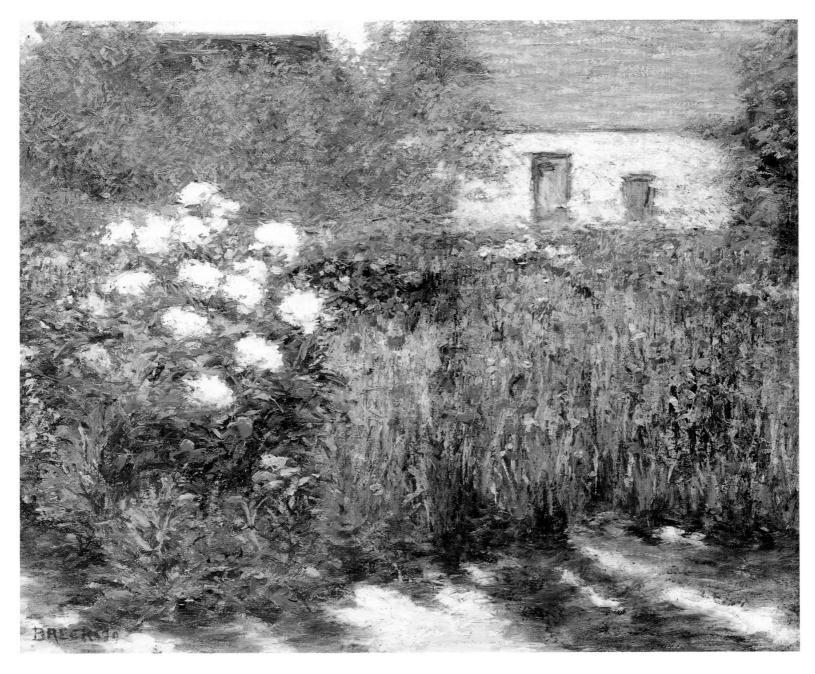

G H BREITNER

Dutch 1857-1923

Corner of Leidsche Square,

c. 1895

Oil on canvas

Private Collection

The Dutch had always been very receptive to French art and they showed an early and enthusiastic interest in the works of Courbet, Corot, and the painters of the Barbizon school. The fact that the Impressionists were actively concerned with the depiction of light and atmosphere especially recommended them to the Dutch whose own country had produced landscape artists of the quality of Van Goyen and Ruisdael. By the 1890s a whole group of painters, The Hague School, were taking as their subject the coast and polders around The Hague and were using an Impressionist technique to recreate the mysterious light and atmosphere of the Dutch landscape. Breitner himself used a kind of visual realism which in the dramatic use of perspective and photographic immediacy comes close to the urban scenes of Degas and Caillebotte.

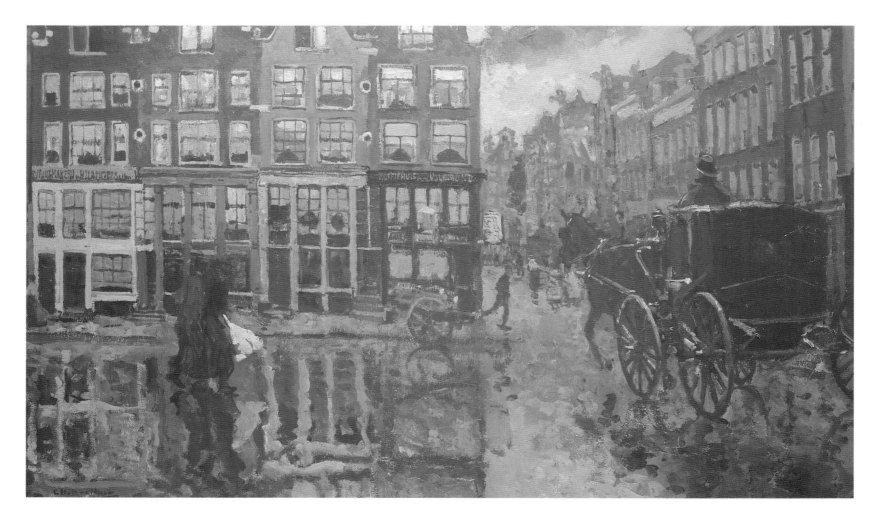

RUPERT BUNNY
Australian 1864-1947

A Summer Morning, c. 1908

Oil on canvas
87¾×71 inches (223×180.3 cm)
Art Gallery of New South Wales, Sydney
Purchased 1991

Bunny was one of a number of Australian artists who spent most of their working lives overseas. In 1884 at the age of nineteen he went to Europe and was based there until 1932. In London and Paris Bunny had considerable success at the Royal Academy and the Salons and he did not identify so much with contemporary French avant-garde movements. But he did develop an eclectic style which owed much to the influence of painters such as Alma-Tadema and John Singer Sargent. Bunny was almost exclusively concerned with painting domestic scenes of elegantly dressed women. *A Summer Morning,* in which three women concern themselves with feeding kittens, is typical of his oeuvre. That this scene is set on a balcony is revealed by the clever inclusion of the mirror in the background which reflects the landscape in front of this scene.

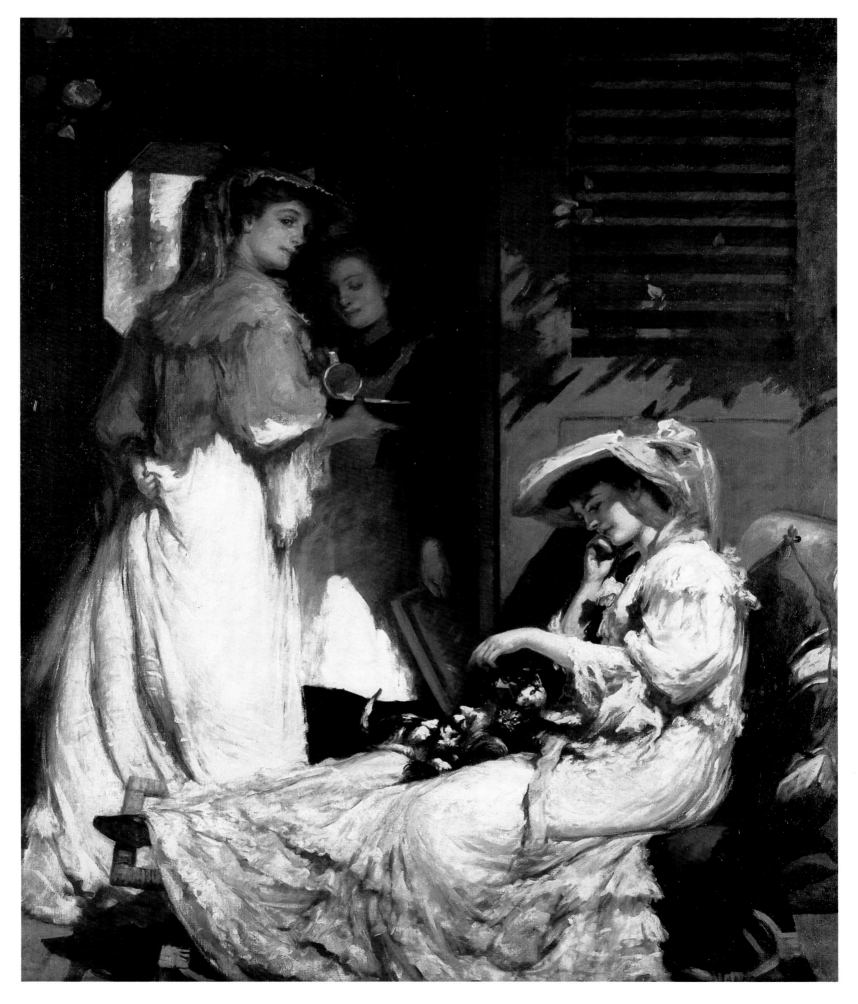

GUSTAVE CAILLEBOTTE

French 1848-94

Le Pont de L'Europe, 1876

Oil on canvas
49¼×70¾ inches (125×180 cm)
Musée du Petit Palais, Geneva

A painter of great originality, Caillebotte produced some of the most memorable urban images of the nineteenth century. He was a law student when he met Monet and Renoir and began discussing the idea for a group exhibition, yet Caillebotte did more than almost anyone else in support of Impressionism: he gave financial help to the members by buying their paintings at artificially inflated prices; gave gifts of money and bought his own paintings at an 1877 auction to provide funds for future Impressionist exhibitions. In addition to being a designer of yachts, Caillebotte was a keen gardener, an enthusiasm he passed on to Monet.

Initially Caillebote's paintings were akin to those of Degas, but they were marked by a much stronger preference for natural, unposed figures – the workman leaning over the bridge to look down on the Gare St Lazare and the dog trotting off in the direction of the Place de l'Europe – and unusual viewpoints. With its striking perspective and sense of photographic immediacy, Caillebotte's *Le Pont de l'Europe* goes further than Manet's or Monet's versions of the scene in exploring the sheer physicality and massiveness of the bridge, itself a technological feat of engineering where six newly built Paris streets converged.

Directly covering the spot where the lines of perspective meet, Caillebotte has depicted a young man-about-town engaged in conversation with an elegantly dressed young woman. The nature of their conversation is uncertain and it led one contemporary commentator to write that they were not to be seen as a married couple but to view the incident as 'a common little vignette that we have all observed with a discreet and benevolent smile.'

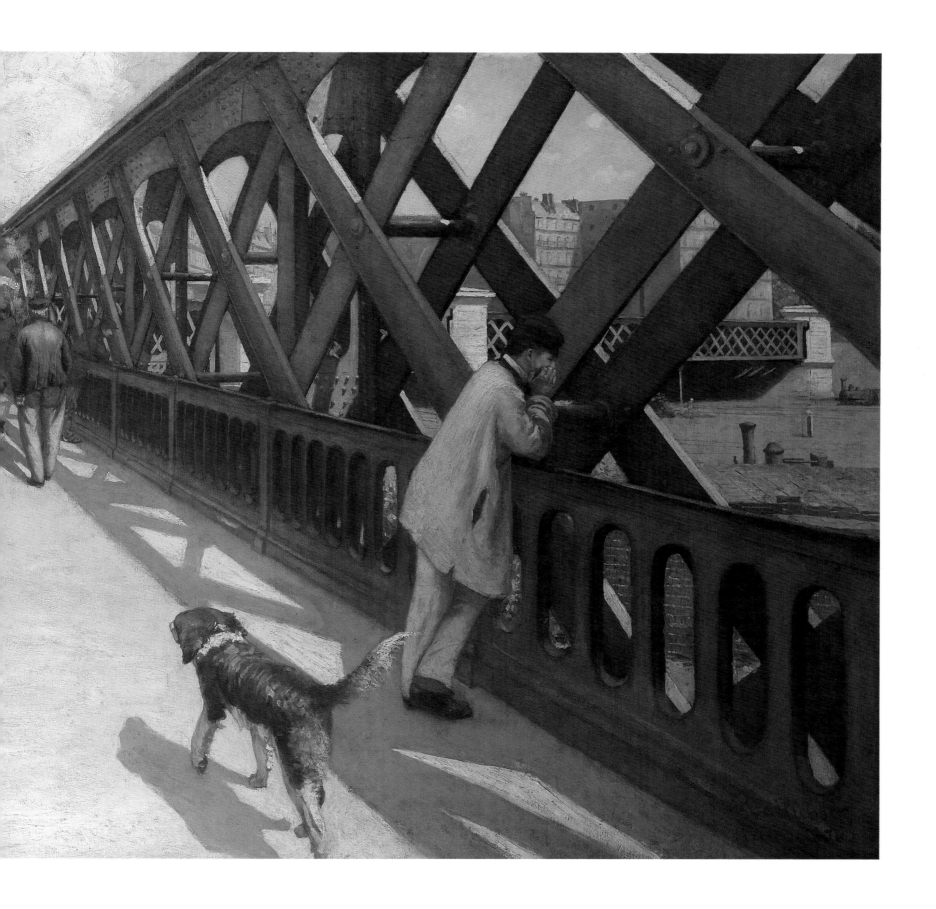

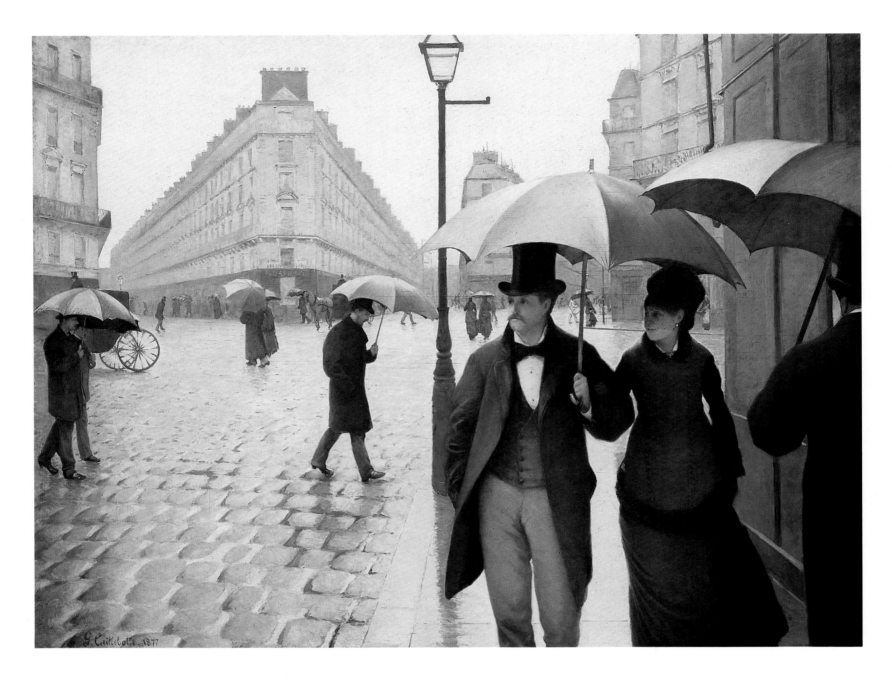

Paris Street: Rainy Day, 1877

Oil on canvas
83½×108¾ inches (212.2×276.2 cm)
Art Institute of Chicago
Charles H and Mary F S Worcester
Collection, 1964.336

Caillebotte's reputation as a painter has largely been overshadowed by his controversial legacy to the French nation of his magnificent collection of paintings by his fellow Impressionists. Forecasting his own early death, in 1876 Caillebotte drew up his will in which he made provision for the next Impressionist exhibition and bequeathed his collection to the nation with the proviso that the paintings should first be shown in the Musée du Luxembourg and eventually the Louvre. When Caillebotte died 18 years later, this collection consisted of 3 Manets, 16 Monets, 8 Renoirs, 13 Pissarros, 7 Degas, 8 Sisleys, 5 Cézannes, and his own *The Floor Strippers* (1875). Renoir was named as executor of the will and after a great deal of delay (including the rejection of part of the collection because of lack of space) the bequest was accepted and was to form the nucleus of the Jeu de Paume collection. Most of the works have now been transferred to the Musée d'Orsay.

This large painting – the figures are life-size – depicts a scene in an actual location in Paris near the Gare St Lazarre and was exhibited at the Impressionist exhibition in 1877 where an anonymous reviewer remarked: 'Caillebotte is an Impressionist in name only.' It is true Caillebotte never used the Impressionist palette or technique but he did paint images of the contemporary urban landscape and the people who lived in it. The painting's size, the strong use of perspective, and the inclusion of a cropped figure who appears to be walking into the picture leads to the extension of the pictorial area beyond the frame and into space. It has been suggested that Georges Seurat may have seen this painting in 1877 and remained under its influence when he began his own monumental painting *Sunday Afternoon on the Island of la Grande Jatte* (page 194).

Périssoires sur l'Yerres, 1877

Oil on canvas
40¼×61⅜ inches (104×156 cm)
Milwaukee Art Museum
Gift of the Milwaukee Journal Company
in Honor of Miss Faye McBeath

At the fourth Impressionist exhibition Caillebotte exhibited a number of boating scenes. This large painting – unusually large for such an informal subject – is one of three versions of the same subject all painted within two years of each other: three men paddling their périssoires or sculls down what is believed to be the River Yerre. Next to painting and gardening, boats were a passion for Caillebotte who was also a yacht designer, and boating was a popular pastime which he and his Impressionist colleagues recorded in many paintings at Argenteuil and Chatou, villages on the banks of the Seine, which were popular with Parisians and painters alike. Unlike the river scenes by Monet, Caillebotte's closely observed and detailed treatment of the figures contrasts with his summary techniques used for the landscape and water. This more traditional approach with the emphasis on the human figure was at odds with the Impressionist practice whereby all the elements in a picture were treated with the same degree of emphasis.

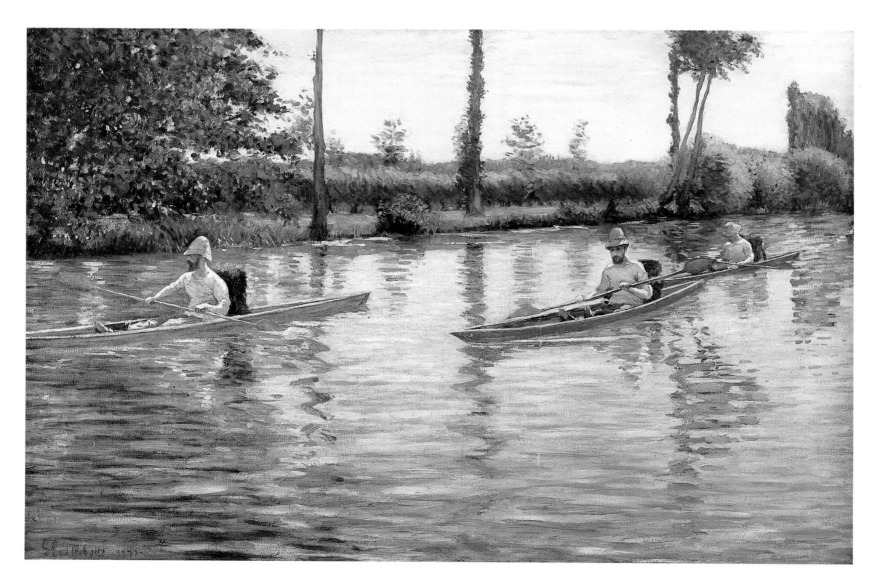

JOSEPH R DE CAMP

American 1858-1923

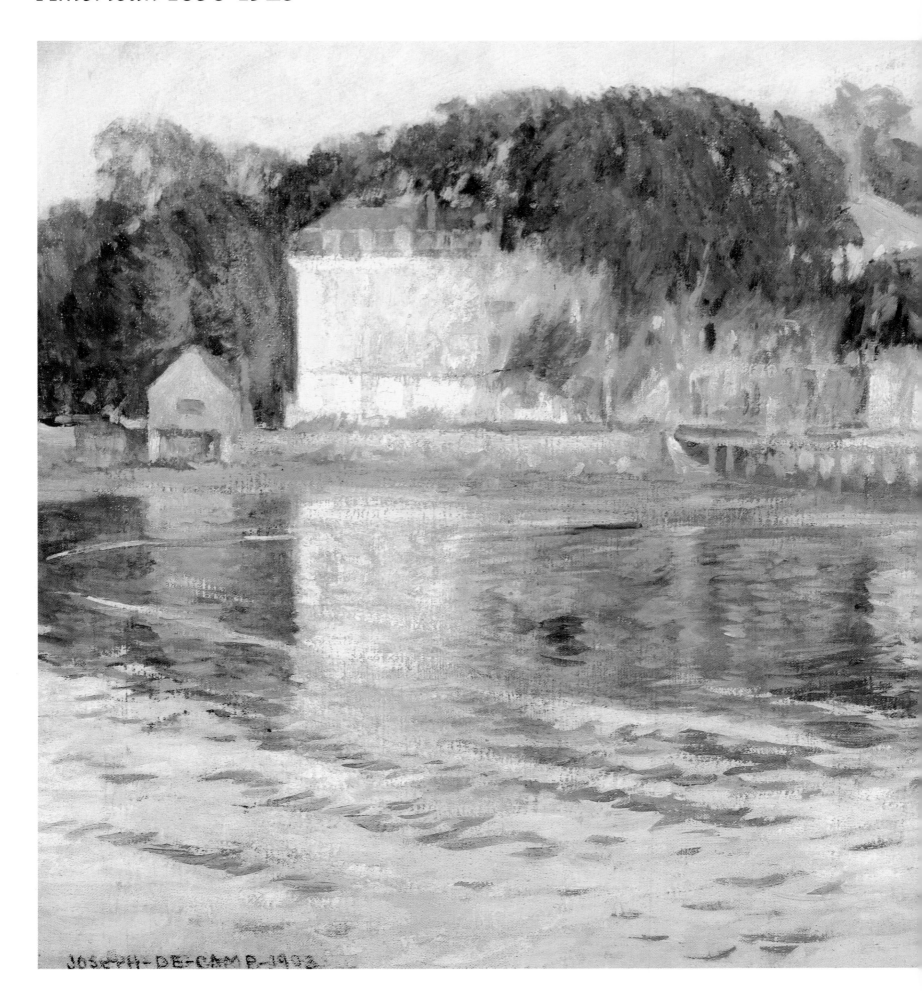

JOSEPH-DE-CAMP-1903

The Little Hotel, 1903
Oil on canvas
20×24¹⁄₁₆ inches (50.8×62.7 cm)
Pennsylvania Academy of the Fine Arts,
Philadelphia
Joseph E Temple Fund

De Camp was a native of Cincinnati and a student at the Munich Royal Academy in Germany. Later based in Boston, De Camp established a reputation as a figure painter and undertook several commissions including a portrait of Theodore Roosevelt. It was in the summer of 1900, while working with fellow 'Ten' member John H Twachtman at Gloucester, Massachusetts, that De Camp 'absorbed' Impressionism. De Camp was never fully to renounce his more formal academic and conservative portrait style, but rather he reserved his Impressionist approach and technique for landscape studies.

The hotel of the title has been identified as the Hawthorne Inn at Rocky Neck, Gloucester, which De Camp painted during flood time from the garden of his rented house. Any assessment of De Camp's subsequent development as an Impressionist is difficult: in 1904 a fire completely destroyed the contents of his Boston studio.

RAMON CASAS

Spanish 1866-1932

Interior in the Open Air, 1892
Oil on canvas
Collection Marqués de Villamizar

In Spain the Renaixença was a peculiarly Catalan movement in the arts which coincided with a revival of Catalan separatism and aimed at promoting regional art and literature. In contrast, with his contemporaries like Rusiñol and Miguel Utrillo, Casas launched the modernismo art movement in Barcelona in the 1870s. Modernismo was the Spanish Art Nouveau and derived a great deal of its vitality from the Catalan artists and writers living in Paris. For a Catalan artist a trip to Paris was almost obligatory: Rusiñol, Utrillo, and Casas lived in and among the Impressionists in Montmartre and adopted the Impressionist manner of painting though they were later to adopt very different idioms of their own. The artists of the Modernismo were to stimulate many younger Spanish artists including Torres-García, Nonell and the young Pablo Picasso, in his youth a close friend of Casas.

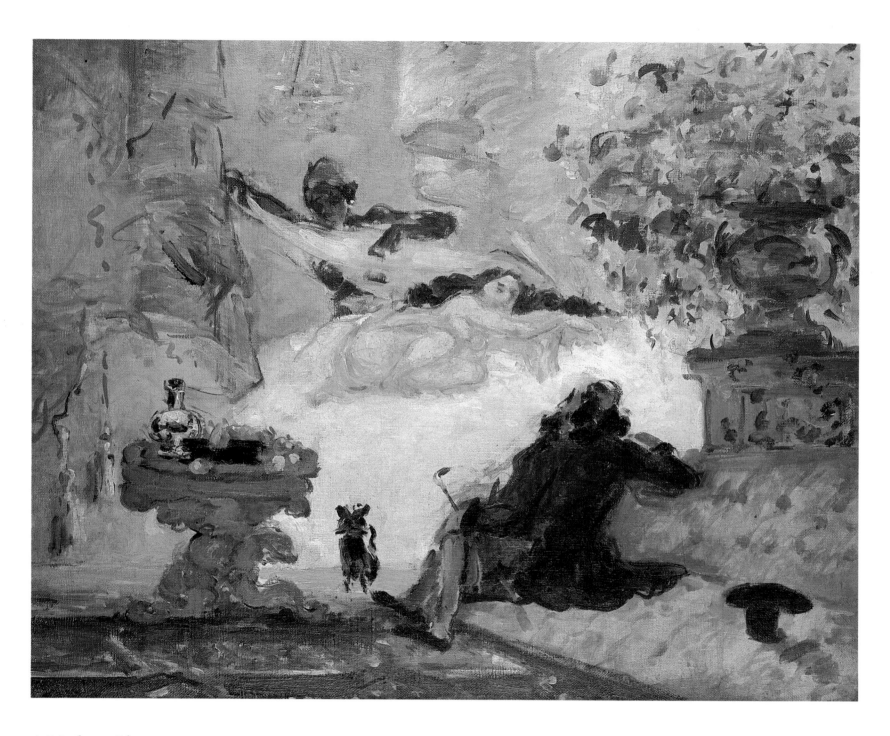

A Modern Olympia, 1873

Oil on canvas
18×22 inches (46×56 cm)
Musée d'Orsay, Paris

Manet's celebrated painting *Olympia* in-
spired a number of artists to create their
own versions of the subject. On compari-
son with Manet's painting it becomes
apparent that Cézanne's version was in-
tended as a parody of the original. The
black maid, instead of offering her mistress
a bunch of flowers still wrapped in their
paper, is here 'unwrapping' her mistress,
revealing her delights to the seated male.
This balding, bearded man is in fact
Cézanne himself, and instead of the black

cat, the Baudelairean symbol of promis-
cuity and lasciviousness, Cézanne has
painted a lapdog. This seems to be a refer-
ence back to Manet's source for his paint-
ing, Titian's *Venus of Urbino*, where the dog
was used as a symbol of fidelity.

Cézanne's *A Modern Olympia* marks a
turning point in his work, a shift from the
angst-ridden images of sexual frenzy,
drunkeness, and violence to an art which is
an exploration of his relationship with per-
ceived reality.

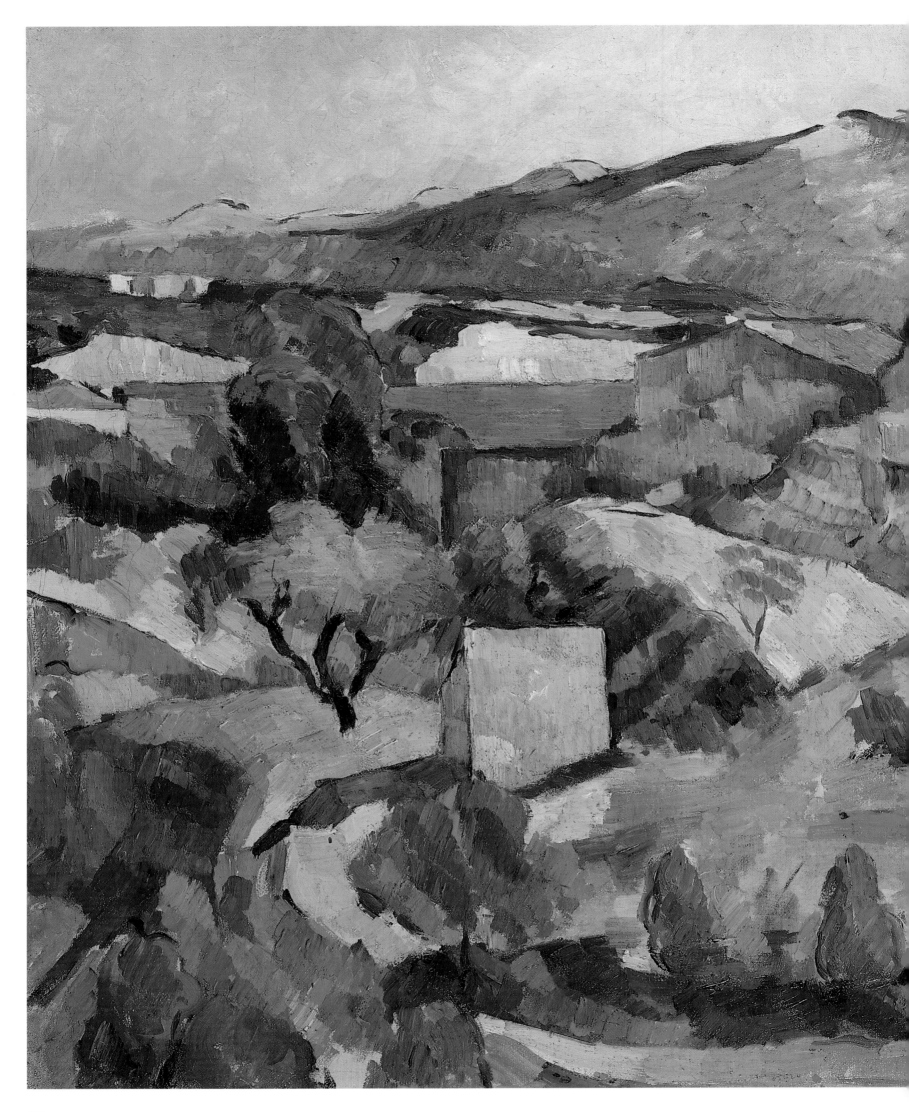

Mountains Seen from L'Estaque,

c. 1879

Oil on canvas
21×29 inches (53×74 cm)
National Museum of Wales, Cardiff

L'Estaque was a small fishing village near Marseilles which Cézanne first got to know in 1870 when he was living there with Hortense Fiquet. Fiquet was working as an artist's model in Paris when she met Cézanne in 1869 and shortly afterwards they began living together. When the war broke out, they moved together to L'Estaque. It appears that the relationship between the two was never entirely a happy one: Hortense disliked provincial life but it was here that Cézanne re-established his original passion for landscapes which he had abandoned for some time in Paris. He was greatly attracted to the village and wrote to Pissarro in 1876 that the village was 'like a playing card; red roofs against the blue seas' and he returned to the place on several occasions.

In this work, the composition is solidly constructed within the rectangle of the painting area and through a system of steps we are led down a road, behind the building, and into the countryside via a series of related arcs while the light falls from the upper right to the lower left emphasizing the diagonal movement of the landscape.

Zola's House at Medan, c. 1880

Oil on canvas
23×28 inches (59×72 cm)
Glasgow Museums: The Burrell
Collection

In 1878 as a result of his growing popularity and prosperity, the novelist Emile Zola bought a house at Medan on the Seine, north-west of Paris, about nine miles from Pontoise, which he began to use as a country retreat. It was close to the railway which cut across part of the property, but made travel to and from Paris easy. There Zola was able to indulge in his passion for writing, photography, and entertaining his friends: Monet, Pissarro, and Renoir were frequent visitors, but Zola's most regular house guest was Cézanne, who until the break between them in 1886, spent several weeks each year at Medan.

In this painting Cézanne has painted the view from a small island in the River Seine and Zola's house is actually out of sight to the right. Cézanne has taken one of Pissar-ro's favorite pictorial devices of a view of building through a framework of trees and foliage which allowed him to produce a composition based on horizontal bands held in place by the verticals of the trees.

Still Life with Plaster Cast,

c. 1895

Oil on canvas
28×22 inches (71×56 cm)
Courtauld Institute Galleries, London

A concern with the apparent lack of structure in the Impressionist technique led Cézanne to recapture a more classical sense of balance – in his own words 'to re-do Poussin from Nature.' The still life allowed Cézanne to arrange all the elements of the composition to suit his own sense of color and form. In *Still Life With Plaster Cast* Cézanne used the vertical form of the statuette of Cupid, viewed from an

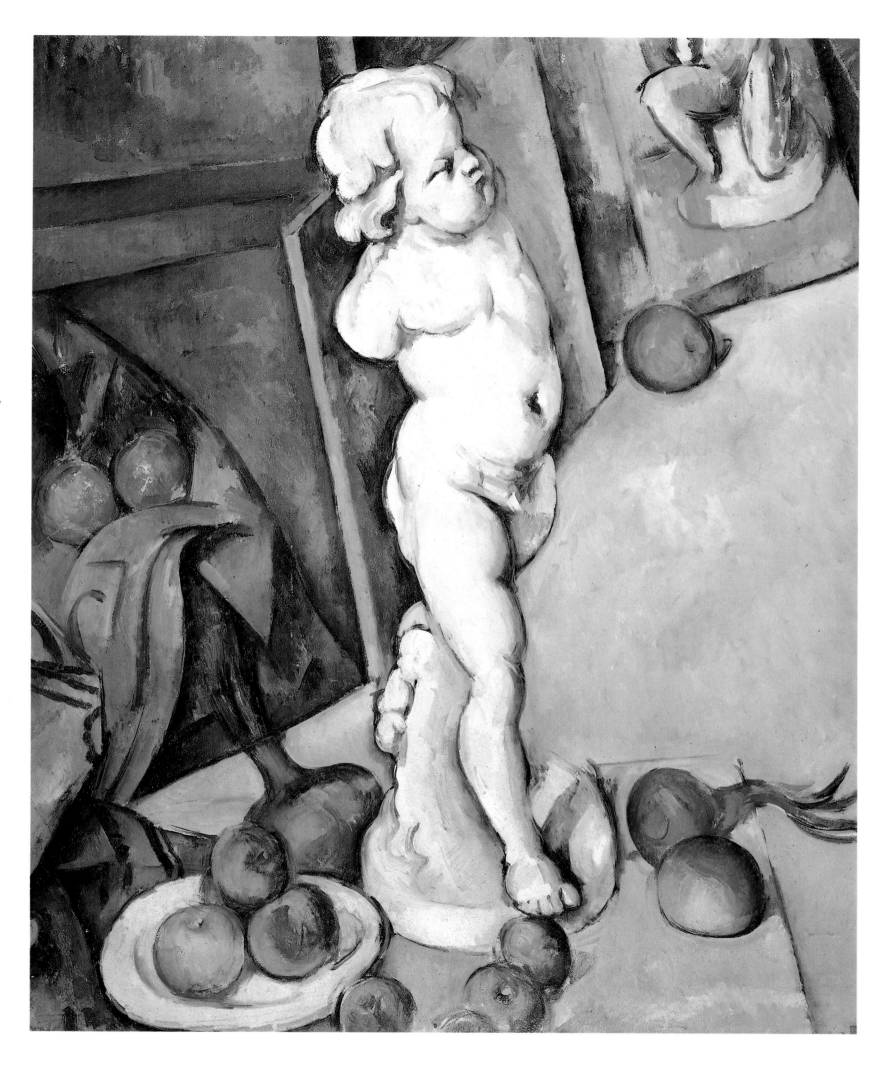

unusual angle and which extends almost the entire height of the canvas, to form the central axis around which a whole system of echoes and contrasts of light and form revolve. As part of his continuing search for a means of producing an accurate record of reality, Cézanne aimed to express the contradictions of binocular vision rather than adhering to the convention of single point perspective. This causes the forms in his paintings to shift disconcertingly in their relationships and establishes a tension between the apparent solidarity of three-dimensional forms and the flatness of linear designs.

WILLIAM MERRITT CHASE

American 1849-1916

Near the Beach, Shinnecock,

c. 1895
Oil on canvas
30×48½ inches (76.2×122.2 cm)
The Toledo Museum of Art, Toledo, Ohio
Gift of Arthur J Secor

From 1891 to 1902 Chase, under the patronage of wealthy Long Islanders, ran the Shinnecock Summer School, the first important plein-air painting school in America. An article published in 1893 about the school stated:

The advantage to living in such a place is that all an artist has to do is take out his easel and set it up anywhere, and there it is in front of him, a lovely picture.

This picture shows Chase's wife and two of their daughters strolling through a meadow not far from the beach. Almost half of the painting is of the sky and it seems as though Chase followed his own advice often given to his students:

Try to paint the sky as if we could see through it, and not as if it were a flat surface or so hard you could crack nuts against it.

LOVIS CORINTH

German 1858-1925

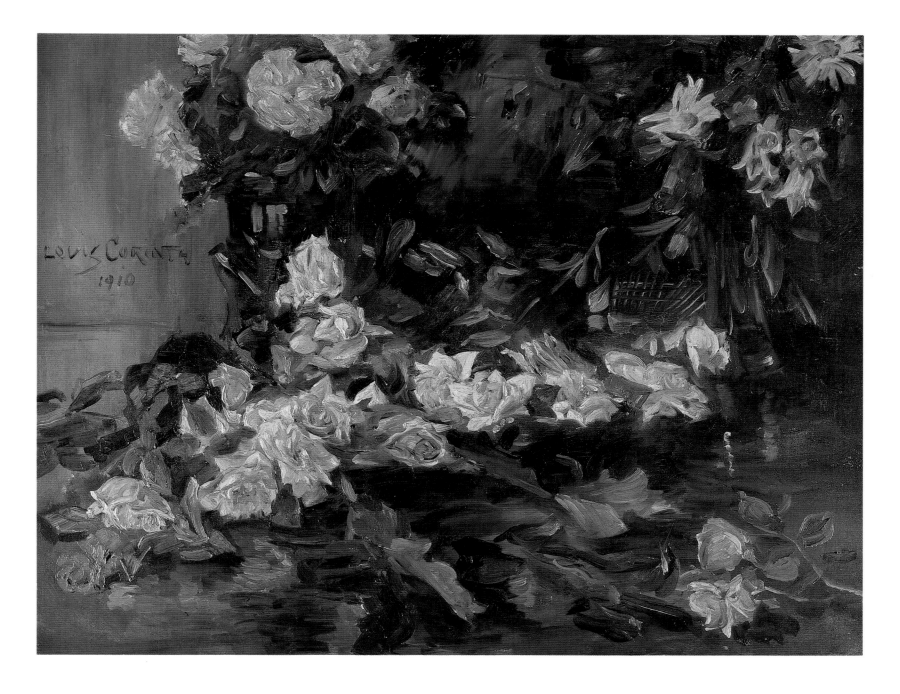

Roses, 1901
Oil on canvas
Christies, London

Impressionism came somewhat late to Germany and it was only after his move to Berlin in 1900 that Corinth became one of three outstanding painters of the period. Influenced by Corot and Courbet, what Corinth learned was the appreciation of light. Impressionism for German painters meant a liberation of light, color, and atmosphere and while the term 'Impressionism' was used to describe almost any explorative art form, its influence was so diffused in the areas of technique and visual apprehension to preclude the concept of a true 'school' of Impressionism in Germany.

CHARLES-FRANÇOIS DAUBIGNY

French 1817-1875

Landscape

Oil on canvas
23¾×35½ inches (60×90 cm)
Metropolitan Museum of Art, New York
Bequest of Matthew T Fiske Collord in
Memory of Josiah M Fiske, 1908

One of the most helpful, and an artist who
was perhaps the most influential on the
Impressionists, was Daubigny. His own
style evolved in the direction of the Barbi-
zon School (although he did not live or
work in the region) and he was an early
and enthusiastic practitioner of *plein-air*
painting, particularly concerned with
atmospheric effects. Although Dutch in-
fluences are evident in his work, it was
never derivative. From the beginning,
Manet was one of his most devoted
admirers and the two first met at Trouville
in 1865. In 1868 Daubigny was instrumen-
tal in getting work by the Impressionists
admitted to the Salon for which he was
serving as a jury member. It was also Dau-
bigny who introduced Manet to Paul-
Durand Ruel. Daubigny's example even
extends to Monet's famous floating studio
in which he was painted by Manet. The
studio-boat was based on a similar 'botin'
that Daubigny, who was particularly in-
terested in river scenes, had used twenty
years earlier in his career.

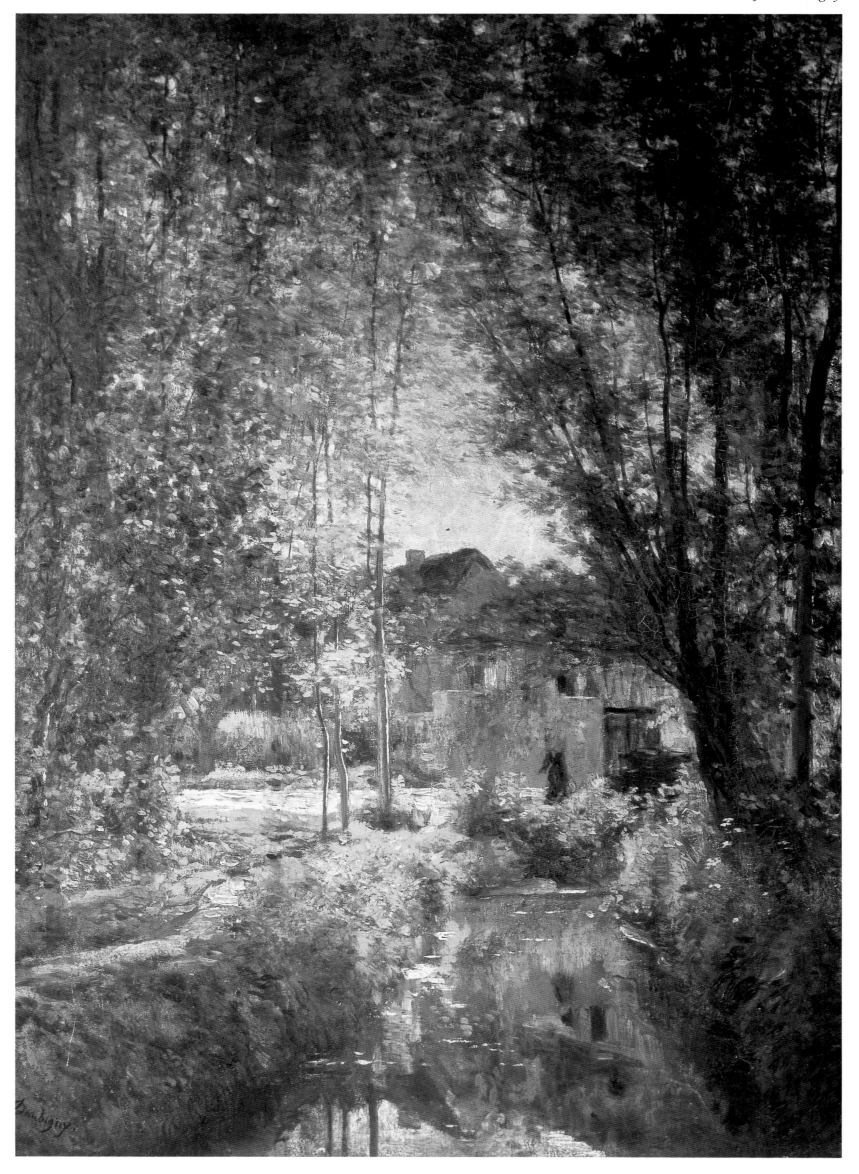

EDGAR DEGAS

French 1834-1917

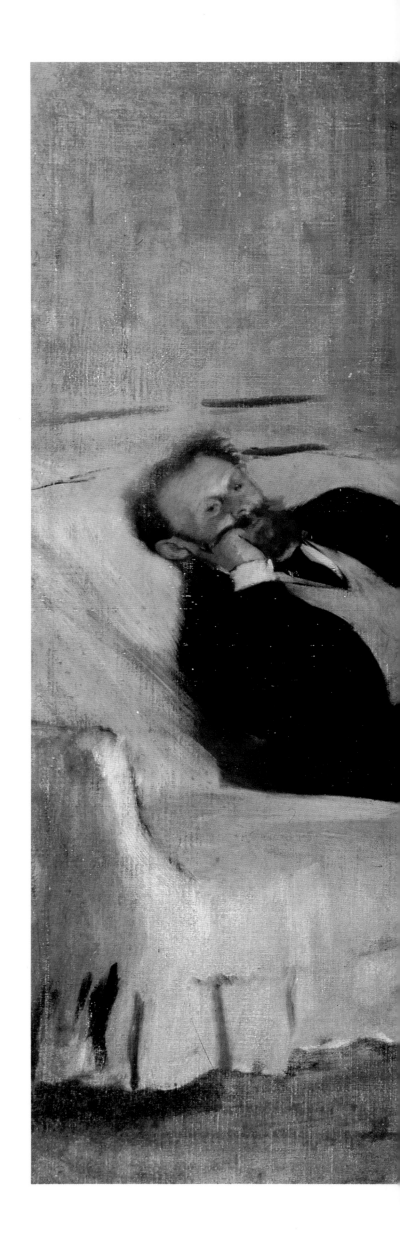

Portrait of Monsieur and Madame Edouard Manet, c. 1868-9

Oil on canvas
25⅝×28 inches (65×71 cm)
Kitakyushu Municipal Museum, Japan

Although the Impressionists' main interests were in either natural or man-made landscapes, portraiture played an important part in many of their works and they created some of the most outstanding examples of this genre. Unlike their academic contemporaries, the Impressionists did not rely on commissioned portraits as a source of income and often works of this kind were undertaken as a gesture of patronage on the part of the sitter or, as in this painting, as a demonstration of friendship on the part of the artist. According to Degas, the true purpose of portraiture was to 'depict people in familiar and typical attitudes, above all, to give their faces the same choice of expression as one gives their bodies.' Although Degas and Manet publicly squabbled and criticized each others' work, they were for many years on friendly terms and during the 1860s and 1870s they met socially in each others' homes. This painting is probably set in Manet's apartment in the rue St Petersburg and depicts Manet listening to his wife playing the piano. Some time around 1900 Degas added the strip of blank canvas on the righthand side and never got round to restoring the obliterated figure of Madame Manet at the piano.

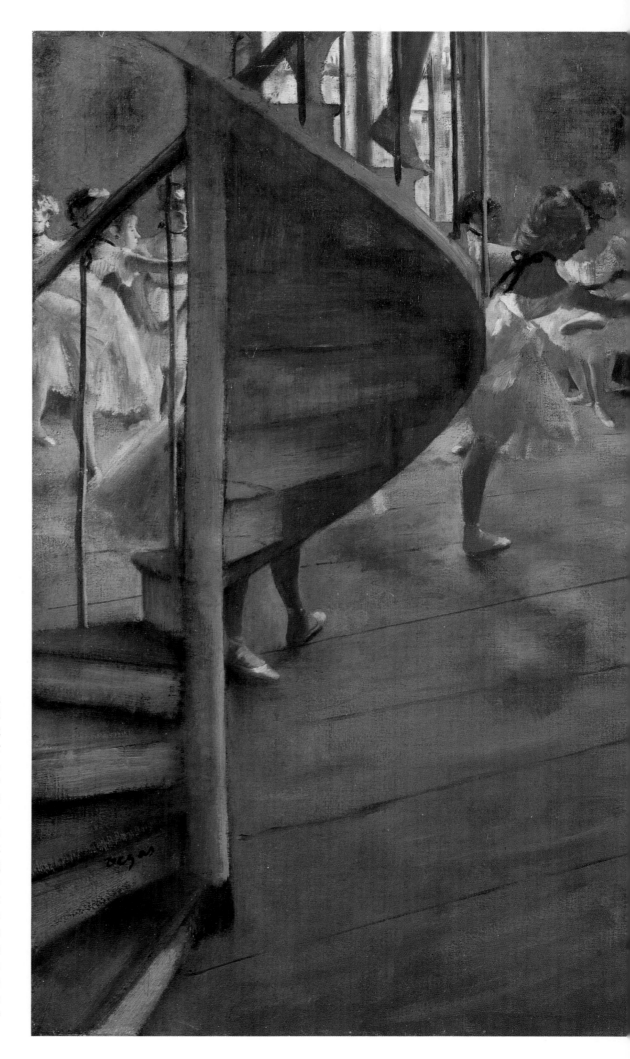

The Rehearsal, c. 1874

Oil on canvas
30×39 inches (58.4×83.2 cm)
Glasgow Museums: Burrell Collection

After his trip to the United States in February 1873, Degas returned to Paris and began working on the theme of the ballet rehearsals, a theme he had explored earlier in 1872, but only in very small canvases. This painting comes from February 1874 and Degas' housekeeper Sabine Neyt was the model for the tartan-shawled mother. The red-shirted ballet master may be a composite of Louis Merante (the ballet master who appears in the earlier painting of *The Dance Class at the Opera* of 1872) and Jules Perrot (partner to Marie Taglione, and the ballet master who appears in the *Dance Class* [1874]). At this time Degas was gathering a stock of studies of dancers who posed for him in his studio in the rue Blanche and from this repertoire of studies Degas was to produce dance paintings and pastels for the next thirty years.

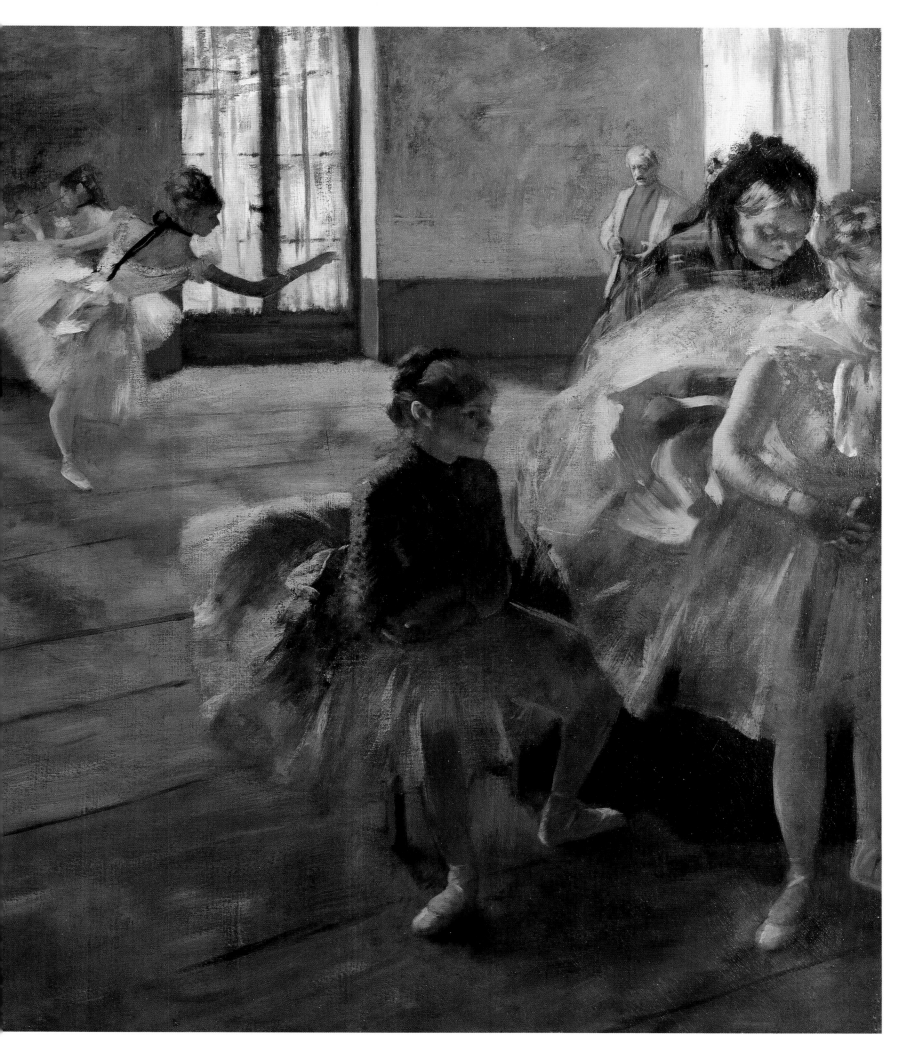

The Dance Class, 1874

Oil on canvas
32½×30 inches (82.6×76.2 cm)
Metropolitan Museum of Art, New York
Bequest of Mrs Harry Payne Bingham,
1986

The ballet-master here, Jules Perrot, is the only male dancer to appear in Degas' ballet pictures. While Degas may have had a predeliction for ballerinas, it should also be remembered that the roles for male dancers in French ballets were declining at this time with the public preferring the spectacle of women dancing in a manner, that although rooted in the past, was more vigorous and mobile than would previously have been considered correct behavior for a woman. This is one of two versions of *The Dance Class*: a version in the Musée d'Orsay in Paris presents us with the back of the dancer in the foreground, Perrot placed more centrally, and the ballerina 'en attitude' is replaced by the standing figure of a ballerina either in preparation or at the end of her 'enchaînment.'

Of the two versions, the one reproduced here makes a greater use of blacks – the mirror frame and the deeply shadowed left foreground against which the lightness of the dancers' dresses and the reflected sky stand out clearly. The rehearsal does not appear to be for a specific ballet even though the figures are dressed for performance, but are arranged according to Degas' own compositional preferences.

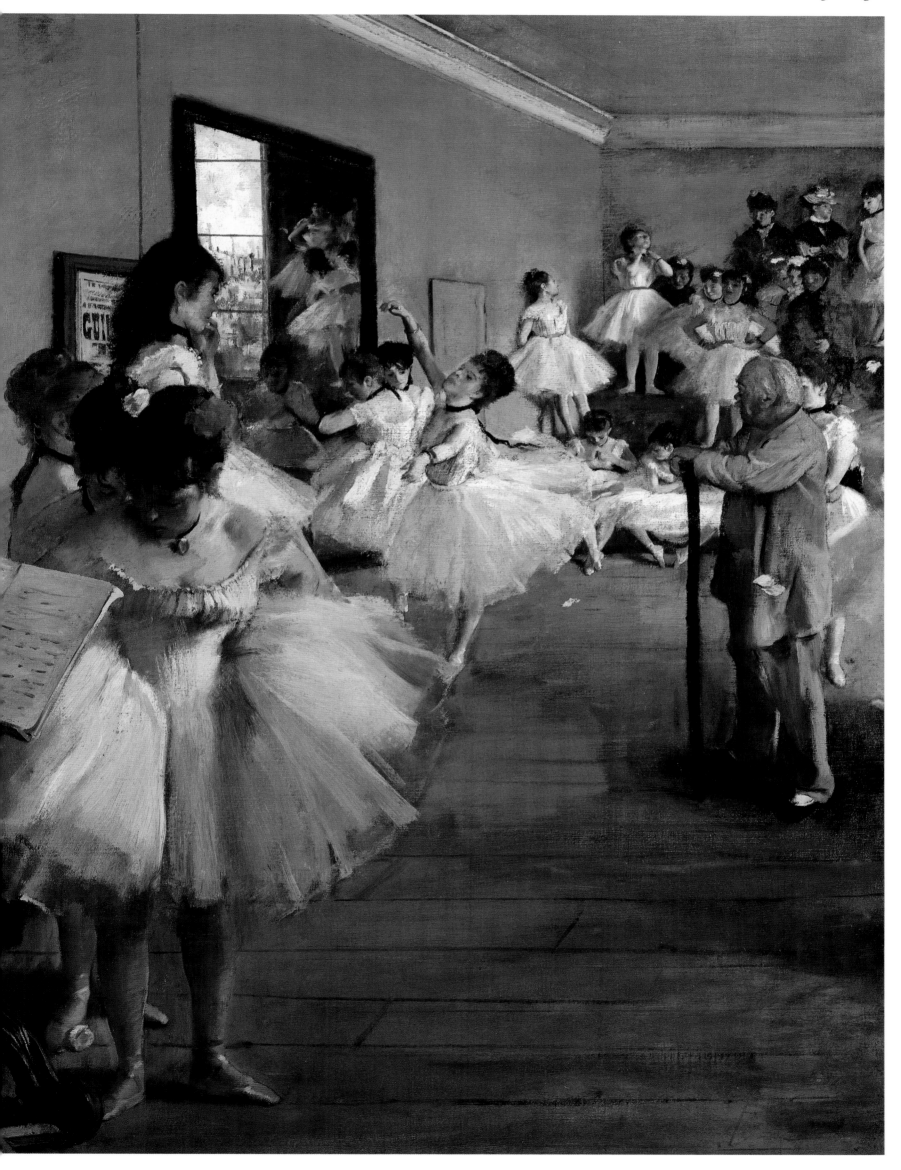

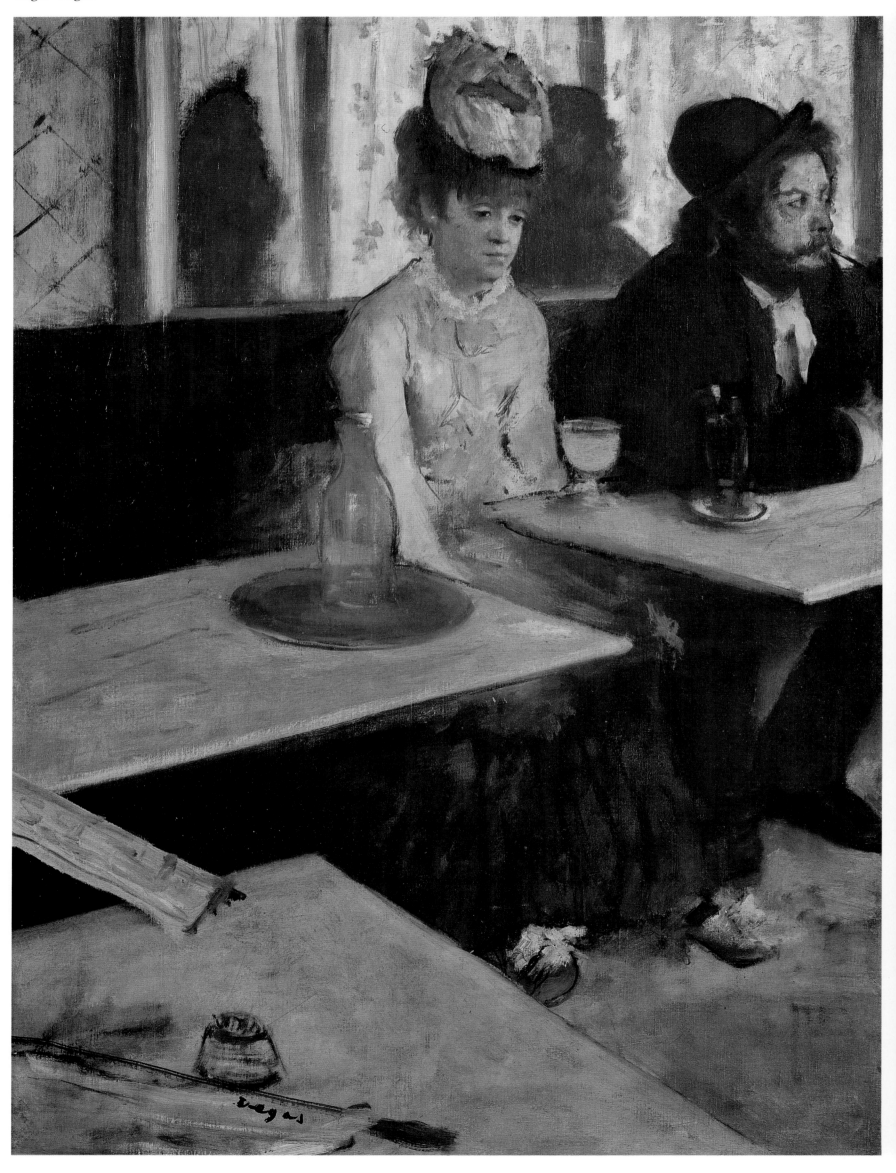

In the Café (L'Absinthe), 1876

Oil on canvas
36¼×26¾ inches (92×68 cm)
Musée d'Orsay, Paris

It was in 1893 that the alternative and more famous title of *L'Absinthe* was given to this painting when it was exhibited in London. The model for the female figure was Ellen Andrée (1857-1915), a successful actress who began her career as an artists' model and who was one of the regular visitors at the café Nouvelle-Athenès in the Place Pigalle. There she became friendly with most of the Impressionists and featured in Manet's paintings *La Parisienne* (1876), *Au café* (1878), and *La Jeune Femme Blonde aux Yeux Bleus* (1878), Renoir's *Luncheon of the Boating Party* (1881) as well as in the works of the more conventional Salon painters like Alfred Stevens. The male figure was modeled by Marcellin Desboutin (1823-1902), a painter, engraver, and author as well as a professional 'bohemian' who claimed to have gambled away an ancestral castle in Italy. Desboutins was typical of a whole group of painters who, though not particularly successful, were on the fringe of the Impressionist movement: Desboutins exhibited at the 1876 Impressionist exhibition but a lack of determination or an excessive fondness of café life and other distractions condemned him to artistic obscurity.

Degas' realist intentions for this painting show an unhappy woman, possibly a prostitute, drinking alone. The relationship, if any, between the man and the woman is uncertain. Degas has used a double viewpoint which looks down at the plane of the table and directly at the figure of the woman to create a spatial play inspired by Japanese art and by cropping off Desboutins' knee and pipe, rather like a snap-shot, he gives a reality to the work.

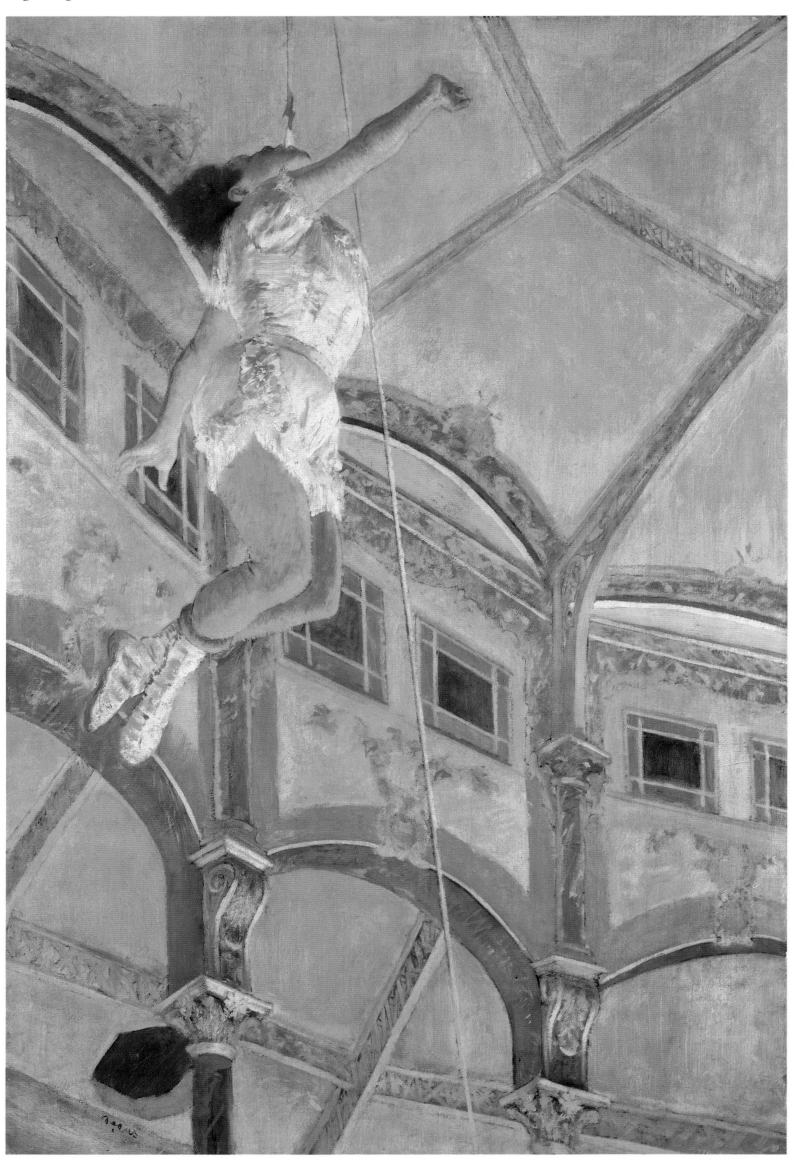

Miss La La at the Cirque Fernando, 1879

Oil on canvas
46×30½ inches (116.8×77.5 cm)
National Gallery, London

Miss La La was a mulatto circus artiste who was billed as 'The Cannon Woman' and performed an act whereby a cannon, suspended on a chain held in her teeth, was fired. In this painting Degas has depicted Miss La La performing another of her acts – being hauled by her teeth towards the roof of the Cirque Fernando, a permanent circus building erected in 1875. La La had appeared there in 1879 before going on to perform to packed houses in London, and Degas went several times to see her act and sketch her at work. Degas had positioned the figure of La La asymmetrically at the top lefthand corner of the composition. Emphasizing the space surrounding her is the rope which forms a diagonal through the picture. By excluding all references to the audience, the immediacy of the scene is heightened. The qualities of La La's performance – her suspension, tension, and balance – were qualities which Degas also saw in ballet dancers and which he would explore in his sculptures of ballerinas in the 1890s.

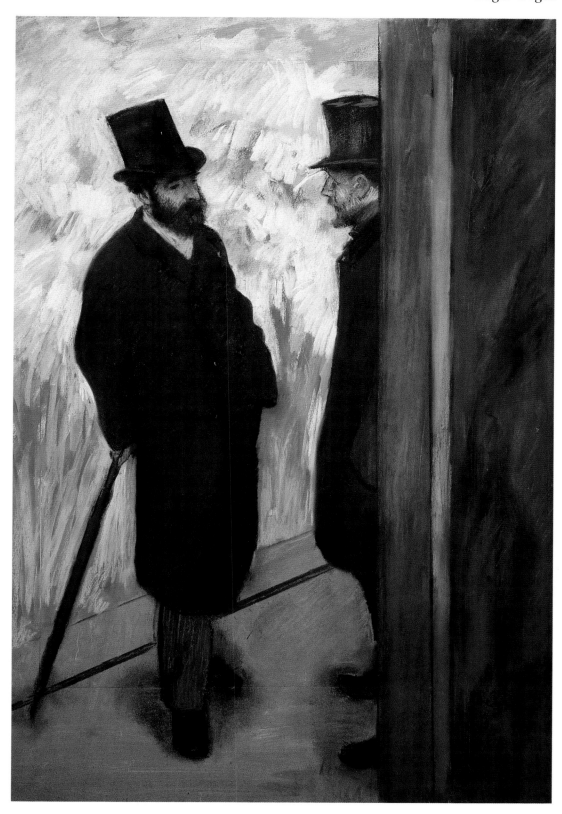

Ludovic Halévy and Albert Cave, 1879

Pastel on paper
31⅛×21⅝ inches (79×55 cm)
Musée d'Orsay, Paris

Ludovic Halévy (1834-1908), a novelist and dramatist had been Degas' friend since their schooldays together. Most famous as the librettist of many of Offenbach's operattas and of Bizet's *Carmen*, Halévy also collaborated on a comedy, *Le Cigale* (1877), which presented a satirical picture of the Impressionists and for which Degas sketched the decor for a scene set in an artist's studio. Some years later Degas also produced a series of monotypes and related drawings to illustrate Halévy's very successful novel *La Famille Cardinal* (1880), which depicted a rather seedy mother, a father, and two daughters, Virginie and Pauline, who were dancers at the Opéra. The illustrations were never published: it is said that Degas used Halévy as the model for one of the protagonists, thereby emphasizing a biographical element which annoyed Halévy.

Halévy's companion in this painting is the dilettante Albert Boulanger-Cave, and both are shown in the wings of a theater, possibly the Opera. Both men were also in fact senior civil servants (though Halévy had retired in 1874) and are shown in smart formal day clothes. Two tiny accents of color are provided by the red ribbons of the badge of the Legion of Honor on the lapels of their coats.

Diego Martelli, 1879

Oil on canvas
43½×39¾ inches (110×100 cm)
National Gallery of Scotland, Edinburgh

In 1879 Degas painted a group of portraits of male sitters in their working environment. Martelli was a Florentine painter and art critic who wrote in defence of Impressionist principles. In 1878 he made a protracted stay in Paris for the Exposition Universelle acting as a correspondent for a number of Italian newspapers. A year later he was beginning to explain the Impressionists to the Italians in terms of their resemblance to the Florentine Macchiaioli group of painters. In Degas' portrait Martelli is shown in his rented Paris apartment surrounded by familiar objects: his pipe, an inkwell, a handkerchief, and a pair of slippers. Around this time Degas had written in his notebook: 'include all types of everyday objects positioned in a context to express the *life* of the man or woman.' This portrait which exists in two versions, is also the best example of Degas' use of a high viewpoint which he adopted at this time. He even considered having a series of tiers built in his studio so he could look down on his subjects.

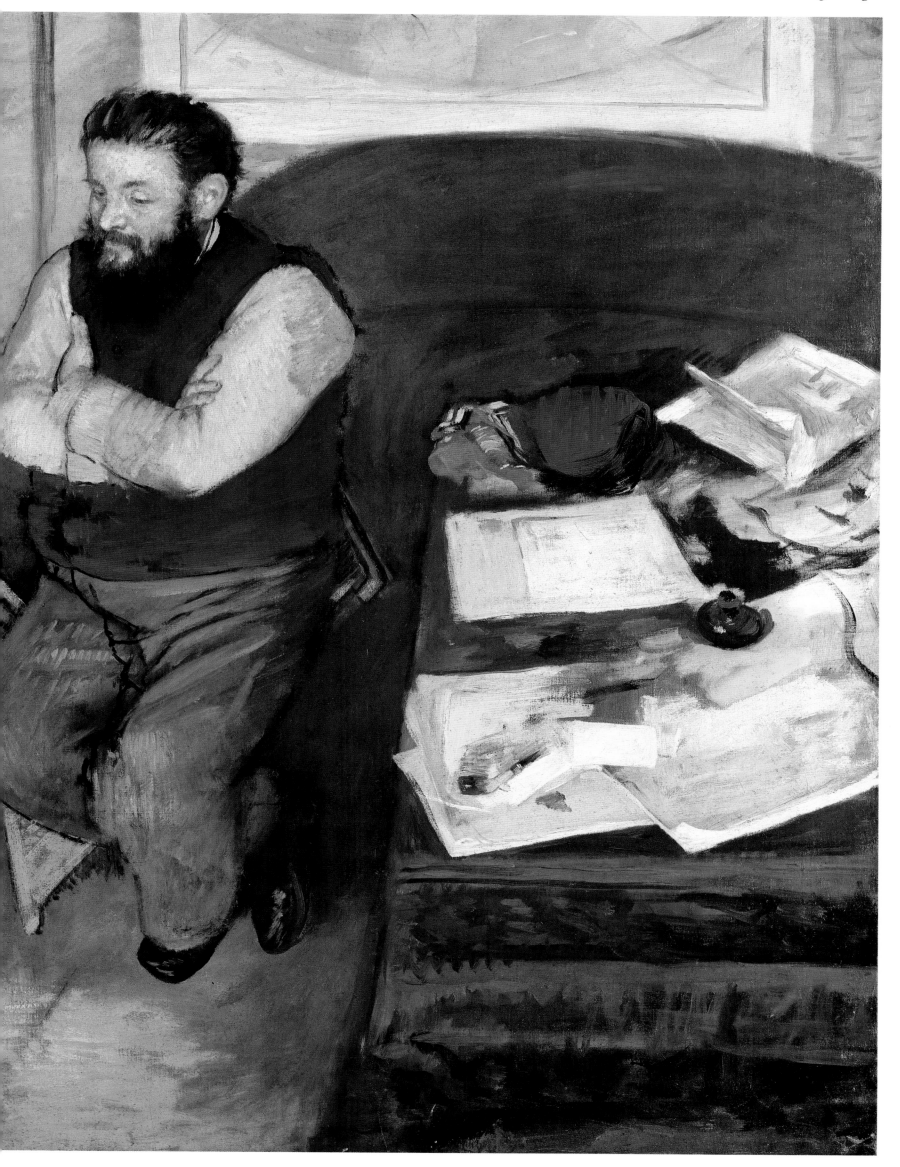

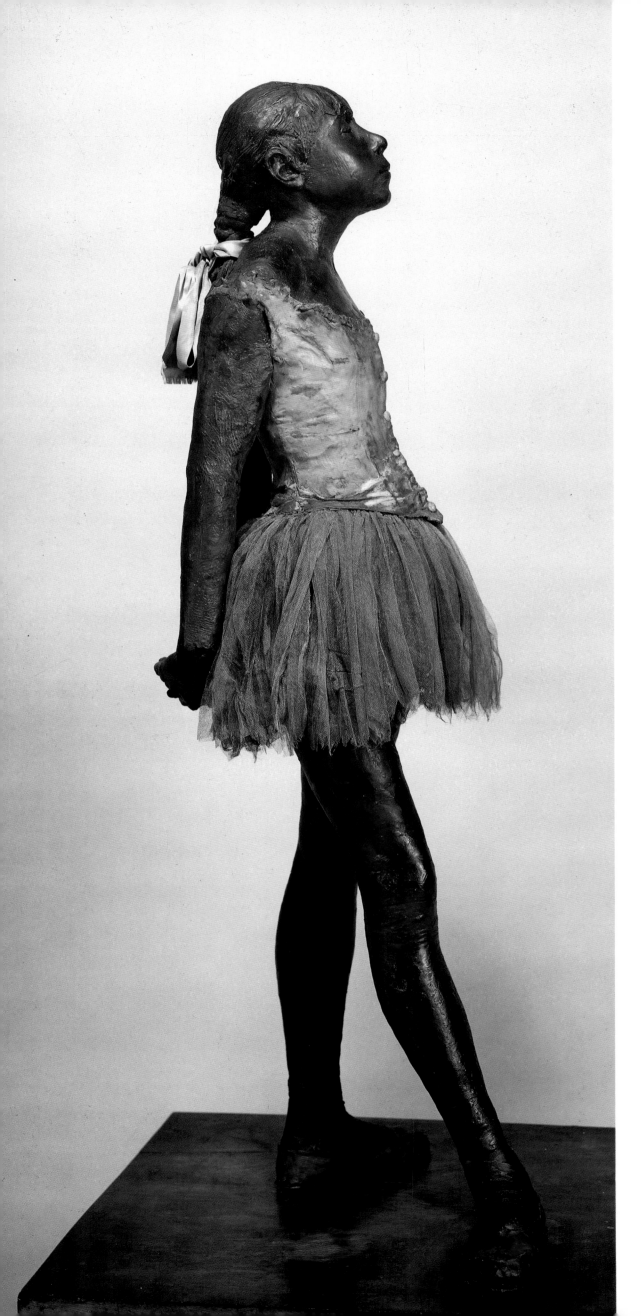

The Little Fourteen-Year-Old Dancer, 1880

Yellow wax
Height 39 inches (99 cm)
Collection of Mr and Mrs Paul Mellon,
Upperville, Virginia

Few of the Impressionist painters ventured into sculpture but two of them, Renoir and Degas, did make significant forays into it. While Renoir, with considerable technical assistance, translated figures from his paintings into three-dimensional objects, Degas created new notions in sculpture, explored its possibilities, and used it to extend his oeuvre of paintings and pastels. It is not known precisely when Degas started producing sculpture but by 1869 he had started to produce models of horses in wax which were cast into bronze after his death. Around 1878 when he was deeply involved in ballet scenes, Degas started work on the figure of the 14-year-old Marie van Goetham, one of three sisters who were all ballet students. Degas made at least sixteen studies of her in charcoal, chalk and pastel and a smaller nude wax version prior to this clothed figure.

It was the only sculpture that Degas exhibited (at the 1881 Impressionist exhibition) in his lifetime. The realism of the ⅔-life-size flesh-tinted wax figure dressed in a linen bodice, gauze tutu, and with a head of real hair caused confusion and some horror along with considerable praise as it was seen by many critics as being without precedent.

Other studies of dancers, bathers, and horses accumulated in Degas' studio but he was reluctant to have them cast, finding the mutability of wax a constant invitation to explore form. However, in 1921, initiated by the dealer A A Hebrard, more than twenty bronze versions of the little dancer were cast in bronze by Albino Palazzolo.

At the Milliners, 1882

Pastel on paper
29⅞×33⅜ inches (75.9×84.8 cm)
Thyssen-Bornemisza Collection, Lugano

This is an interesting painting in that it is one of the few works in which Degas made a still life a prominent feature. In this painting we look down on to a display of hats of silks, feathers, satin, and straw, that have been arranged in a milliner's shop window, toward the figure of the young woman inside who tries on hats. It is possible that Mary Cassatt, who often took Degas with her on shopping trips, may have modelled for these two figures. The back of the left-hand figure shares certain affinities with a back view of Cassatt leaning on an umbrella in one of Degas' standing portraits of her.

Most of the middle-class women in Degas' pictures are shown passively seated or standing before a mirror, having their hair combed or sometimes playing a musical instrument. These images contrast sharply with the activity of the working-class dancers, singers, laundresses, and prostitutes depicted in Degas' works. The pictures of Cassatt and the milliner pictures of 1882-86 are the only works by Degas which show a woman of his own class dressed for outdoor activities – even if it is only to choose a hat! In this pastel the customer is oblivious to the presence of the 'vendeuse,' who has been rendered even more anonymous for us by the placement of the full-length mirror.

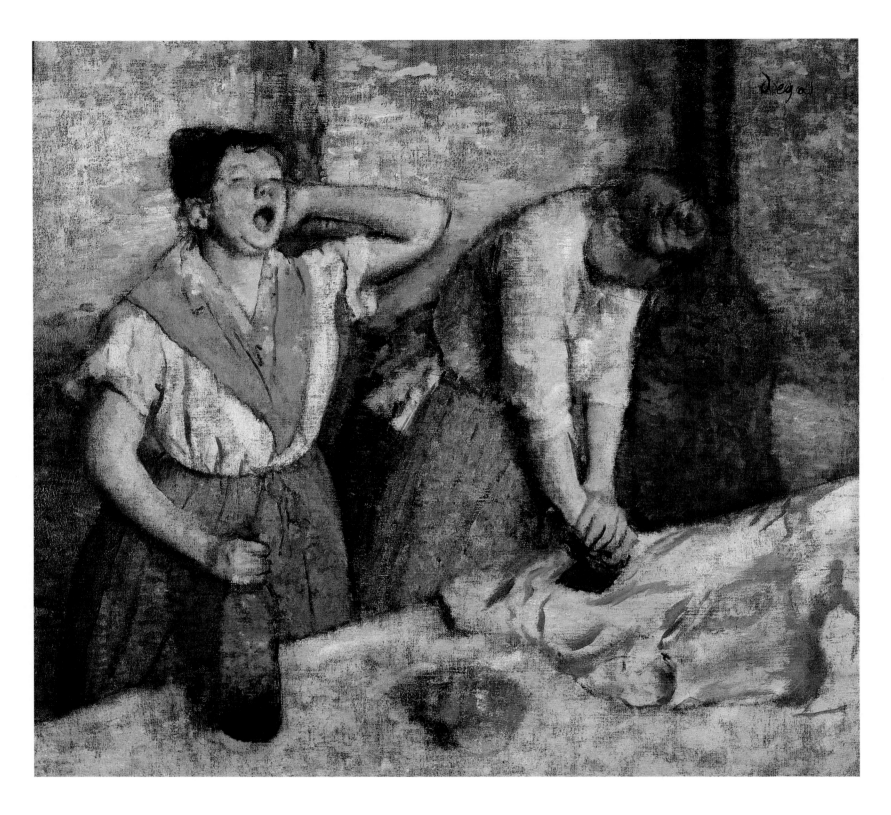

Women Ironing, c. 1884

Oil on canvas
30×31⅞ inches (76×81 cm)
Musée d'Orsay, Paris

This is one of four versions of the same subject worked on by Degas. Since the 1860s Degas had been captivated by the world of the laundress. Even during his visit to America he was prone to think of them: 'Everything is beautiful in this world of the people. But one Paris laundry girl, with bare arms, is worth it for such a pronounced Parisian as I am.'

Graphic artists like Daumier had produced images of laundresses and Degas with his interest in modern life, must have considered them a worthwhile subject. In the 19th century, women in the laundry trade were frequently the subject of popular prints which stressed their supposed susceptibility to the advances of amorous males. Degas' laundresses have often been linked with Emile Zola's best selling novel *L'Assommoir* published in 1877. A passage in the novel conjours up the image of: 'A man passing a laundry shop would glance in, surprised by the sound of ironing, and carrying a momentary vision of bare-breasted women in a reddish mist.' Furthermore, Zola's novel charts the alcoholic disintegration of Gervaise Macquart who for a while was a successful laundress. Degas' depiction of the truth of hard work and the emphasis he gives to the wine bottle are close in sentiment to Zola's central message of the destructive force of alcohol amid a life of drudgery of the poor, a theme that Degas also touched on in *In the cafe ('L'Absinthe)*.

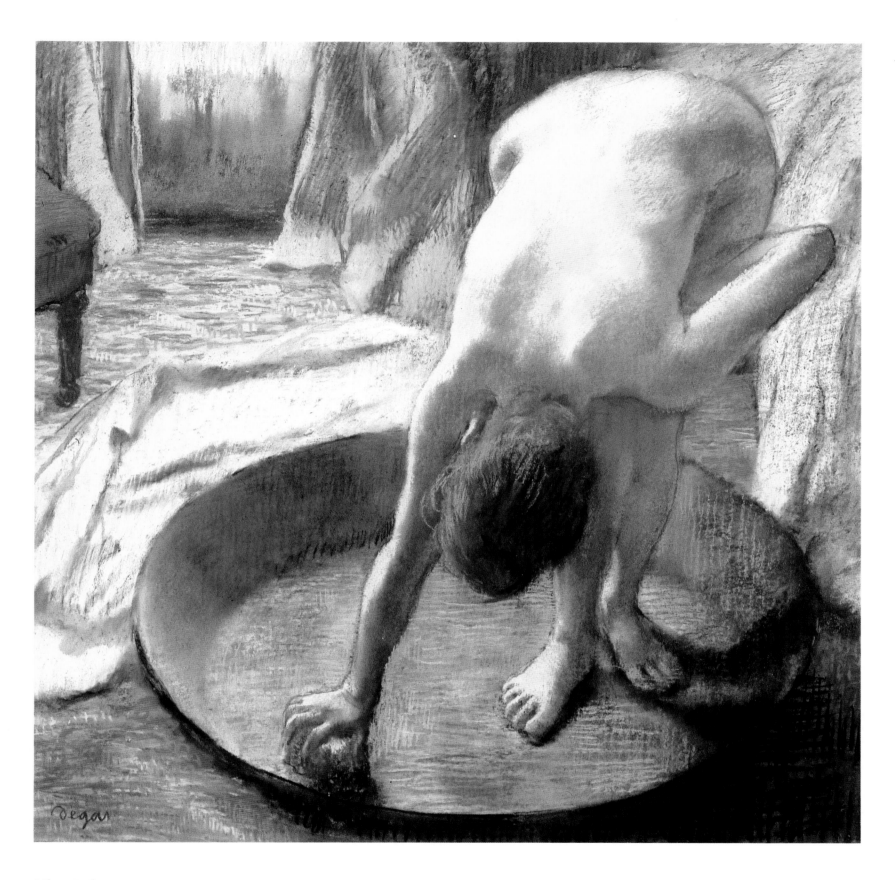

The Tub, 1886

Pastel on paper
27½×27½ inches (70×70 cm)
Hill-Stead Museum, Farmington,
Connecticut

While this pastel belongs to the same suite as *Women Bathing in a Shallow Tub*, it is not certain whether it was exhibited at the eighth Impressionist exhibition since it is one of four related works that show a woman stooping and holding a sponge in her outstretched hand. Around the same time Degas was exploring the formal problem of the nude figure contained within the circle of a bath in some wax sculptures. For all the series, Degas' studio manner was to allow the model to go freely through unrehearsed actions using the various props until Degas found one he liked. In the 1890s Georges Jenniot visited Degas' studio and watched this unusual approach to posing and was struck by how contorted the human body could look in reality – often completely at odds with our mental notions of its appearance or capabilities. Paul Gauguin who later wrote of this series: 'Drawing has been lost, it needed to be rediscovered. When I look at these nudes, I am moved to shout "It has indeed been discovered".'

THOMAS DEWING
American 1851-1938

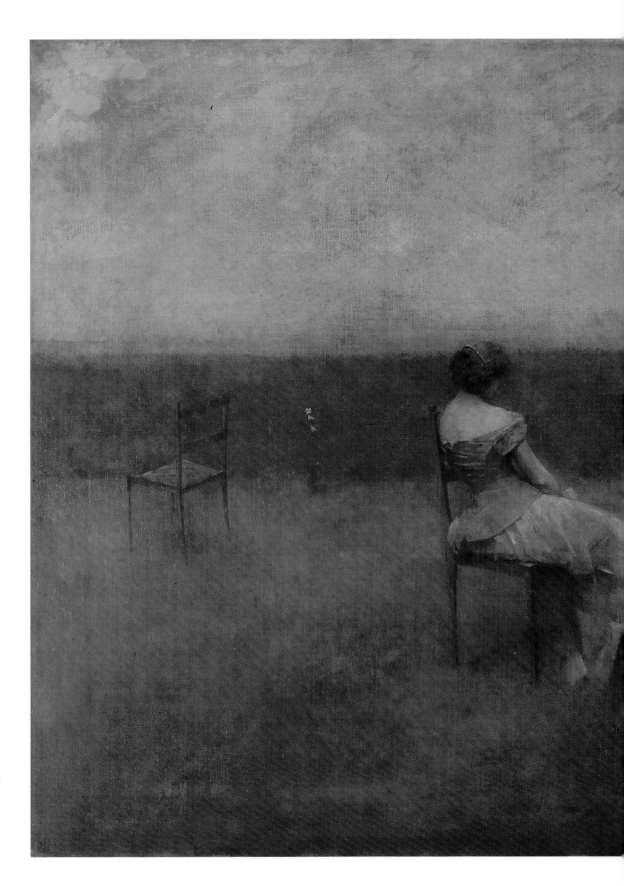

The Recitation, 1891

Oil on canvas
30×50 inches (76.2×127 cm)
Detroit Institute of Art
Detroit Museum of Art Purchase, Picture Fund

A member of the 'Ten,' Dewing first studied at the Boston Museum of Fine Arts School and then at the Académie Julian in Paris. Occasionally he collaberated with his wife Maria Oakey, a well-known flower painter and Dewing's own recognizable style only emerged in the 1890s when he began work on a series of paintings of women in vague, dreamlike landscapes. The trance-like appearance of his figures is enhanced by his use of a gentle golden light. *The Recitation* is set on a vast lawn which appears to extend to the sea, if not into infinity. The bands of color, variations of blues and greens, are Whistlerian while the figures, which are more substantial than the landscape, owe more to the academic manner of painting that Dewing had abandoned. These combine to produce a painting that many see as being closer to the Symbolists than to mainstream Impressionism.

JOHN ENNEKING
American 1841-1916

Blossoming Trees, 1898
Oil on canvas
18×24 inches
Vose Galleries of Boston, Inc

Ohio-born Enneking moved to Boston in the mid-1860's. The following decade he studied in Munich and Paris, where he became friendly with Daubigny. On his return to America Enneking had a solo exhibition which was a great and unexpected success and from then on he was one of Bostons' favorite and most prolific landscape painters. Enneking had been considered as a possible candidate for inclusion in the 'Ten', but was excluded when the membership of this group was restricted to artists that had been affiliated with the National Academy and Society of American Artists. Constantly reworking his canvases, Enneking fluctuated between a Barbizon style for his woodland scenes at twilight and an Impressionist impasto manner for his summer New England landscapes. So fond of the New England scenery, Enneking helped to develop Boston's public park system and became one of America's first champions of environmental issues.

JEAN-LOUIS FORAIN

French 1852-1931

The Client or *The Brothel,* 1878

Gouache on paper
10×13 inches (25×33 cms)
Private Collection, London

A recorder of contemporary life in the tra-
dition of Daumier, Forain was a close
friend of many of the Impressionists and
exhibited with them in 1879, 1880, 1881,
and 1886, even though his work, which
apart from the shared enthusiasm for con-
temporary scenes that brought him close
to Degas, had very little in common with
mainstream Impressionism. Forain's
major achievement was in his drawing and
his caricatures with their incisive lines, wit
and their ability to delineate character. His
first group of exhibited works include a
number of small-scale watercolors and
gouaches in bright contrasts of color of the
pourtours or balcony walks of the Folies
Bergeres. *The Client* is also executed in this
medium.

To the right of the painting a well-
dressed man in a top hat rests his chin on
the handle of his umbrella as he ponders
on the relative merits of the prostitutes
who parade before him.

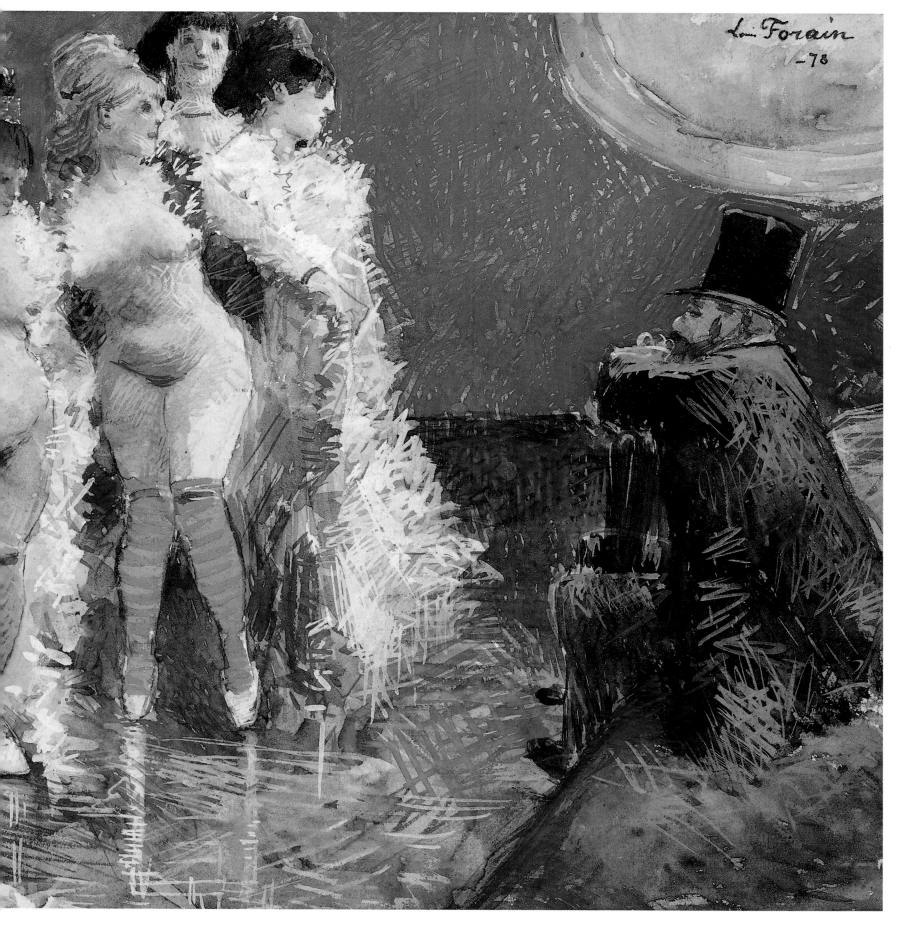

FREDERICK FRIESEKE

American 1874-1939

Summer, 1914

45×57¾ inches

The Metropolitan Museum of Art, New York

George A Heard Fund, 1966

In spite of living so close to Monet, Frieseke was more influenced by Renoir, who like him was more interested in the figure, especially the female nude, than in landscape painting. Frieseke was one of the few American Impressionists who regularly painted the nude. Most American artists shied away from frank expressions of female sensuality. Historian Samuel Isham remarked: 'There is no room for the note of unrestrained passion; still less for sensuality. It is the . . . beauty and purity of young girls which [Americans] demand, but

especially the last.' Frieseke valued spontaneity in painting and did not believe in constructing a painting from a series of preliminary studies but was concerned with capturing color sensations and patterns. The nude woman's flesh for Frieseke was simply another surface whose tones are brought out by a dappled summer light through the trees.

Lady in a Garden, 1912

Oil on canvas

31⅞×25¾ inches

© Daniel J Terra Collection

Terra Museum of American Art, Chicago

Frieseke dominated the second generation of American Impressionists who flocked to

Giverny at the turn of the century. Born in Michigan and trained at the Academie Julian in Paris, Frieseke was much acclaimed in Europe, especially in Italy, before his reputation reached back home to America and set the tone for many of the later American Impressionists. Like so many of his paintings, *Lady in a Garden* is set in Frieseke's own carefully tended garden in Giverny. Although it was important to his art, Frieseke himself was not particularly interested in gardening – his wife did all the landscaping – and he approached flower painting not as a botanist, but as a colorist: 'I know nothing about the different kinds of gardens, nor do I ever make studies of flowers. My one idea is to reproduce flowers in sunlight . . . If you are looking at a mass of flowers in the sunlight out of doors you see a sparkle of spots of

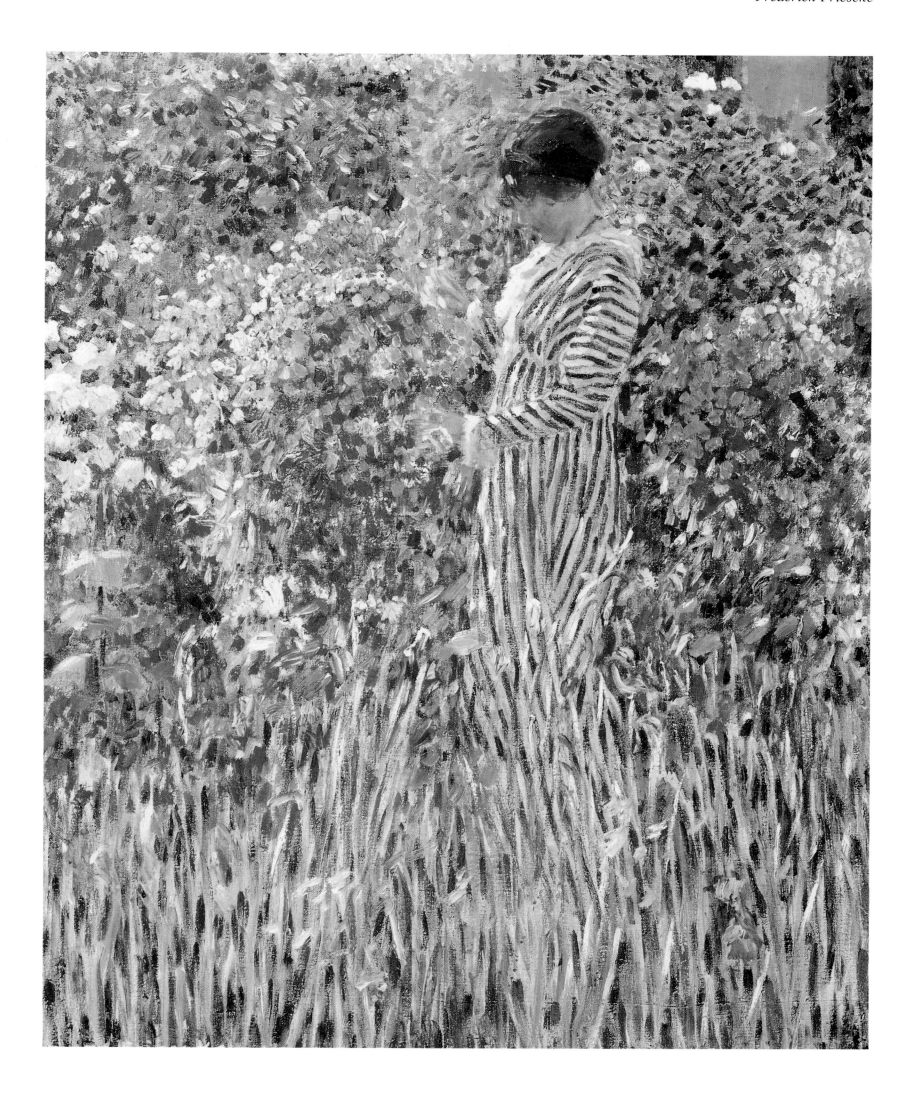

different colors; I paint them that way.' At first glance it is difficult it see the figure of the woman: the stripes of her dress break down the mass of her body and seem to fuse her with the long stalks of the flowers she stands in.

PAUL GAUGUIN
French 1848-1903

Study of a Nude: Suzanne Sewing, 1880

Oil on canvas
45×32 inches (114×81 cm)
Copenhagen, Ny Carlsberg Glyptothek

Gauguin painted this study of a nude while he was still an amateur artist and it was the first work which gave any indication of his serious ambitions as an artist and marked a decisive new departure from his earlier Pissarroesque landscapes. When the painting was shown at the sixth Impressionist exhibition in 1881, it earned Gauguin his first unequivocable praise from the critic J K Huysmans who remarked on its modern quality both in terms of its subject matter and in its treatment. The model was Gauguin's maid Suzanne (sometimes also called Justine) who had also posed for Delacroix in her youth. Unlike the contemporary Salon nudes which Huysmans criticized, Gauguin has not made his nude into a sexual object but instead has depicted Suzanne's body truthfully: she does not recline seductively but assumes a rather unflattering pose as she performs the mundane task of sewing. While the picture is a nude, it is also a genre scene, representing everyday life, a subject favored by seventeenth-century Dutch and eighteenth century French painters. Gauguin's painting remained unsold for eleven years until 1892: when Gauguin was in Tahiti his wife Mette managed to sell it to a Danish artist and the following year it was exhibited in Copenhagen alongside the first selection of Tahitian paintings Gauguin had sent back to Europe.

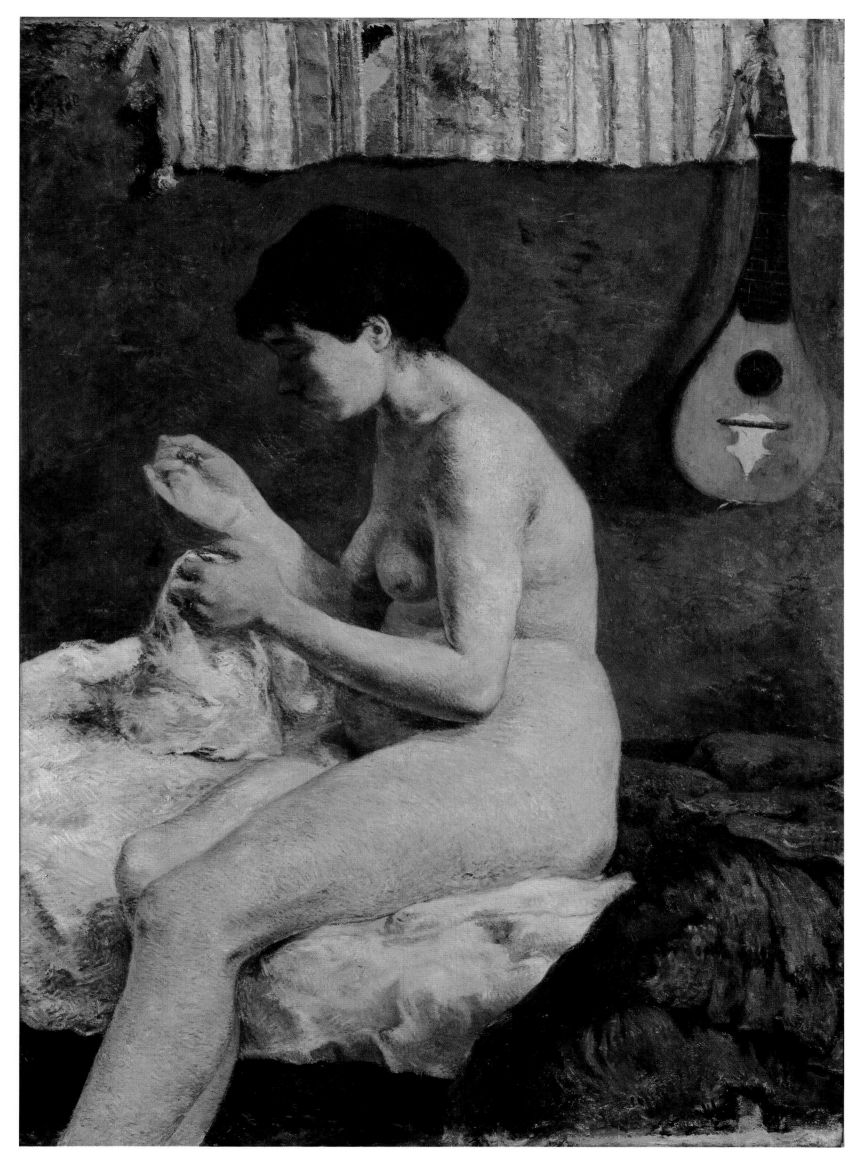

Still Life with Oranges, c. 1881
Oil on canvas
13×18¼ inches (33×46cm)
Musée des Beaux-Arts, Rennes

Exhibited at the seventh Impressionist ex-
hibition in 1882, the subject matter of
oranges is a rare one in French still life
painting. It is possible that Gauguin
selected this fruit as it allowed him to ex-
plore the use of complementary colors. In
many ways he followed the tried and tested
formulae of French still-life painting from
Chardin to Cézanne: the balancing of form
and the use of the knife to point into the
picture space demonstrate Gauguin's fami-
liarity with the formal language of the tra-
ditional still life. Like Pissarro and
Cézanne, Gauguin also uses a patterned
wallpaper as a background and like
Cézanne, he introduces distortions – the
bowl of fruit cuts the table top in half
thereby making any meeting of the far
edges of the table impossible. Furthermore
the ellipses of the rim and base of the fruit
bowl are inconsistent. Like many other Im-
pressionists Gauguin also used the tech-
nique of optically mixing colors and frac-
tured brushstrokes.

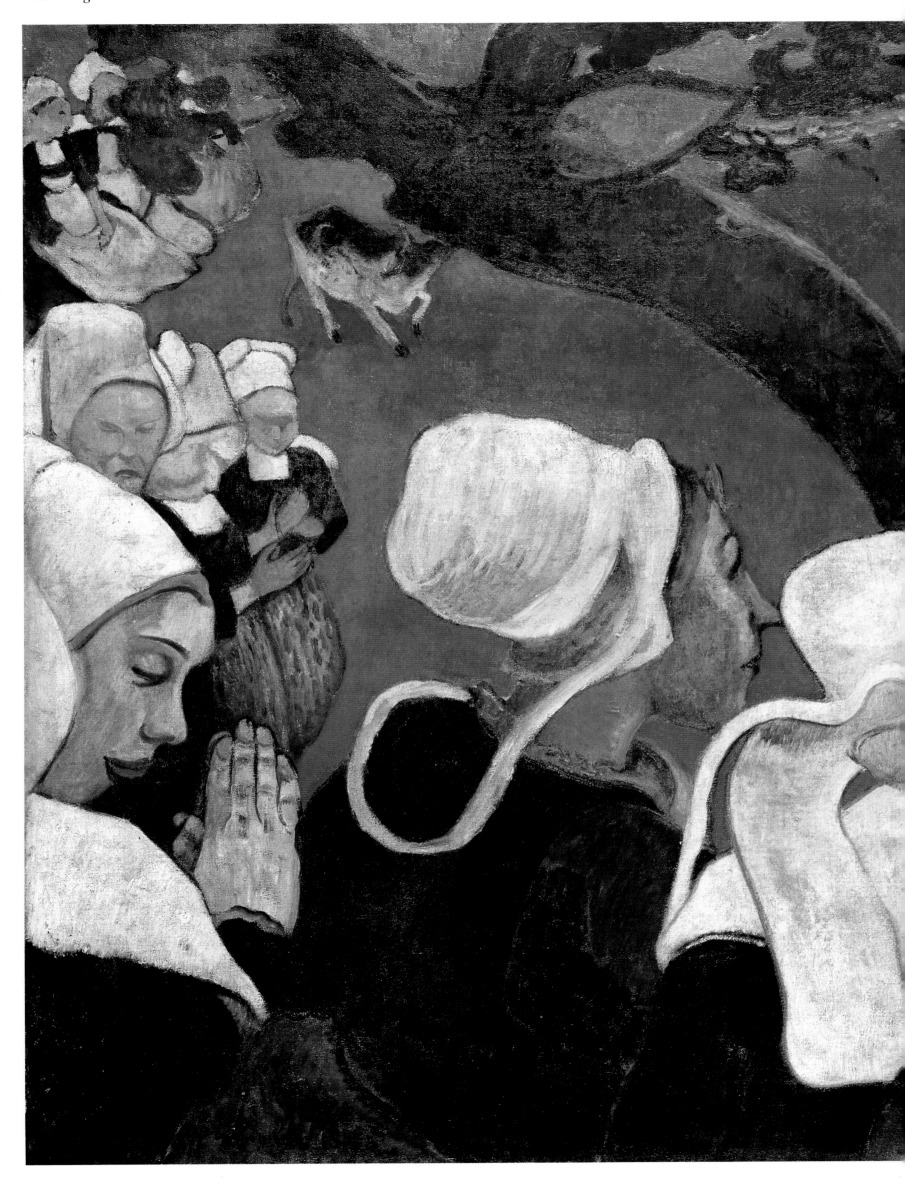

**The Vision After the Sermon:
Jacob Wrestling with the Angel,**
1888

Oil on canvas
28¾×36¼ inches (73×92 cm)
National Gallery of Scotland, Edinburgh

Originally painted for a church in Brittany
but refused by the priest, this painting has
often been regarded as marking the turn-
ing point in Gauguin's art, the moment he
finally abandoned Impressionism and the
desire to create an illusionistic equivalent
for the real world in favor of a truly modern
approach that asserts the two dimensional-
ity of the picture surface. Many of these
characteristics were in fact already ap-
parent in Gauguin's art before this date:
the flattening of space is evident in his
paintings from the first period in Pont-
Aven and Martinique and Gauguin had
become increasingly interested in decora-
tive, exotic, and 'primitive' art forms such
as Japanese prints, stained glass, and re-
ligious carvings. The same interests were
also shared by other artists, van Gogh and
Bernard in particular. Gauguin's painting,
while heavily indebted to Emile Bernard's
Breton Women in the Meadow in its arrange-
ment of figures, the decorative treatment of
the headdresses, and the exaggerated
colors, perspective, and drawing, never-
theless embarks on a new realm of subject
matter previously unexplored by the Im-
pressionists. The tendency towards
symbolic abstraction, exemplified by
Gauguin's use of the flat red plane to re-
move the setting from reality and to
symbolise a higher 'spiritual' plane
alienated Gauguin's former mentor, Pis-
sarro, who in 1881 was to complain bitterly
about Gauguin's new-found critical
acclaim.

Portrait of a Woman with a Still-Life by Cézanne, 1890
Oil on canvas
25¾×21⅝ inches (65.3×54.9 cm)
Art Institute of Chicago
Joseph Winterbotham Collection

In 1881 Gauguin had joined Pissarro at his home in Pontoise where the two worked together. Here, they were joined by Cézanne and both Gauguin and Pissarro were to profit from watching Cézanne paint. The limitations of the Impressionist techniques had caused doubts in Pissarro's mind and he tried to solve them by reference to Cézanne's technique. Cézanne had recognized that the analysis of light, taken to its logical conclusion would lead to a disintegration of the picture surface and a lack of any kind of pictorial unity. Gauguin obviously learnt a great deal from watching Cézanne and from his own collection of Cézanne's canvases, the majority of which were painted in the closely hatched style of the 1880s. For some time Gauguin adopted Cézanne's method of ordering picture space.

The very clear influence of Cézanne is evident in this portrait of Marie Lagadu, a fact pointed up by the inclusion in the background of a Cézanne still life which was owned by Gauguin. Because of her black eyes, the model has been variously identified as Marie Henri and as Marie Derrien (referred to often as Marie Lagadu).

Hail Mary: La Orana Maria, 1891
Oil on canvas
44¾×34½ inches (113.7×87.7 cm)
Metropolitan Museum of Art, New York
Bequest of Sam A Lewisohn, 151

Fuelled partly by his visits to colonial exhibitions at the Exposition Universelle and partly by his growing dissatisfaction with Brittany which had failed to live up to his idea of the 'savage,' on 1 April 1891, Gauguin left France for Tahiti. His first letters written shortly after his arrival there make it clear that he was both charmed by the place but also disappointed at not finding what he had expected in the way of ancient customs and religious rituals. Many of the Tahitians had in fact been converted to Christianity, attended missionary schools, and had adopted European clothing. Because of the lack of any apparent native artistic tradition, Gauguin began to construct one for himself. In this painting Gauguin returned to the religious themes he had explored in Brittany in paintings such as *The Vision after the Sermon*. This painting is unusual in that it deals with the incursion of Christian culture into the lives of the Tahitians, something that Gauguin was at pains to avoid in favor of the more exotic and alien. In *La Orana Maria*, which is also slightly larger than the majority of his works and more highly finished, Gauguin has depicted the Madonna and child with the traditional western halo, but as Tahitians. The pose of the two worshipping women was taken from photographs of the Buddhist temple reliefs at Borobudur in Java. Although the subject matter is drawn from western conventions and the painting is ostensibly a religious one, Gauguin has treated it as a Tahitian genre scene and it becomes a composite of eastern and western influences.

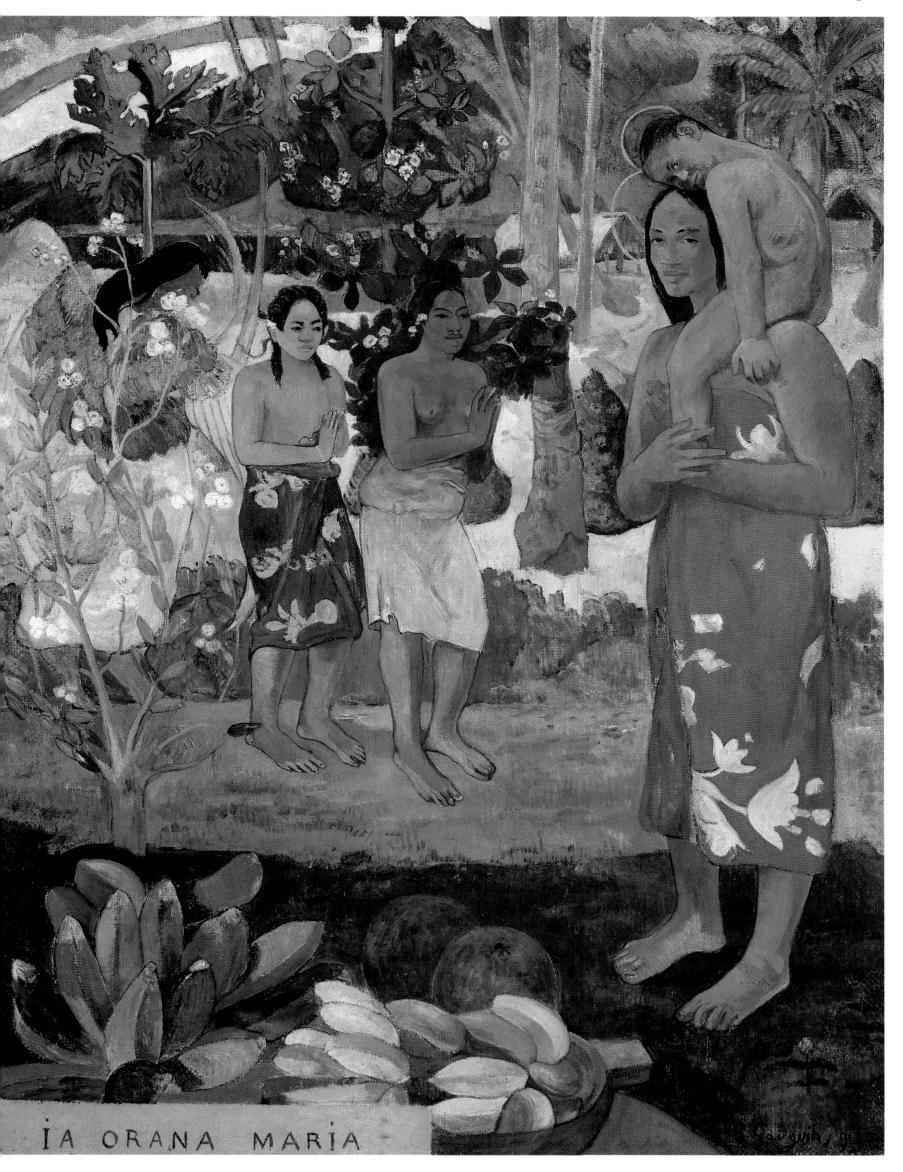

IA ORANA MARIA

VINCENT VAN GOGH

Dutch 1853-90

Still Life: Vase with Flowers, Coffee Pot and Fruit, 1887

Oil on canvas
16¼×15 inches (41×38 cm)
Von der Heydt-Museum, Wuppertal

Vincent van Gogh embarked on his artistic career late in life and began by painting rural peasants or typical working figures from urban life in a dark tonal manner that is similar to that adopted by his contemporaries in The Hague School. In 1886 van Gogh left Antwerp for Paris where he went to the atelier of Félix Cormon, a liberal teacher who included amongst his pupils Toulouse-Lautrec, Anquetin (whose works impressed van Gogh), Gauguin (who introduced him to Pissarro), and Emile Bernard. Impressionism, alongside the influence of Japanese prints, was to give van Gogh the elements he required for his own work: from Impressionism he gained a new attitude to color and a freer, more rigorous brushwork. But van Gogh was never an Impressionist in the true sense of the word. He made use of the technical discoveries of the Impressionists but directed these towards the exploration of feelings rather than the depiction of external phenomena, and while he shared their enthusiasm for contemporary life, van Gogh's paintings were marked by the

same idealistic fervor he had retained from his early admiration for artists like Millet, Hubert von Herkomer, and Frank Holland.

Voyer-d'Argenson Park, Asnières, 1887

Oil on canvas
29¾×44½ inches (75.5×113 cm)
Rijksmuseum Vincent van Gogh, Amsterdam

In the two years between 1886 and 1888 that he was in Paris, van Gogh's work shows his experimenting with a wide range of new stylistic ideas and responding not only to Impressionism but also to the latest technical developments of Seurat, Signac, and the Neo-Impressionists. Their themes and motifs were also of great importance to him: the landscapes of the industrial suburbs, the urbanising of Montmartre and the modern pastoral of the city parks all occur in van Gogh's works. For a painter interested in the modern city as subject, the Paris suburb of Asnières offered numerous intriguing juxtapositions – the verdant riverbanks and parks, the new road and rail bridges and factories of Clichy. The area had also been recently focussed on by Seurat in his two monumental paintings *Bathers at Asnières* and *Sunday Afternoon on the Island of the Grande Jatte*. In his own painting van Gogh makes use of a modified version of Seurat's divisionist technique, applying the pigment in small spots of color.

ARTHUR CLIFTON GOODWIN

American 1864-1920

On South Boston Pier, 1904

Oil on canvas
15⅞×20 inches (40.3×50.8 cm)
Toledo Museum of Art, Toledo, Ohio
Gift of Florence Scott Libbey

The American Impressionists, like their French counterparts, were eager to explore the new subjects such as the cityscape. But in choosing to paint urban scenes, the Americans on the whole preferred to depict the less sordid aspects of urban life. Not for them the brothels and bars peopled with the demimonde; they preferred instead scenes that reflected the optimism of a nation that was being stimulated by new industries. Goodwin's oil from 1904 with its informality of approach and freshness of observation was close in style to that of his contemporaries on the continent. The informal groups of women talking and looking out at boats in the harbor are reminiscent of Boudin's scenes at Trouville, Deauville, and Le Havre.

ARMAND GUILLAUMIN

French 1841-1927

Les Quays de Bercy, 1881
Oil on canvas
22×28 inches (55×71 cm)
Musée du Petit Palais, Geneva

The longest-surviving and most loyal of the Impressionists, Guillaumin is also probably the least well known. In contrast to his Impressionist friends who in the 1870s made studies of the western suburbs of Argenteuil and Chatou where Parisians could be seen enjoying their leisure on the river, Guillaumin painted aspects of the working river. In his painting of the quays at Bercy, a traditional – in topographical painting – broad panorama view is adopted and the figures are kept small in scale. Amid a scene of working barges, cart-horses, and pontoons, is the profile of a fashionable young woman, complete with bustle and umbrella, an image which helps to locate the painting in the late nineteenth century.

The Bridge of Louis-Philippe, Paris, 1875

Oil on canvas
18×23¾ inches (46×60cm)
National Gallery of Art, Washington DC
Chester Dale Collection Loan

Once again Guillaumin chose as his subject the working river. This subject would have fitted the critic Jean Rousseau's comments that these motifs were 'vulgar and ugly.' Artistic taste of the time was conditioned to expect painters to treat overtly picturesque and sentimental subjects. Others, notably Emile Zola and George Moore were to defend the Impressionists' choice of subject matter. Moore wrote later in 1886: 'Contrasting with these [Berthe Morisot's] distant tendernesses, there was the vigorous painting of Guillaumin. There life is rendered in violent and colorful brutality.' Guillaumin's passion for color would in fact toward the end of his career, bring his work close to that of the Fauves.

LILIAN WESTCOTT HALE

American 1881-1963

Zeffy in Bed, 1912
Oil on canvas
30×21¾ inches (76.2×55.2 cm)
Sheldon Memorial Art Gallery
University of Nebraska, Lincoln
NAA-Beatrice D Rohman Fund

The Impressionists' paintings of people in their unguarded moments against a background of informal interiors have become valuable records of life in the late nineteenth century. One of the most charming of these is *Zeffy in Bed*. The model, Rose Zeffer, was used by both Hale and her husband Philip, and is here shown barely awake, her face the only clearly defined element in the painting. Lillian Hale was known as much for her delicate charcoal drawings as for her paintings. In both media she used a particularly idiosyncratic approach of parallel strokes to create a soft, almost smoky effect.

CHILDE HASSAM

American 1859-1935

Gathering Flowers in a French Garden, 1888

Oil on canvas
28×21⅝ inches (71.1×54.9 cm)
Worcester Art Museum Worcester,
Massachusetts
Theodore T and Mary G Ellis Collection

In the 1880s there was a veritable flood of young American artists concentrated in and around Paris. Hassam first traveled to Europe in 1883 but a three-year stay in France beginning in 1886 when he studied at the Académie Julian proved for him to be a watershed. Before this trip Hassam had specialized in dark-toned scenes of Boston streets. In Paris he adopted the Impressionist's palette and touch. A founder member of the 'Ten,' Hassam, after Mary Cassatt, is the American artist most clearly associated with Impressionism. Henry James wrote: 'When today we look for "American Art," we find it mainly in Paris, when we find it out in Paris, we at least find a good deal of Paris in it.'

Gathering Flowers in a French Garden is one of a number of garden paintings by Hassam: on his return to America in 1889, he spent some of his summers at a small hotel on the isle of Shoals run by the well-known horticulturalist and poet Celia Thaxter, whose garden Hassam painted over and over again.

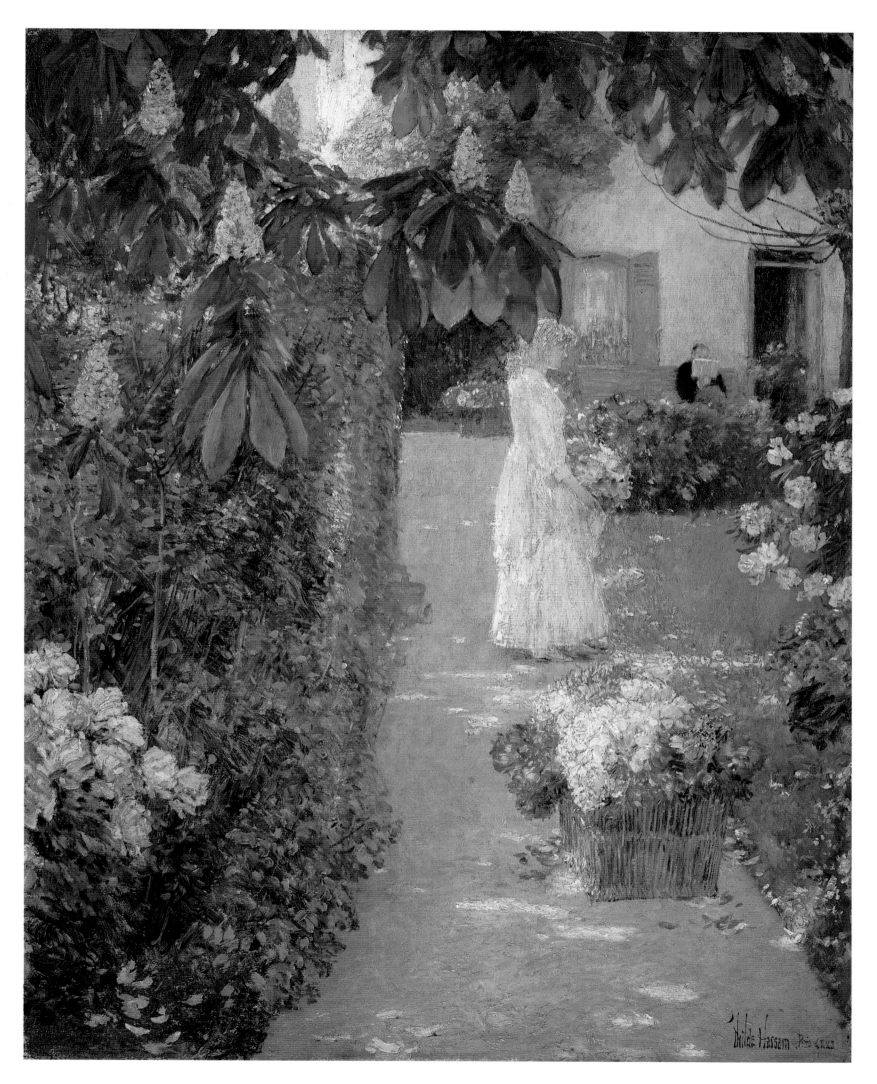

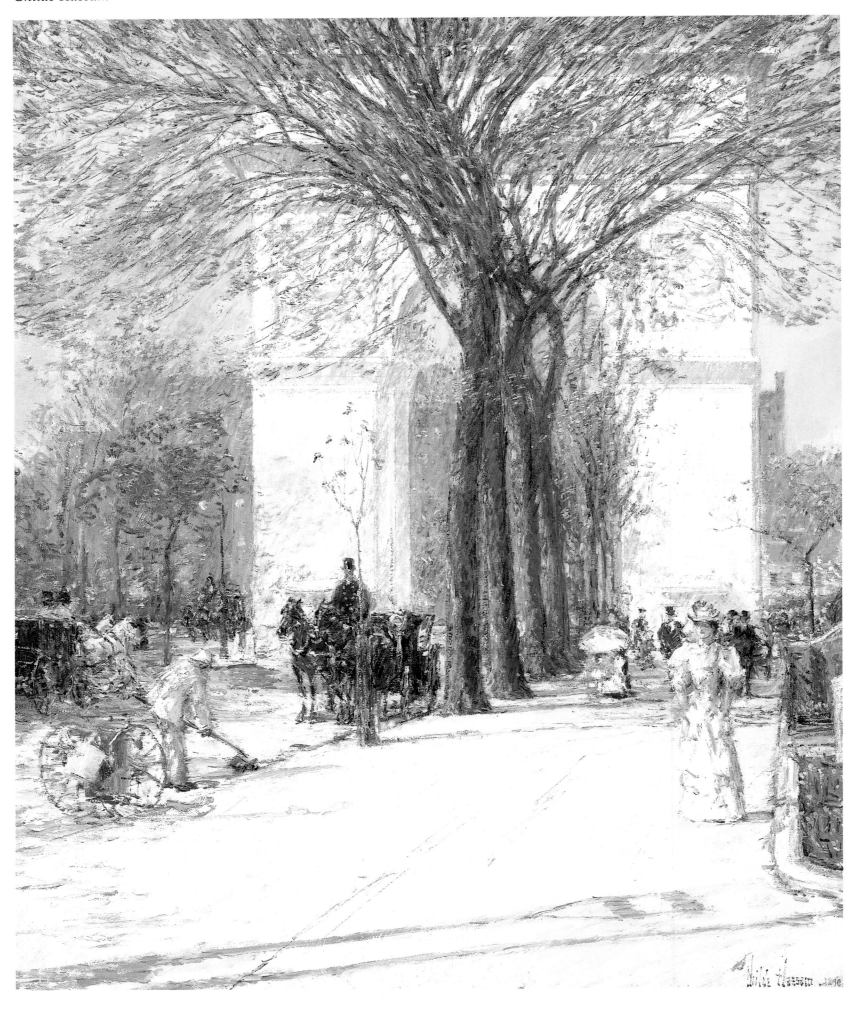

Washington Arch in Spring, 1890

Oil on canvas
27⅛×22½ inches (68.9×57.2 cm)
The Phillips Collection, Washington DC

Re-established in New York, Hassam became celebrated for his seasonal views of New York. In *Washington Arch in Spring* Hassam shows a cross section of modern urban life: a street cleaner, horses and carriages, pedestrians, including a child in a buggy pushed by a nanny. The arch, designed by Stanford White, was originally a wooden structure painted to resemble stone and was erected in 1889 to commemorate the 100th Anniversary of President Washington's inauguration. Six years later the wooden arch was replaced by a permanent stone structure. Hassam's painting shows the original wooden arch as it straddled the street at its terminus. The stone arch, which still stands today, was built within Washington Square.

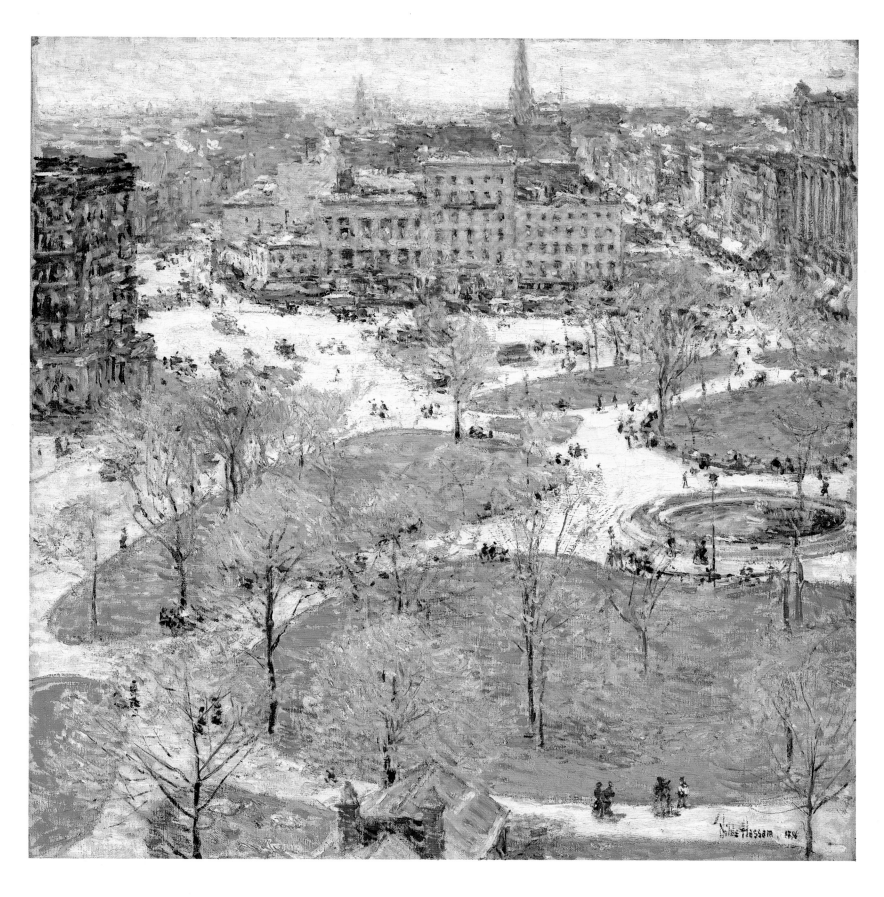

Union Square in Spring, 1896

Oil on canvas
21½×21½ inches (54.6×54.6 cm)
Smith College Museum of Art
Northampton, Massachusetts

When Hassam returned to America in 1889 he established his studio at 95 Fifth Avenue in New York. Lower Fifth Avenue was already a fashionable area, but by the time Hassam moved there, the avenue's uptown end was beginning to be colonized by wealthy New Yorkers. Hassam's aerial view of Union Square is close in subject and style to the street scenes of his French contemporaries, notably Pissarro's *Avenue de l'Opéra: Sun on a Winter Morning* (1898) and Monet's *Boulevard des Capucines* (1873).

WINSLOW HOMER
American 1836-1910

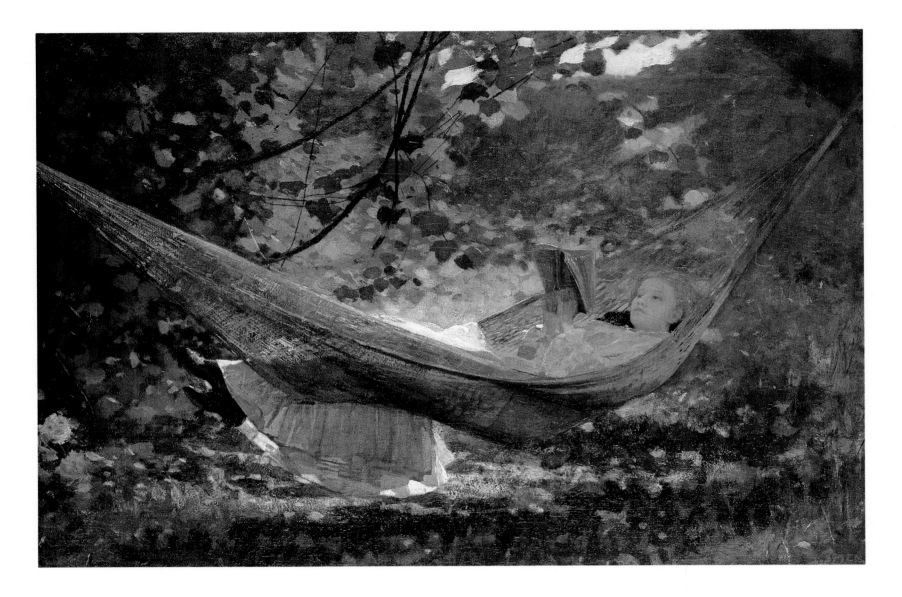

Sunlight and Shadow, 1872

Oil on canvas
15¾×22½ inches (40×57.2 cm)
Cooper-Hewitt Museum
The Smithsonian Institution National
Museum of Design, New York
Gift of Charles Savage Homer

In 1867 Homer traveled to Paris to see his paintings exhibited at the Exposition Universelle and also apparently viewed the early examples of Impressionism during his trip. On his return to America Homer's paintings began to display a new lighter palette, a more intense preoccupation with the effects of light while the figures were less heavily modeled. Furthermore Homer was a committed plein-air painter. In 1880 he commented on *Sunlight and Shadow* by saying 'A painter who begins and finishes indoors a figure of a man, woman or child, misses a hundred little facts . . . a hundred little accidental effects of sunshine and shadow that can be reproduced only in the immediate presence of Nature.'

Apple Blossom Time, 1883

Oil on canvas
27⅛×22⅛ inches
Pennsylvania Academy of the Fine Arts,
Philadelphia
Bequest of J Mitchell Elliott

Inness did not like being compared to the Impressionists: he believed the movement was simply a passing fashion that had arisen from what he called 'a sceptical scientific tendency to ignore the reality of the unseen' and which he saw as far too attached to the material world. Inness was in fact a follower of the mystic Swedenborg and in his paintings sought to reveal invisible spiritual truths within matter. Yet his highly subjective response to the landscape – often that in the area around his home in Montclair, New Jersey – came from his contact with the paintings by the Barbizon artists. Meanwhile, the atmospheric style does link him with Impressionism, particularly the painting style of Whistler.

LAURA KNIGHT
British 1877-1970

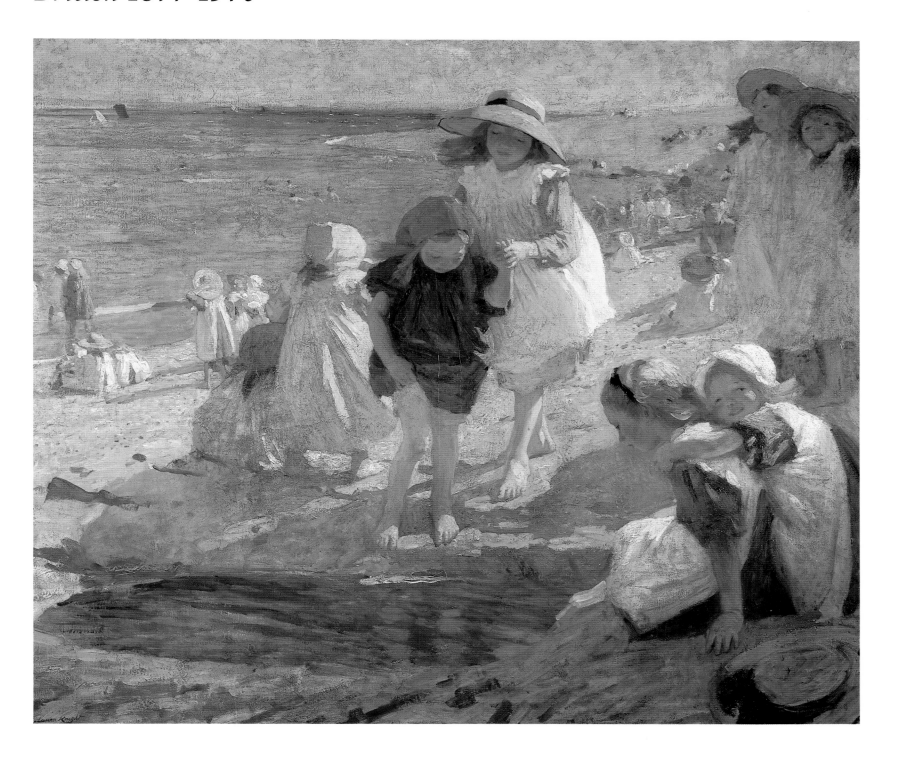

The Beach, 1908

Oil on oak panel
Laing Art Gallery, Newcastle-upon-Tyne

Born in Long Eaton in Derbyshire, Knight (née Johnson) studied at Nottingham School of Art. Following a trip to Holland in 1903 her work was much influenced by the Hague School with its dark tonal qual-ities. In 1907 she moved with her husband, the painter Harold Knight (1874-1961), to Newlyn in Cornwall. There, although she imported some of the characteristics of Impressionism, she did not fully accept its premises. Knight's Impressionism concerned itself with the accurate recording of local color rather than the scientific analysis of the mechanism of seeing.

MAX LIEBERMANN

German 1847-1935

Terrace of the Restaurant Jacob,
1902-03
Pastel
98⅜×192⅞ inches (700×100490 cm)
Kunsthalle, Hamburg

Almost from the beginning the Germans seem to have felt an empathy with Impressionism. A number of exhibitions in Munich and Berlin had introduced them to the works of Courbet while a number of German painters studied in Paris at the Académie Julian.

By the end of the 1880s a number of German artists had adopted some of the techniques of Impressionism. Liebermann, who had studied in Paris, was particularly influenced by Corot. In his painting *The Terrace of the Restaurant Jacob*, the contemporary middle-class subject matter, the loose brushwork and the outdoor lighting explain why he is often described by commentators as one of the 'Triumvirate of German Impressionism.'

EDOUARD MANET
French 1832-83

Music in the Tuileries Garden,
1862
Oil on canvas
30×46 inches (76×117 cm)
National Gallery, London

The reluctant leader of the Impressionists, who never participated in their exhibitions, Manet was nearly 50 years old before he adopted a truly Impressionistic technique, largely under the influence of Monet and Berthe Morisot. In this painting Manet made a concerted and conscious attempt to paint a modern subject in a modern manner: the gathering together of the elite of Parisian intellectual and artistic society under the trees in the Tuileries Gardens. Manet has painted himself on the extreme left surrounded by his friends which include the Symbolist poet and critic Charles Baudelaire and Theophile Gautier. Also depicted are Manet's brother Eugene (in the centre, leaning, wearing a top hat), the realist critic Champfleury and the artist Fantin-Latour. Behind Eugene is the bespectacled figure of the composer Jacques Offenbach. In representing these members of the haute-bourgeoisie, the new rulers of the 'modern world', Manet ignored the traditional methods of composition, perspective, drawing and color. For example, Eugene is engaged in conversation with nothing more than a patch of gray paint. What Manet has accomplished is an approach that encouraged a sense of actuality, a sense that is common to the works of the Impressionists.

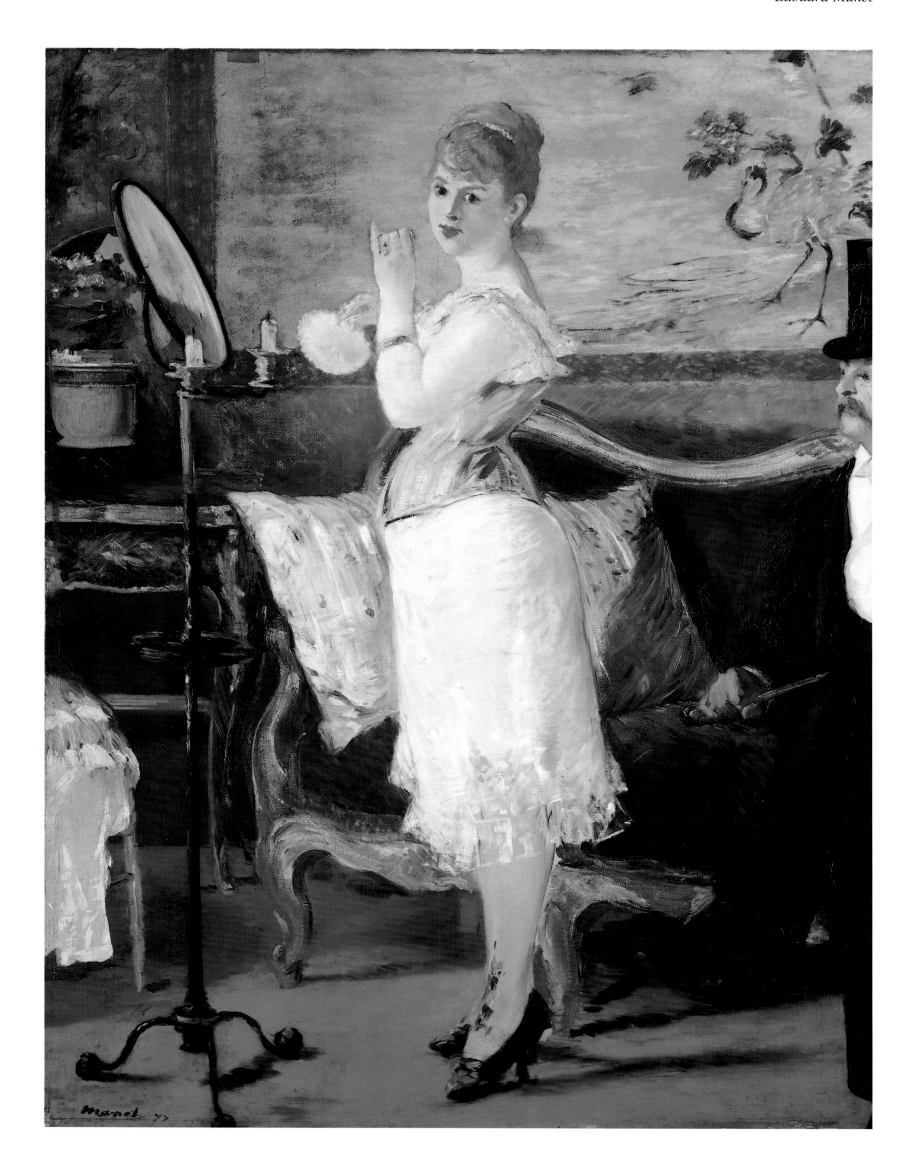

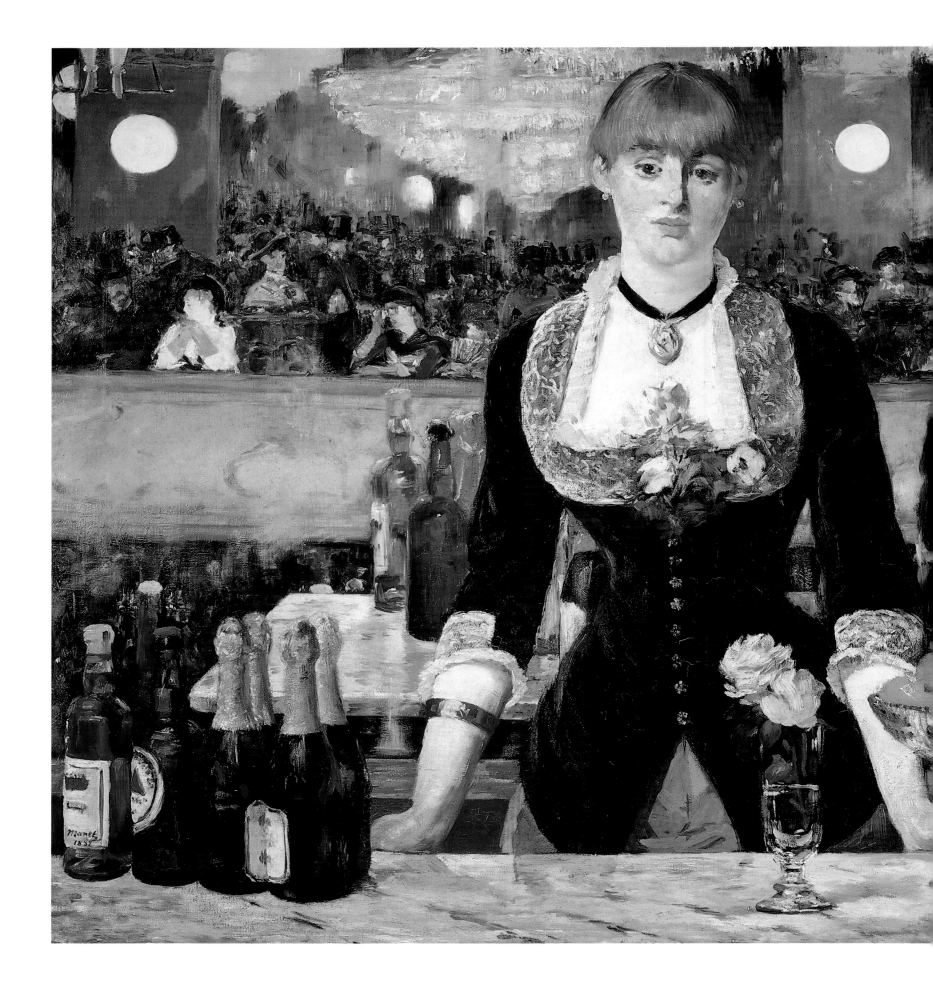

The Bar at the Folies-Bergère,
1881-82

Oil on canvas
38×51 inches (97×130 cm)
Courtauld Institute Galleries, London

This final masterpiece, *The Bar at the Folies-Bergères* was begun when Manet was gravely ill with a type of circulatory paralysis and is in many ways, a large-scale tribute to the Paris of his day, exemplified by one of the most popular entertainment places. Replacing the academic goddesses of Salon paintings is an ordinary waitress at work in an urban, vulgar place of entertainment, and in place of traditional perspective-based composition, Manet creates spatial ambiguity by the inclusion of the large mirror behind the barmaid. Compositional problems led Manet to reconstruct in his studio several small bars from the upper level of the Folies-Bergères while the model stood on a platform behind the counter – something she would have done at the Folies. Glimpsed in the mirrored reflection of the crowds, Manet included his friends Marie Laurent (described as an indifferent actress but a courtesan of genius and on whose character Marcel Proust based the figure of Odette Swann), Jeanne Demarcey, and Gaston Latouche.

CLAUDE MONET
French 1840-1926

Le Déjeuner sur l'Herbe (Final Study), 1865
Oil on canvas
51¾ × 71¼ inches (130×181 cm)
Pushkin Museum, Moscow

In March 1863 Monet saw a small exhibition at Martinet's gallery in Paris of works by Manet which included his painting *Déjeuner sur l'Herbe*. For the Impressionists Manet became a hero and the somewhat unwilling leader of the movement. In the summer of 1865 Monet began work on an enormous canvas, some 20 feet by 15 feet, also entitled *Déjeuner sur l'Herbe* and influenced by Manet's version. Instead of a group of contemporary men and a naked woman with poses based on a sixteenth-century engraving, Monet painted a modern gathering of his own middle-class friends with the forest of Chailly as the backdrop. This type of painting on a vast scale was traditionally reserved for history painting, not life-size pictures of everyday ordinary life. Studio posed and largely studio painted, the canvas remained unfinished and was eventually abandoned. The painting was later damaged in storage at Bazille's studio where Monet had left it as security for unpaid rent, and as a result Monet cut the canvas down and, although fragments of this survive, the entire composition is known only from this large oil study.

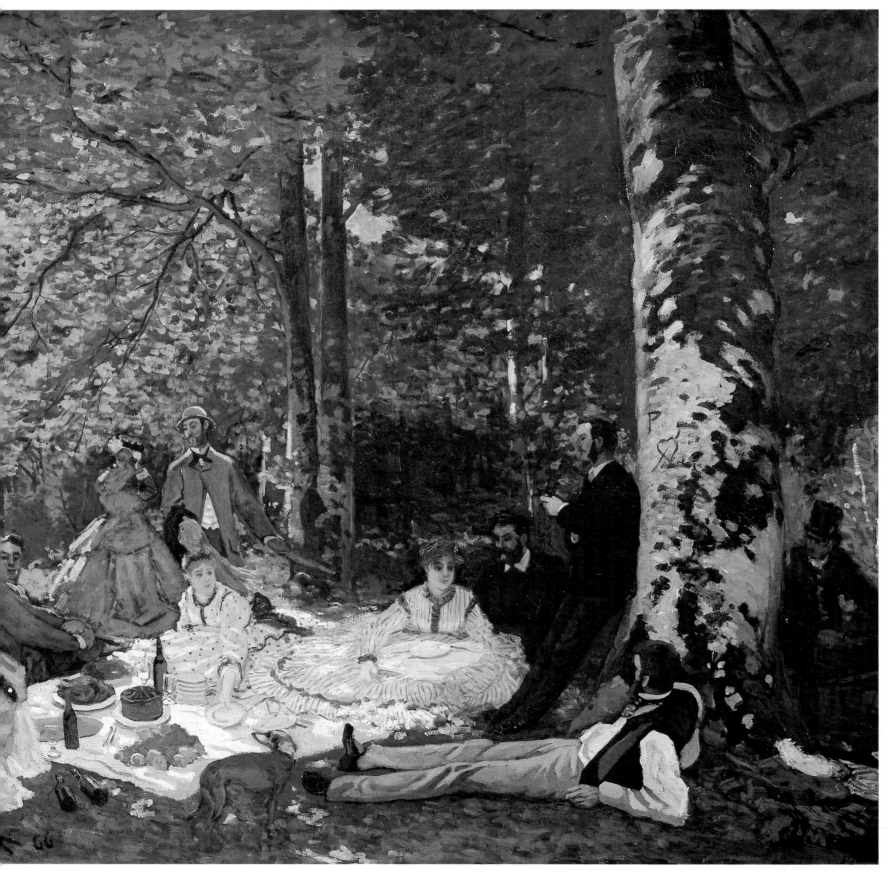

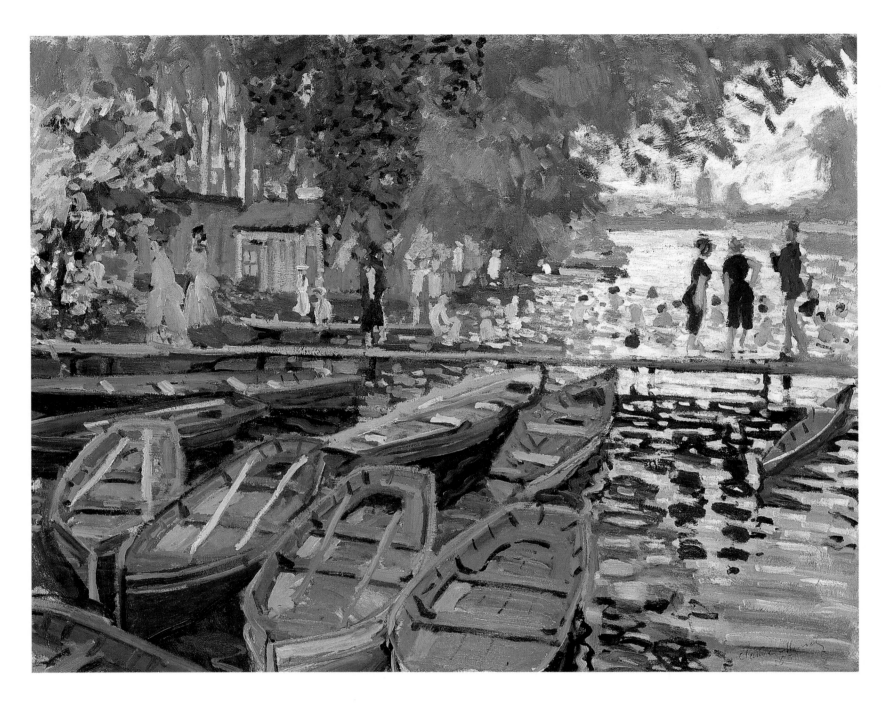

Bathers at La Grenouillère, 1869

Oil on canvas
30¼×36¼ inches (77×92 cm)
National Gallery, London

La Grenouillère (The Froggery) was a restaurant and bathing place on a small branch of the river Seine at Croissy. It was a very popular area since the new railway line from Paris to Saint Germain, the first line to be finished in France, had a station at nearby Chatou. Both Monet and Renoir painted several views of the place in 1869 which was considered to be a very contemporary subject. Less interested in the social habits of the people he is painting, Monet was more concerned with expressing the mood of a sunny day in the most direct and spontaneous way possible. The small size of the canvas no doubt made for easy carrying as well as allowing Monet to complete the painting in a short period of time during which the light effects remained near constant.

Women in the Garden, 1866-67

Oil on canvas
100½×80¾ inches (255×205 cm)
Musée d'Orsay, Paris

In contrast to the complications involved in large group paintings such as *Déjeuner sur l'Herbe*, here Monet has concentrated on four separate figures – three of which were based on the figure of Camille, who was later to become Monet's wife – posed in the garden of his rented house in Ville d'Avray. Rather than follow the traditional practice of using color studies made en plein air as the basis for a painting created in the studio, Monet decided to sketch the entire work on to the canvas in the open air. In order to be able to see his models from behind the huge canvas Monet had a trench dug in the garden into which the canvas was placed and which enabled him to work on what would have been inaccessible areas of the canvas. Having chosen his subject and arranged the composition, Monet ignored the subject and concen-

trated on the effects of the light which falls in a diagonal from the top right corner to the lower left of the painting and which pours over the figure in the foreground. As her parasol protects her from the sun, the light does not fall directly on her but is reflected upwards from her outspread dress and the flowers in her lap.

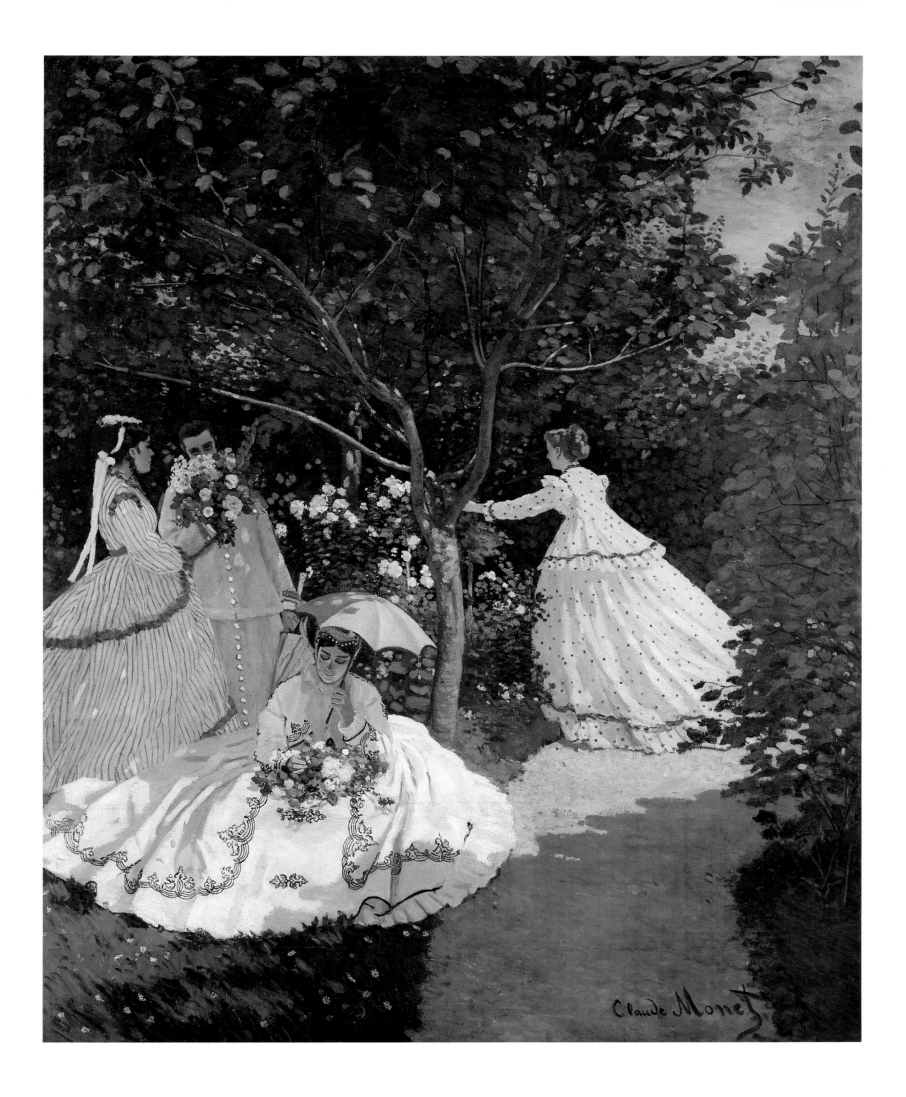

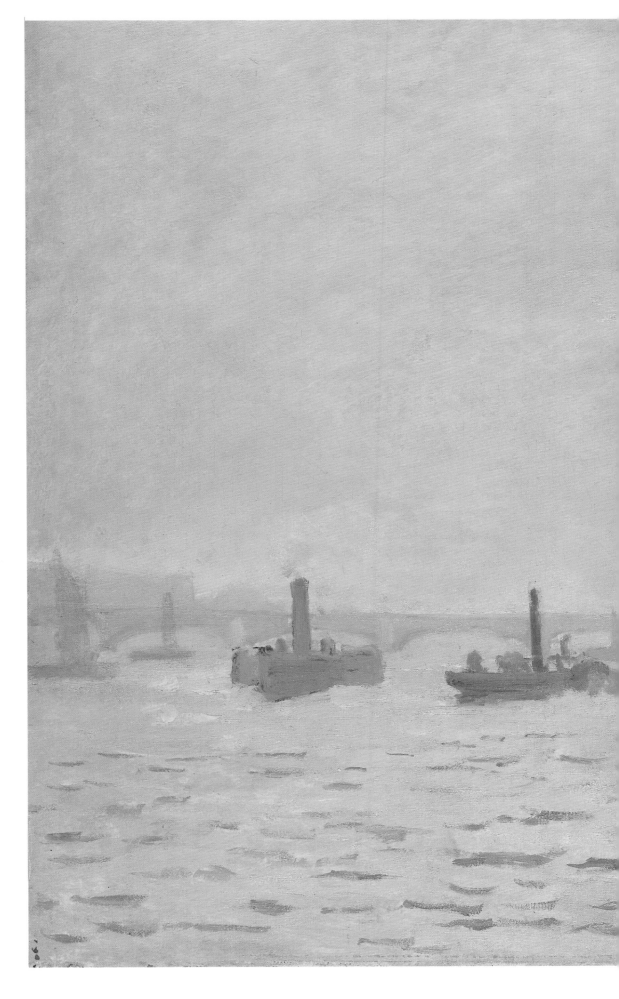

The Thames at Westminster, 1871

Oil on canvas
18½×17 inches (47×43 cm)
National Gallery, London

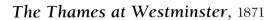

During the Franco-Prussian war and the subsequent troubles in Paris during the Commune, between October 1870 and June 1871, Monet, Pissarro, and Sisley were in England. It was there that Monet made his first contacts with the works of Turner, Constable, and the English watercolorists. In a letter to the English writer Wynford Dewhurst Pissarro wrote: 'Monet and I were very enthusiastic about the London landscape . . . we worked from nature, we also visited museums. The watercolors of Turner and Constable, the canvases of Old Crome, have certainly had an influence on us . . . we were struck chiefly by the landscape painters, who shared more in our aims with regard to plein-air, light, and fugitive effects.' In his view of Westminster Bridge with the Houses of Parliament, in its tonal and geometric composition, Monet may also have found precedents in Japanese prints and in the work of Whistler.

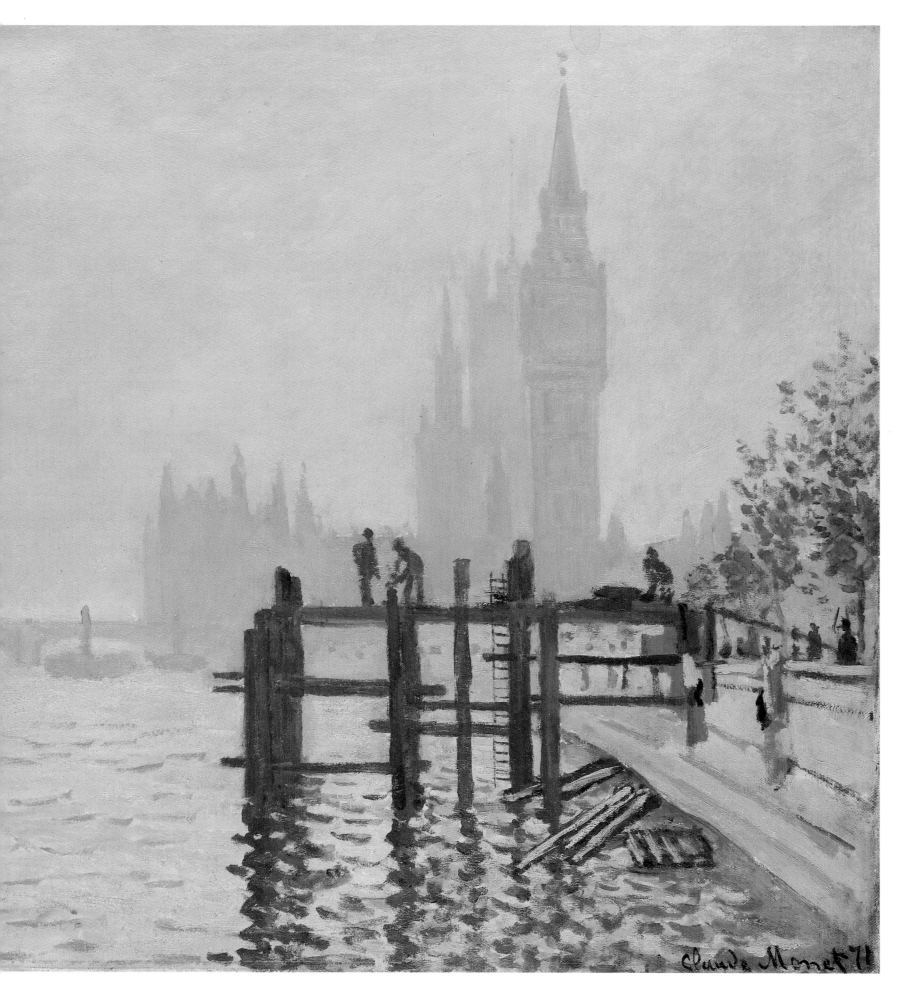

Claude Monet '71

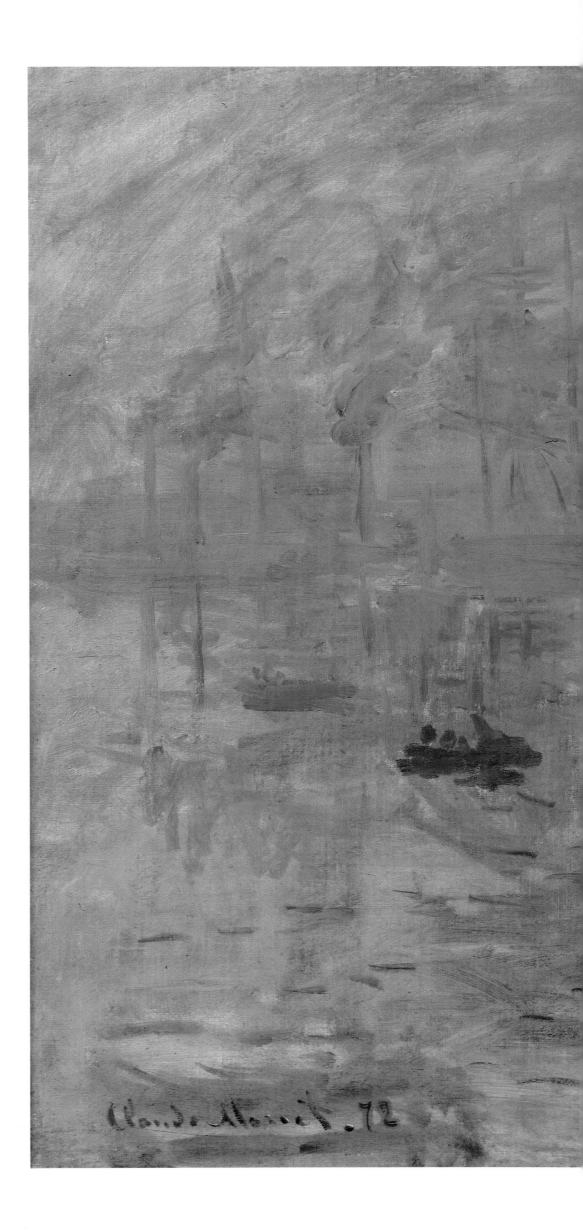

Impression: Sunrise, 1872

Oil on canvas
19×24¾ inches (48×63 cm)
Musée Marmottan, Paris

Another version (Private Collection) of this painting exhibited at the first Impressionist exhibition held at Nadar's photographic studio in 1874. In his later life Monet told the young painter Guillemot: 'This label [Impressionism] that was given to us [was] because of me. I had sent a thing done in Le Havre, a view from a window, seen in the mist with a few masts sticking up in the foreground . . . They asked me for a title for the catalogue, it couldn't really be taken for a view of Le Havre and I said "Put Impression". From that came Impressionism, and the jokes blossomed.' The painting itself features the former outer harbour at Le Havre (now the inner harbor) looking towards the southeast, a view which Monet's friend and mentor Eugene Boudin had painted many times. But in his interpretation, Monet may well have been influenced by the American painter Whistler whose own paintings of night scenes may have been exhibited at Paul Durand-Ruel's gallery around this time.

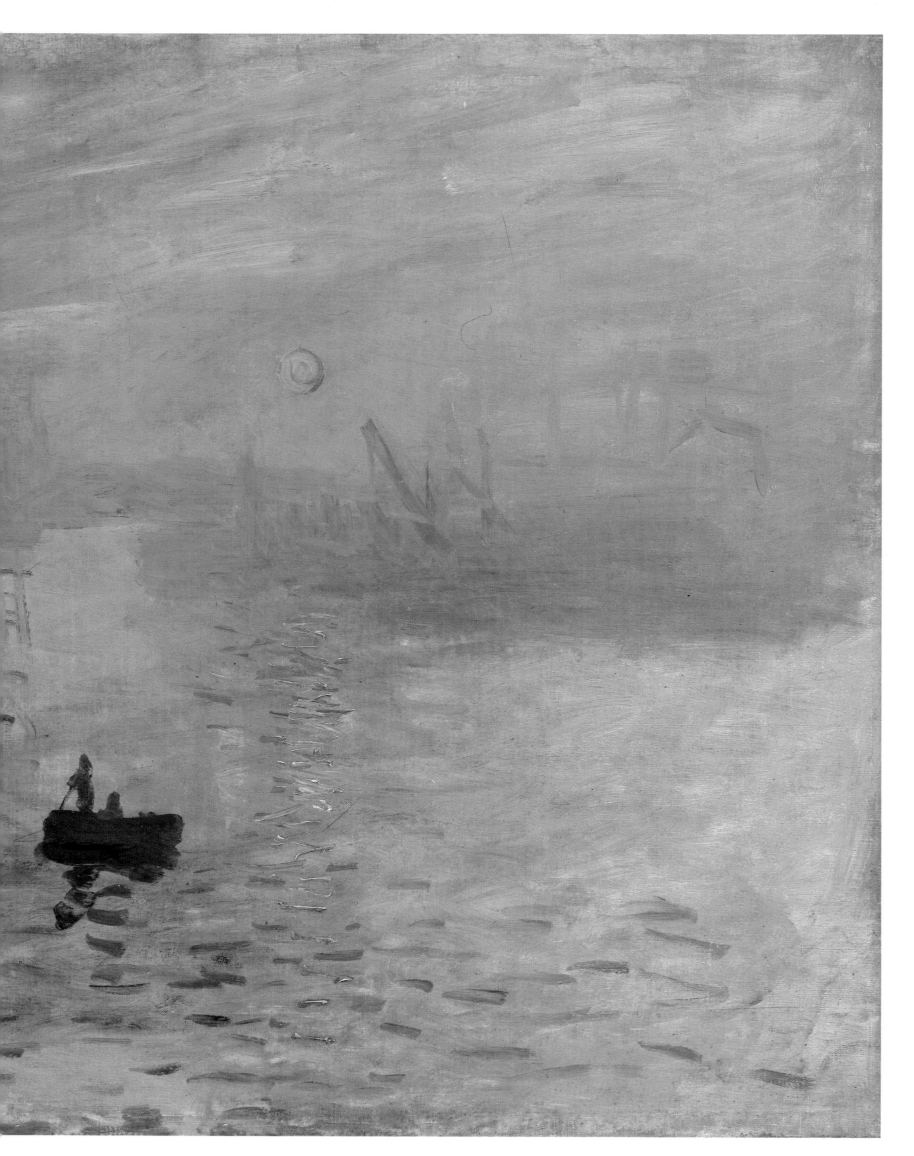

Wild Poppies, 1873

Oil on canvas
19¾×25½ inches (50×65 cm)
Musée d'Orsay, Paris

Another painting that was possibly shown at the first Impressionist exhibition in 1874, *Wild Poppies* was painted in the environs of Argenteuil where in the previous year Monet had rented a house. At the top of a small hillock Monet's wife Camille and their son stand, silhouetted against a band of trees that stretch almost unbroken across the picture. At the lower right, the two figures appear again, having made their journey down the bank through the long poppy-strewn grass. The painting is neither a grand landcape nor an evocation of some long-lost acradia: instead of an antique monument, Monet has used the device of a contemporary red-roofed house, the inhabitants of the countryside for the Impressionists were neither peasants nor nobility, but ordinary people, often escapees from the rigors of modern city life.

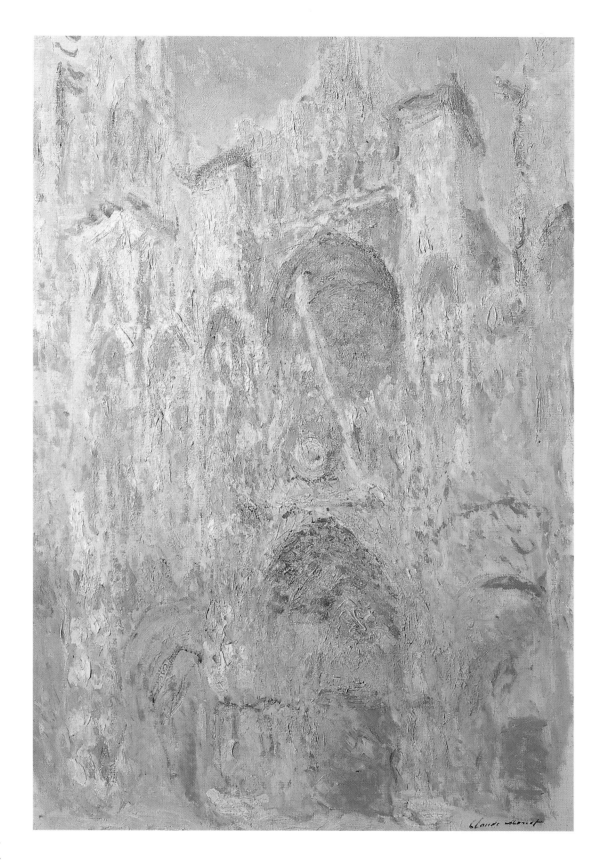

Rouen Cathedral at Sunset, 1894

Oil on canvas
39¼×25½ inches (100×65 cm)
Musée Marmottan, Paris

In 1892, in a room modified to accommodate the large number of canvases that he needed to capture the effects of the constantly changing light, Monet worked for two years on a series of paintings of the west front of Rouen Cathedral. The paintings record the effect of light falling, reflecting off and sinking into, the carved stone of the medieval façade. These were not rapidly painted sketches that captured these separate instances, but judging by the thick, reworked surfaces of the canvases, it appears that Monet must have also worked on these images away from the motif using his memory and experience to adjust the relationships between the canvases so that they read not so much as individual paintings but as a coherent ensemble.

The Japanese Bridge, 1899

Oil on canvas
34¾×30¼ inches (88.2×92 cm)
National Gallery, London

For the last thirty years of his life Monet confined himself almost entirely to painting works related to his garden at his home in Giverny – the exceptions were a group of paintings of views of London exhibited in 1904 and the Venetian paintings shown in 1912. In 1893 he had a narrow stream diverted and opened up to form a small waterlily pond. Modifications to the garden continued and by 1910 Monet was employing six full-time gardeners. His first painting of the original lilypond with its Japanese footbridge dates from 1895 and rapidly this became the focus for his continuing exploration of the ever changing nature of light. This painting, along with eleven other waterlily paintings, were first shown in 1900 at Durand-Ruel's gallery in Paris. Collectively these works show a far greater concern with depth and tonal contrasts than the Haystacks or Rouen Cathedral series.

Waterlilies, 1916

Oil on canvas
78¾×168 inches (200.7×426.7 cm)
National Gallery, London

Having gleaned information from the garden so that he would continue to work and rework these canvases in the studio, Monet had massive studios built on his estate so that he could work on this decorative ensemble. In the later canvases of waterlilies Monet further modified his approach to include an eye-level view of the pond with minimal tonal differentiations and a freer, more calligraphic use of paint. As all the elements of the landscape are eliminated in order to concentrate on the surface of the water, the subject becomes progressively more difficult to make out and it is difficult to decide at this time whether one is looking down at the lilypads floating on the pond or with a fish's eye view of the surface.

BERTHE MORISOT

French 1841-95

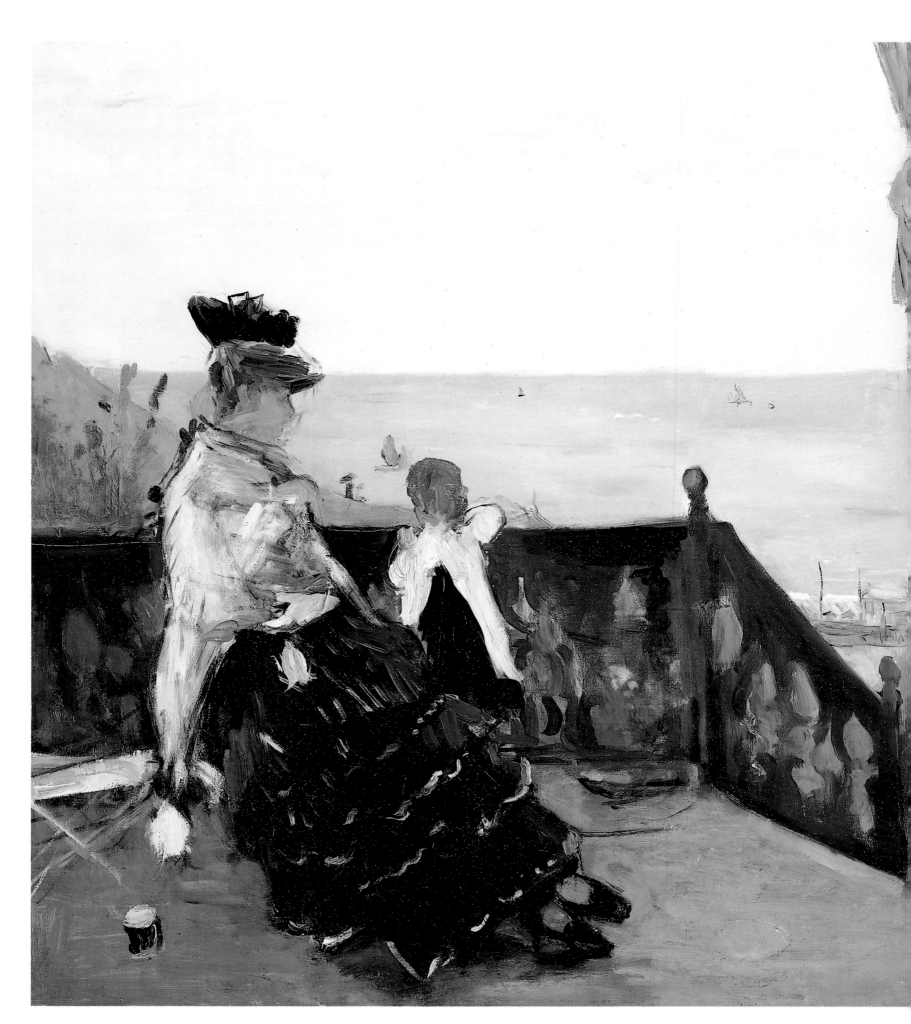

In a Villa at the Seaside, 1874

Oil on canvas
19¾×24 inches (50×61 cm)
Norton-Simon Art Foundation, Pasadena

A regular exhibitor at the official Salons, Morisot attracted a great deal of praise from the critics. In 1868 she met Manet and he was to become a warm admirer, getting her to pose for some of his own paintings, most notably, *The Balcony.* In 1874 the Manet and Morisot families spent a holiday together on the Normandy coast at Fécamp where this seascape was painted. On the veranda of the seaside villa are a seated woman and child who watch the activity on the beach below. On several occasions Morisot used the device of a raised foreground plane and the gaze of a figure to direct the spectator on to the deeper distance. This painting was included in the auction of Impressionist works at the Hôtel Drouot in 1875 where it was bought for 230 francs by Henri Rouart, another painter who had exhibited with the Impressionists at their first show in 1874. Morisot's decision to take part in this sale, against the advice of Manet, confirmed her position as a central figure in the new Impressionist group.

The Cradle, 1872

Oil on canvas
22×18 inches (56×46 cm)
Musée d'Orsay, Paris

Most of Morisot's subjects were taken from her immediate environment and domestic circle. This is in part due to the restrictions society placed on women artists – they were denied access to nude models which made it difficult to acquire the anatomical skills necessary to the figure painter and it was unseemly for a young woman of the haute-bourgeoisie to wander unaccompanied through the streets which made painting street scenes difficult if not impossible. Thus many women artists were forced to concentrate on genres such as still lifes or flower painting. *The Cradle,* which was exhibited at the first Impressionist exhibition in 1874, depicts Morisot's sister Edma by the cradle of her son Jean who is just visible through the gauze of the cradle's curtains. This painting marked the beginning of a series of paintings of mothers and children, a subject Morisot would continue to explore throughout her career.

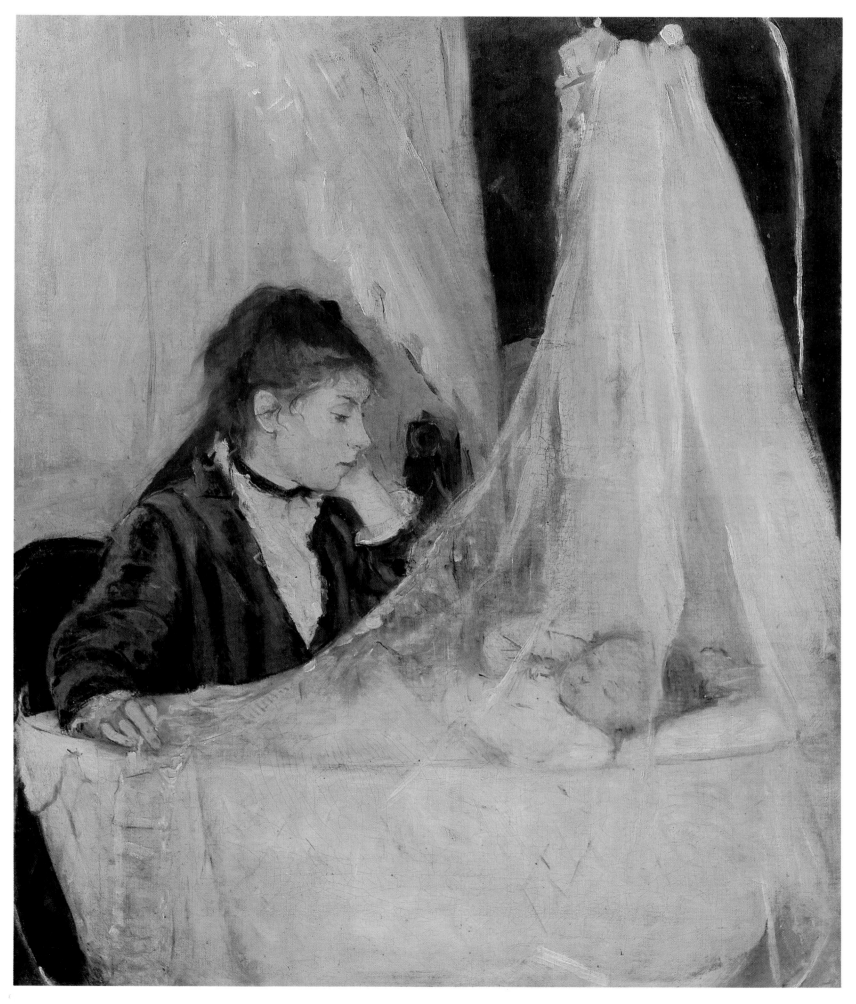

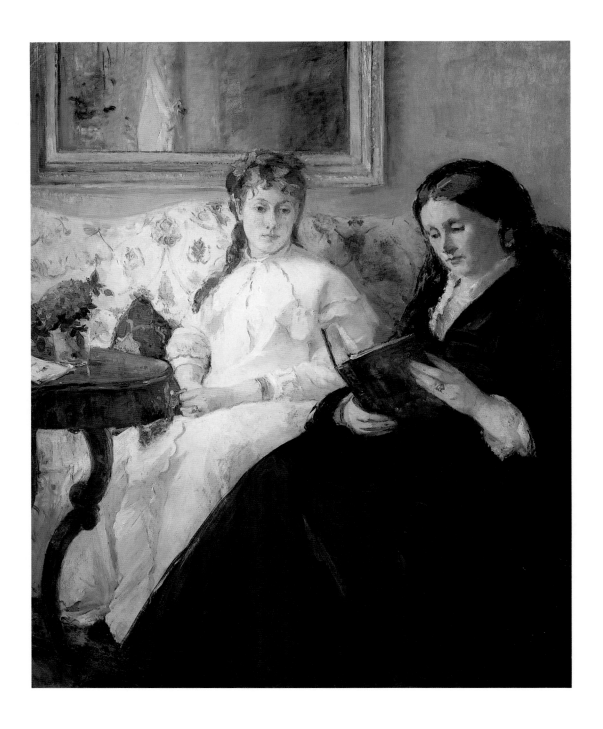

La Lecture (The Artist's Sister Edma and Their Mother), 1870

Oil on canvas
39⅝×31⅞ inches (100×81 cm)
National Gallery of Art, Washington DC
Chester Dale Collection

A frequent model for many of her paintings was Morisot's sister Edma. Both the sisters had received drawing and painting lessons but in 1869 when Edma married a young naval officer she abandoned her own ambitions for an artistic career. In 1870 the Salon accepted Morisot's portrait of her sister and this double portrait of Edma and her mother reading. The influence of Manet in Morisot's work is here apparent. In fact Manet himself had made many alterations to this painting that it caused Morisot considerable embarrassment and she no longer felt justified in exhibiting it as her own.

In The Dining Room, 1886

Oil on canvas
24×19¾ inches (61×50 cm)
National Gallery of Art, Washington DC

This painting was exhibited at the last Impressionist exhibition in 1886 under the title *The Little Serving Girl*. The setting for the painting was the dining room of the house in the rue Paul-Valéry where Berthe and her family had recently moved: in 1874 she had accepted Manet's brother Eugène's proposal of marriage. In a rapid sketchy technique Morisot depicts her maid and family dog in a cool palette of blues, grays, and whites, a subdued range that she particularly favored. Morisot made a point of including in the composition objects with reflective surfaces: the globe and chimney of the lamp, the dresser doors, and the highly polished table all catch and reflect the shafts of sunlight that filter through the windows.

GIUSEPPE DE NITTIS
Italian 1846-84

The Races at Auteuil, 1881

Oil on canvas
Galleria d'Arte Moderna, Rome

Born at Barletta in the south of Italy, de Nittis studied painting in Naples and soon became involved in various anti-academic art movements such as the Macchiaioli. In 1867 he made his first visit to Paris and finally settled in the city in 1872. A friend of Manet and Degas, de Nittis took part in the first Impressionist exhibition in 1874 even though most of the Impressionist group had a rather low opinion of his work. Paul Alexis described de Nittis' works as 'more like pastry than painting.' Though he remained on friendly terms with the group de Nittis realized that his gifts lay elsewhere and he started to produce paintings in a modified Impressionist style. His later works, predominantly paintings of high-society themes and subjects, were to make him successful and in 1878 he was awarded the Legion of Honor, much to the disgust (and possible envy since he also coveted such recognition) of Degas. There is no doubt that de Nittis was greatly influenced by Impressionism even though he was to dilute the style to suit his own purposes.

CAMILLE PISSARRO

French 1830-1903

Hillside at l'Hermitage, Pontoise, Fall, 1873

Oil on canvas
24×29 inches (61×72 cm)
Musée d'Orsay, Paris

Born in Saint Thomas in the West Indies, Pissarro was sent to Paris when young to complete his education. After his return home he persuaded his parents to allow him to study painting and in 1855 he returned to France to study at the Académie Suisse in Paris where later he met Monet. Pissarro's early paintings demonstrate the influence of Corot in his concern for light and atmosphere and in the overall dark tonality. After fleeing to London to escape the Franco-Prussian war, Pissarro returned to France and his home in Pontoise in 1872 which remained his base for the next ten years. Like many of his colleagues, Pissarro began to confine himself to smaller canvases – a practical move in view of the fact that he was painting almost exclusively in the open air. The lighter palette, from which the dark tones of black and earth colors of his earlier canvases have been banished, is also the direct consequence of working out of doors in natural lighting conditions.

The Red Roofs: A Corner of the Village, Winter, 1877

Oil on canvas
22×26 inches (54×66 cm)
Musée d'Orsay, Paris

In the late 1870s Pissarro became increasingly interested in dense motifs where the image is difficult to find and upon which the eye cannot easily focus. Typically in a number of paintings and etchings of the late 1870s, Pissarro chose this view through trees to buildings with a style of painting that is close to that of Cézanne, who had been working alongside Pissarro at Pontoise. *The Red Roofs* may have been exhibited at the 1877 Impressionist exhibition. The critic Leon de Lora said of Pissarro's landscapes: 'Seen close up they are incomprehensible and hideous; seen from a distance they are hideous and incomprehensible.' Nevertheless Pissarro refused to make any concessions to please his audience and his intractibility over his choice of subjects and his constant experimenting with styles were perhaps the reasons for his rather belated acceptance by a broader public.

The Warren at Pontoise, Snow,
1879
Oil on canvas
23¼×28½ inches (59×72cm)
Art Institute of Chicago

The attraction of Pontoise for Pissarro lay in its' balance of old and new: contrasting with the medieval church and old houses were the new industrial buildings. Pissarro painted a number of townscapes with the factories in the background which also capture the rural character of the town.

The winter of 1879 was a particularly harsh one and many of the Impressionists defied the cold to produce snow scenes. In this composition, which harks back to the landscapes produced by Courbet late in his career, Pissarro takes the viewpoint from some high ground looking down on the roofscape below. As in the earlier painting *Red Roofs* Pissarro avoids any particular focus of attention, forcing the viewer to sort out the pattern of surface marks into a legible whole.

The Little Country Maid, 1882
Oil on canvas
25×21 inches (64×53 cm)
Tate Gallery, London

In this painting Pissarro shows a maid-servant sweeping up with a child possibly Pissarro's youngest son Ludovic, seated at the table. Pissarro rarely painted interiors and he depicts a far more modest scene than Morisot's *In the Dining Room*. Morisot was a member of the haute-bourgeoisie and her maid reflects the more elegant style of the Parisienne who pauses in her work to pose. Pissarro, at times on the verge of poverty, has a maidservant, possibly a local girl from the neighboring village of Osney who is unaware of the artist or the spectators' gaze as she continues with her chores. A characteristic feature of many Impressionist portraits is the unusual viewpoint that the artist adopted: here Pissarro adopts a plunging viewpoint, the table top and the chair seat tilted up towards the picture surface.

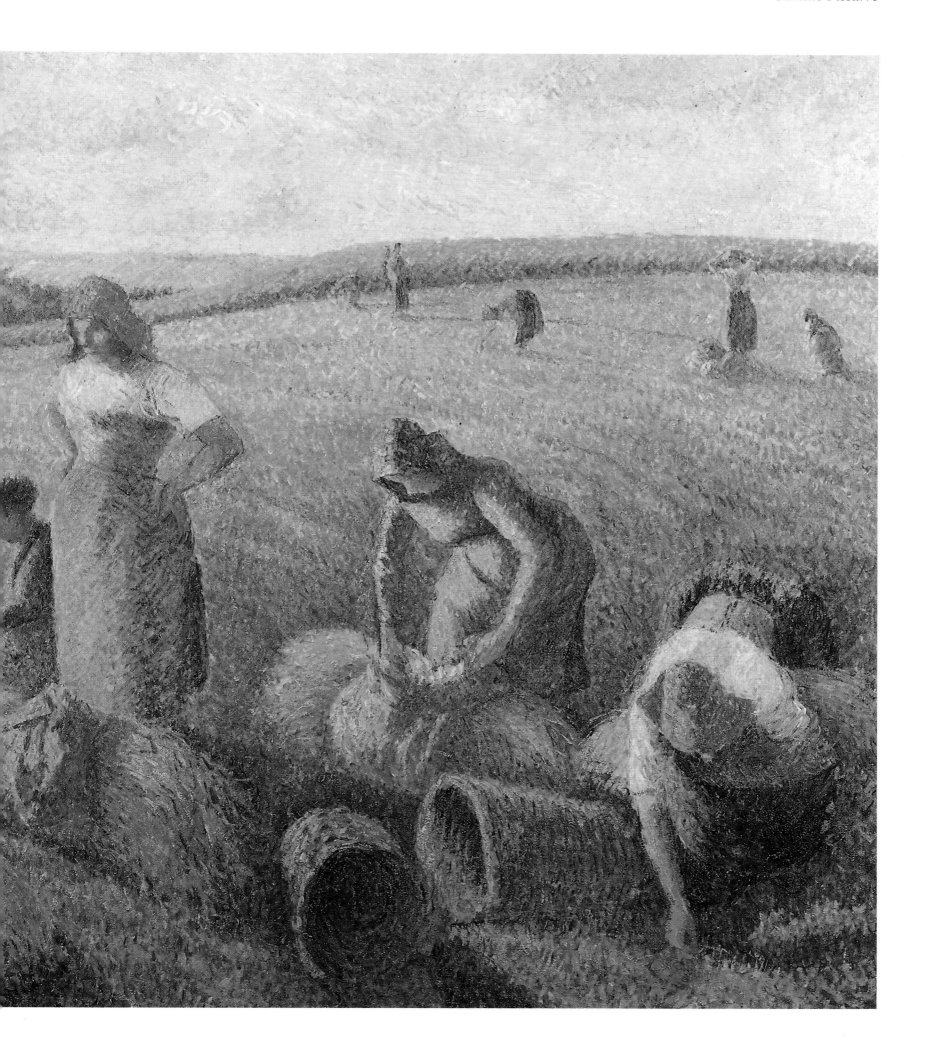

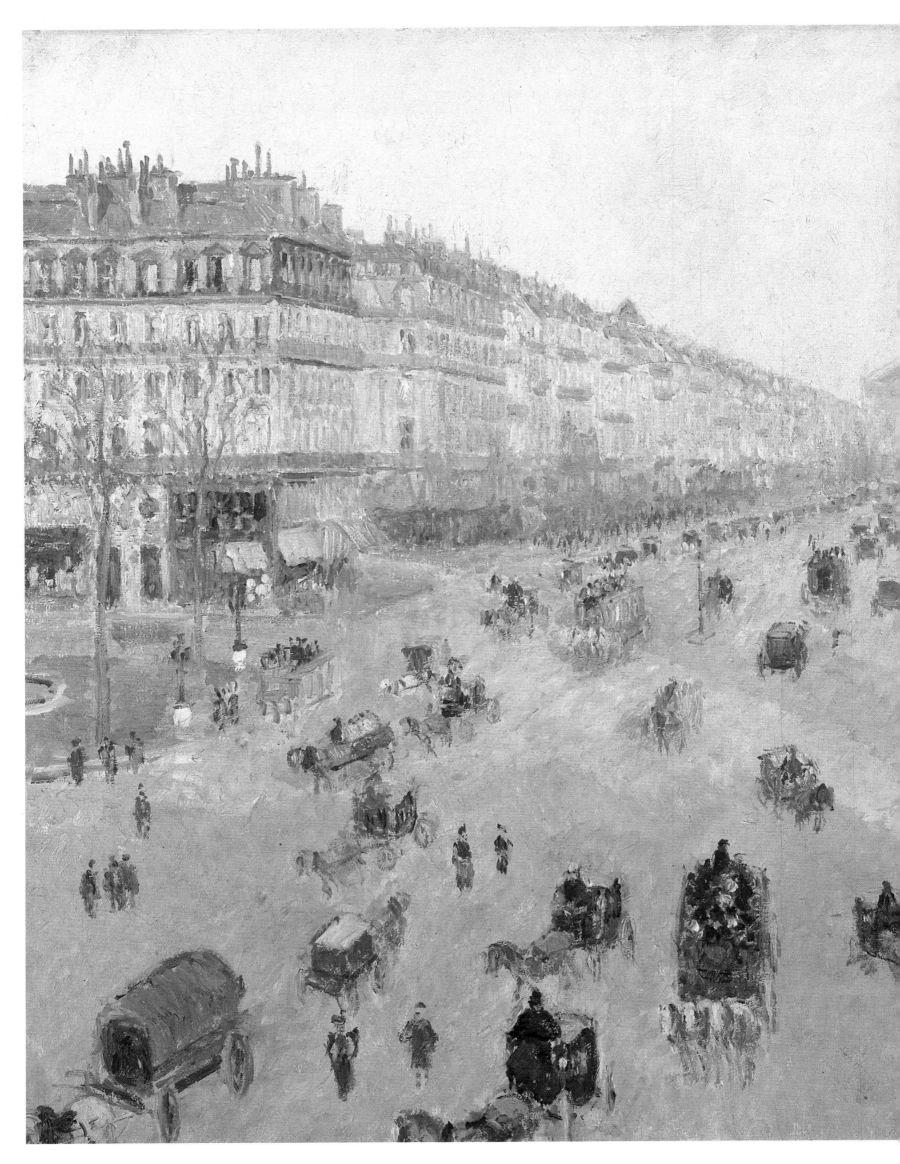

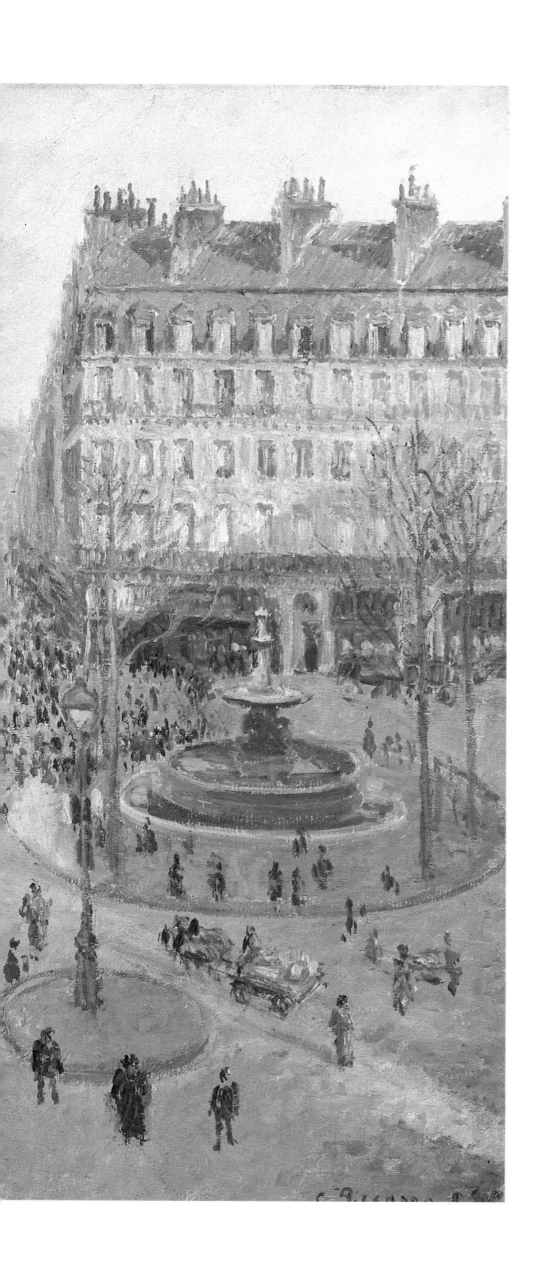

The Avenue de l'Opéra: Sun on a Winter Morning, 1898
Oil on canvas
29×36 inches (74×92 cm)
Musée Saint-Denis, Reims

This painting was bought, along with other paintings in the series, by Paul Durand-Ruel and exhibited in May 1898. Because of eye trouble Pissarro was unable to paint out of doors and in 1897 took a room in the Grand Hôtel du Louvre in the center of Paris which provided him with an attic view northwards up the Avenue de l'Opéra. In this painting Garnier's Opéra building is just visible in the distance. For the next few months Pissarro painted a series of works looking up the avenue and down on the Place du Théâtre (at the lower right of this canvas). The series of Paris street views belong, with the Rouen, Dieppe, and Le Havre scenes, to the cityscapes he produced in the last decade of his life. As a group they form a strong contrast to his equally important group of rural scenes which continued his long established interest in the images of the country.

LUCIEN PISSARRO

Franco-British 1863-1944

The Pinewood at Chipperfield Common, 1914

Oil on canvas
Connaught Brown, London

The eldest son of Camille, Lucien was brought up, so to speak, in the cradle of Impressionism and was taught painting by his father with additional lessons from Manet and Cézanne. Exhibiting at the 1886 Impressionist exhibition, Lucien had, like his father, fallen under the influence of Seurat and had adopted a pointillist style of painting. In the early 1890s he was removed from French influences when he settled in England where he set up the Eragny Press in Hammersmith which published illustrated books, mostly of French origin. When the press ceased publishing in 1914, Lucien's main activity was in painting views of the English landscape. An influential member of the Camden Town Group, Lucien continued to use a modified Neo-impressionist painting style in his work, something that was also used by many of the English-born members of the group.

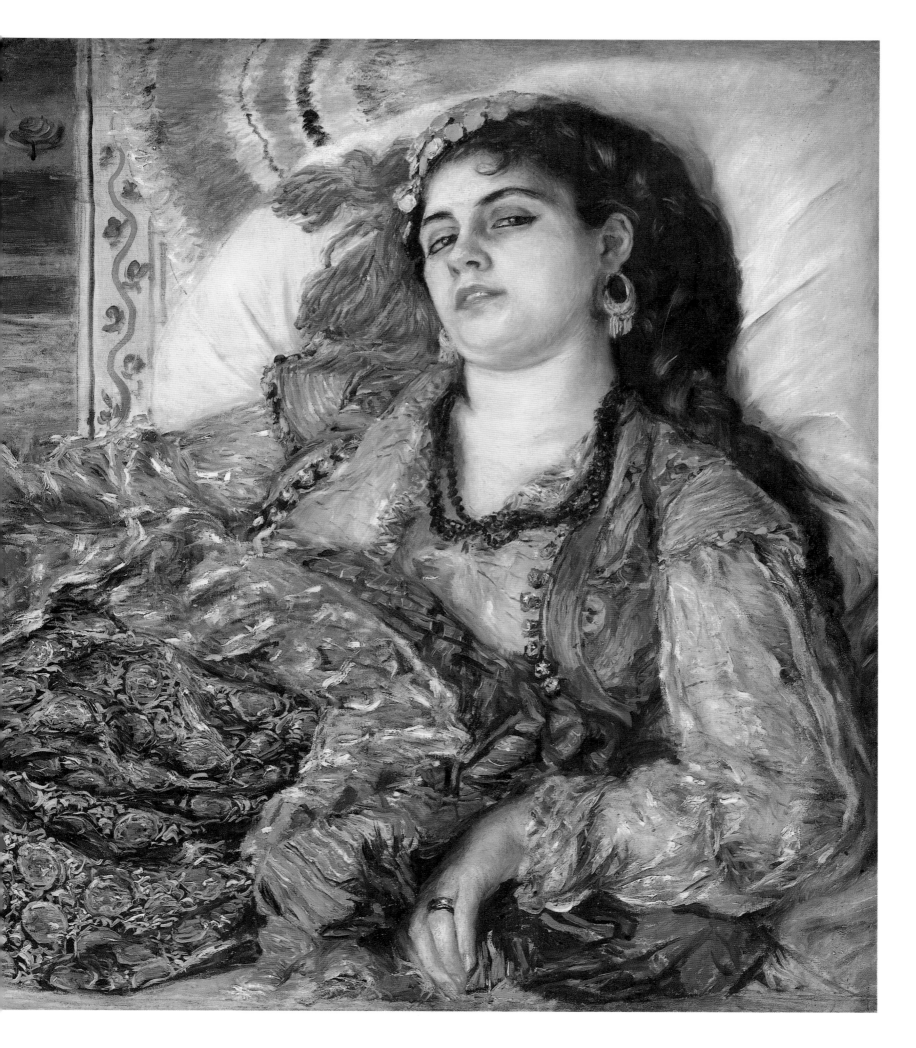

idealized version of an Odalisque or slave in a harem, which owes something to Delacroix, in the warm colors and attention to textures, and to Ingres, whose *Turkish Bath* (1859-63) had suggested the hedonistic and sensuous life in the harem. Surprisingly Renoir at this time had never been to North Africa and would not do so for another ten years. Even then, as a European man, he would never have been given access to such a closed feminine community.

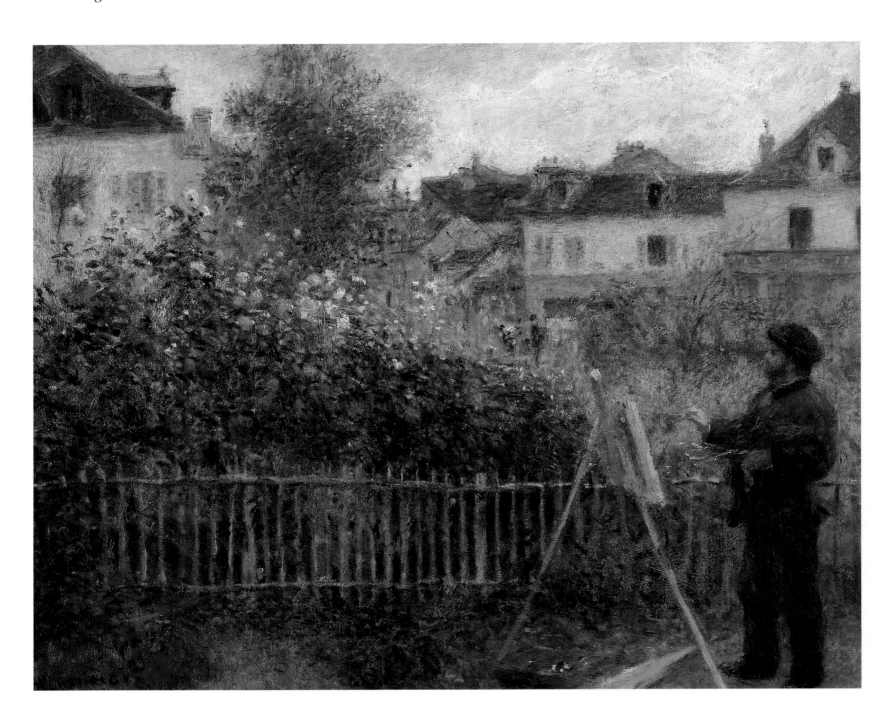

Monet Painting in his Garden at Argenteuil, 1873

Oil on canvas
18⅜ × 23½ inches
Wadsworth Atheneum, Hartford,
Connecticut
Bequest of Anne Parrish Titzell

In the summer and fall of 1873, Renoir and Monet were continuing their practice established in the 1860s of painting together at Monet's home in Argenteuil. The result of this was a very close similarity in their styles. This painting well demonstrates the Impressionist painting practice: Monet is shown working on a small canvas supported on a light easel (compare this with Bazille's studio easel in Renoir's *Portrait of Bazille*) while his paintbox lies next to it on the ground. All of these items were easily portable no doubt contributing to the growth in popularity amongst the Impressionists of painting out of doors. An equally important piece of equipment is shown next to the paintbox – a folded parasol. In the background, just beyond the fence and the screen of rose bushes we are given a glimpse of the new houses that were springing up in the suburb of Argenteuil, an indication of the growth in suburban areas and part of the process of industrialization around Paris in the nineteenth century.

La Loge, 1874

Oil on canvas
31½ × 24¾ inches (80 × 63 cm)
Courtauld Institute Galleries, University of London

Like Mary Cassatt, in *La Loge* Renoir has depicted one of the most representative aspects of contemporary Parisian leisure. In a 'loge' or theater box, an elegant couple survey the rest of the theater audience, for the gentleman raises his opera-glasses to a spectacle way above the stage. The models for this painting were Renoir's brother Edmond and a popular Montmartre model Nini, nicknamed 'Guele de raie' or 'fish-face.' They are dressed as members of the bourgeoisie in elegant evening clothes and jewels. Their apparent wealth is emphasized by their occupation of a box – these were normally rented for the entire season and were an indication of the occupants' social status, a status considerably enhanced if one could display an attractive female companion.

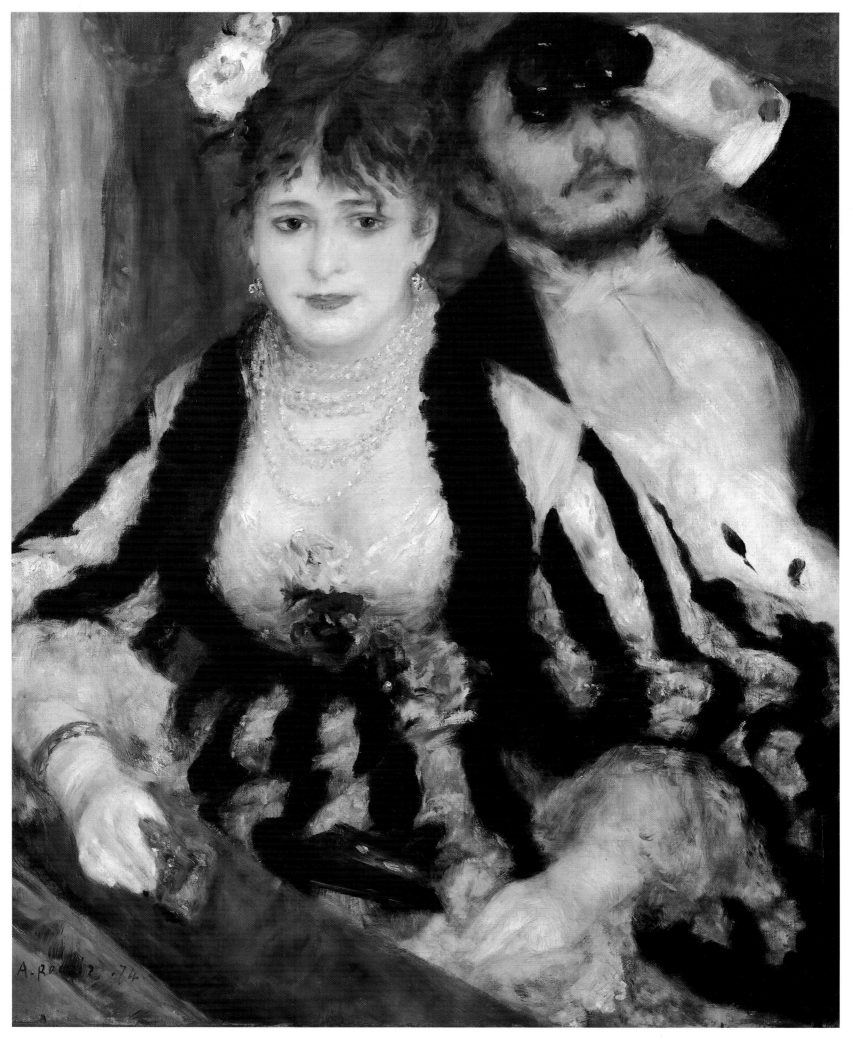

The Seine at Argenteuil, 1874

Oil on canvas
19⅝×23⅝ inches (50×60 cm)
Portland Art Museum, Portland, Oregon

Following the 1874 Impressionist exhibition, the group's finances were in such a state of disarray that the Limited Company of Painters, Sculptors, and Engravers was forced into liquidation. That summer saw Monet and Renoir together again working at Monet's home in Argenteuil, where they were sometimes joined by Manet. The pleasant, rural existance of life on the river became a frequent motif and both Monet and Renoir painted almost identical works using the same composition, technique, and color. In this painting Renoir has used the device of the jetty, on which an elegantly dressed visitor to the river stands, to enable the viewer to enter the picture space. In neither this work nor in Monet's version are any of the boats working craft used for transporting cargo. For both painters the river was simply the site of leisure activities such as boating, swimming and fishing.

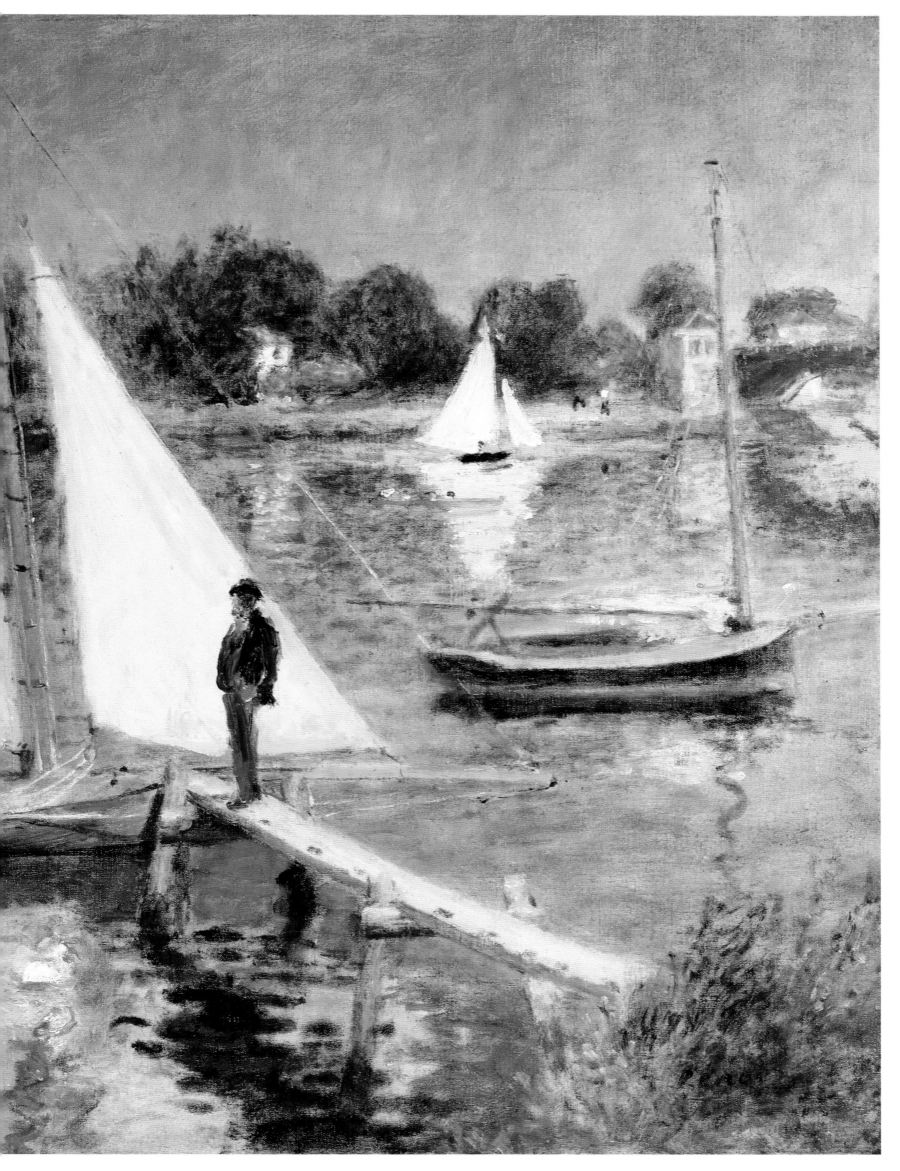

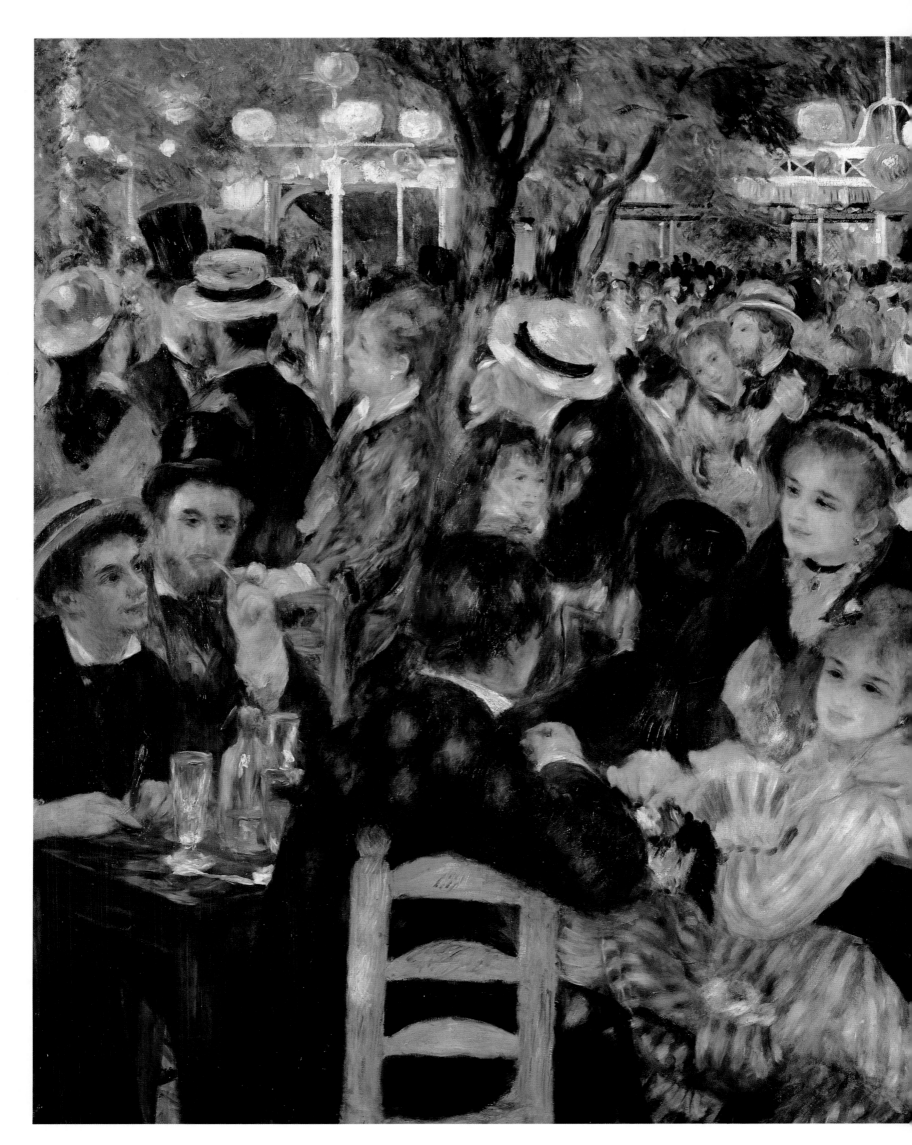

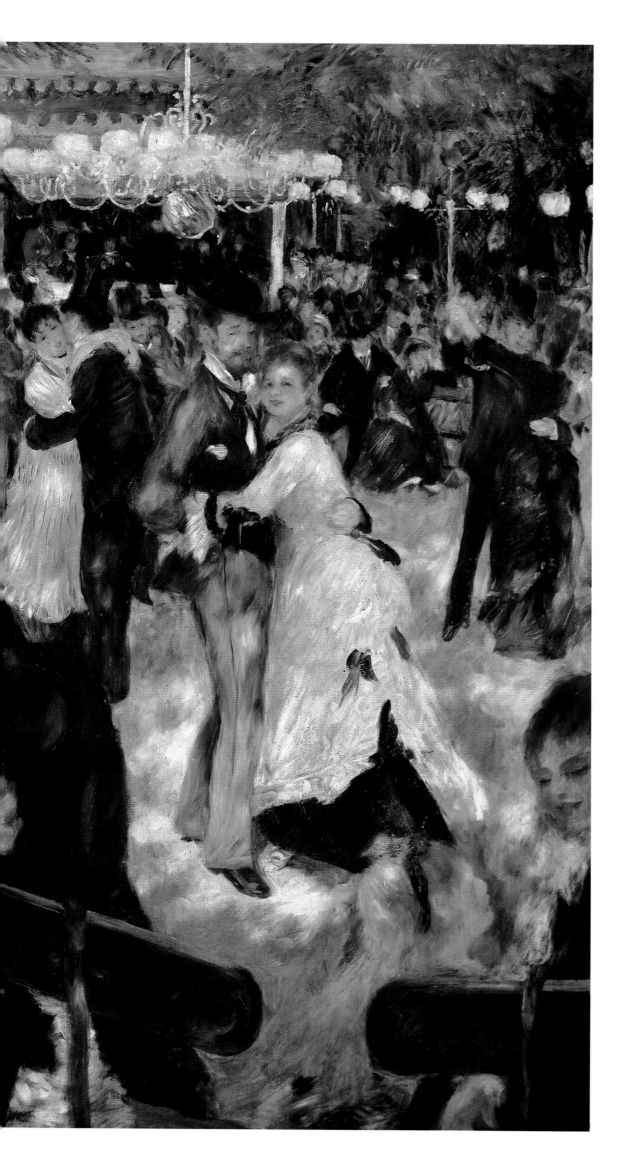

The Ball at the Moulin de la Galette, 1876

Oil on canvas
51½×68⅞ inches (131×175 cm)
Musée d'Orsay, Paris

Much of what we know about this painting has been provided by the writer and critic Georges Rivière, a friend of Renoir who is also portrayed in the foreground as one of the young men drinking at the table. According to Rivière, Renoir had his friends carry the large canvas from his studio in the rue Cortot to the Moulin on the summit of the Butte Montmartre. The Moulin took its name from one of the old windmills which added to the rustic atmosphere which still pervaded Montmartre at this time. Every Sunday afternoon, young Parisians congregated in the dance hall or in fine weather, in the courtyard behind. Here dancing continued until after dark as the Moulin was equipped with overhead gas lamps. This painting however is not an authentic representation of the clientèle at the Moulin: most of the figures in this painting were in fact Renoir's friends with the occasional professional model posing for him. In addition to this finished canvas, there are a number of preliminary studies including at least one oil sketch of the entire scene.

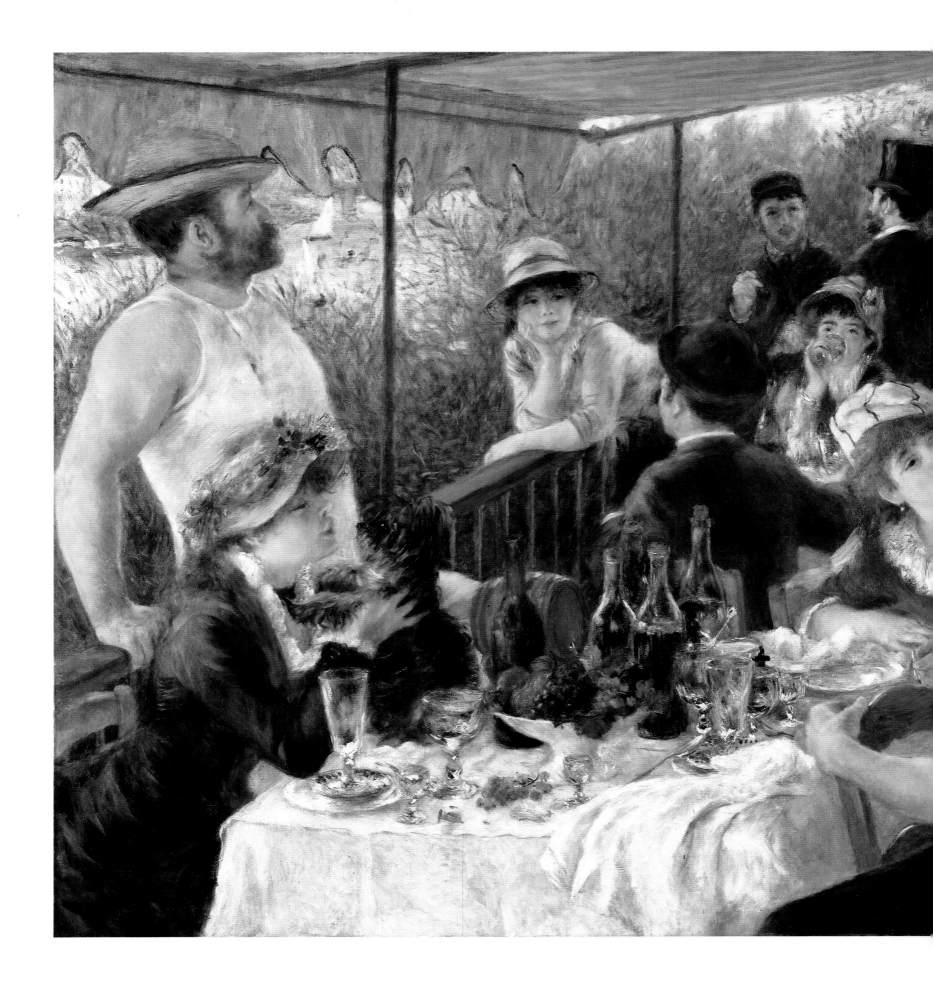

The Luncheon of the Boating Party, 1881

Oil on canvas
51×68 inches (129.5×172.7 cm)
The Phillips Collection, Washington DC

This canvas is almost the same size as *The Ball at the Moulin de la Galette* and also depicts a crowd scene composed of portraits of Renoir's male friends cavorting with female models, all apparently enjoying their leisure time. While the Moulin was essentially an urban scene, *The Luncheon of the Boating Party* is a suburban one. In the summers of 1879, 1880, and 1881, Renoir returned to his favorite spots on the river Seine and painted a number of boating scenes. The location for this painting has been identified as the terrace of the Restaurant Fournaise, which was situated on an island in the river at Chatou. The figure of the oarsman on the right was modeled by Gustave Caillebotte and the young woman with the dog in the left foreground has been identified as Aline Charigot (1859-1915), Renoir's future wife.

Bather Drying her Leg, c. 1910
Oil on canvas
33×26 inches (83×66 cm)
São Paolo Museum of Art

For several years Renoir had been produc-
ing representations of full-length nudes in
which women perform tasks associated
with their toilette, often drying their legs.
This subject marked a return to the more
traditional subject matter of official Salon
art. Like many of Renoir's works of this
period, these paintings are derived from
eighteenth century prototypes: Fragonard
and Watteau both painted women at their
toilette, intimate scenes to which the spec-
tator is privy. In this painting Renoir has
closed in on the model so that her form fills
most of the canvas area. As usual in his
works, Renoir's model keeps her eyes
downcast. In drying her leg she at once re-
veals and conceals her body, adding to the
allure of an already seductive pose. Unlike
some of the other Impressionists, Renoir
never completely gave up the use of black,
which in this painting is mixed with the
other colors and gives the modeling of the
flesh a luminous hue.

TOM ROBERTS

Australian 1856-1931

Impression, 1888

Oil on cedar panel
4⅝×7¼ inches (11×18.5 cm)
National Gallery of Victoria, Melbourne

The subject, style, and format of Tom Roberts' *Impression* is very characteristic of the paintings he exhibited at the 9×5 Impression Exhibition in Melbourne in 1889. The title reflects the aims of the Heidelberg School and the observations of the French painter Gérome: 'When you draw, form is the most important thing; but in painting the first thing to look for is the general impression of color.' Like the other Heidelberg artists, Roberts described himself as an 'Impressionist' even though he used black, mixed colors on his palette, and depended more on tonal contrasts in order to record the effects of light in the natural world. The small size of this panel and the highly evident and relatively large brush strokes indicate the speed with which Roberts painted to capture the mood of the scene.

Union Square in Winter, 1895

Oil on canvas
20×17 inches (50.8×43.2 cm)
New Britain Museum of American Art,
New Britain, Connecticut
Gift of A W Stanley Estate

Robinson went to France in 1887 and stayed there until 1892 and for some time he lived and worked with Monet at Giverny. Robinson was one of the few American painters to attempt serial paintings like Monet as both were interested in the variable effects of light, weather, and atmosphere on fixed subjects. When Robinson returned to the United States, he spent his four remaining years teaching, painting, and spreading the Impressionist style in America. Determined to paint American subjects Robinson painted not only the rural scenery of New Jersey, Connecticut and upstate New York, but also the urban views of Manhattan where he lived. Union Square, a public park opened in 1809, was decorated with sculptures of important figures from American history.

In this painting Robinson singled out Henry Kirk Brown's equestrian statue of George Washington. Painting from inside the park, Robinson's view is to the southeast towards 14th Street (at the right) and Broadway (at the left). All the hard edges of the buildings and monuments are dissolved under the atmosphere thickened with falling snow, painted in dabs of cool, pale blues.

THEODORE ROBINSON

American 1852-96

JAMES SANT
British 1820-1916

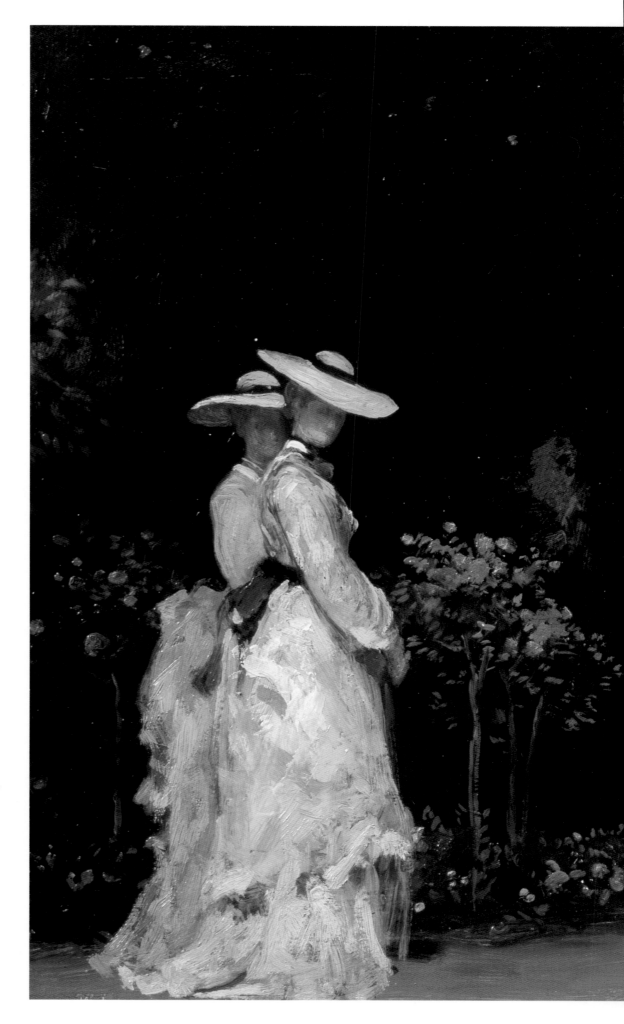

Miss Martineau's Garden, 1873

Oil on canvas
12¼×18½ inches (31.1×47 cm)
Tate Gallery, London

Sant was a consistent exhibitor of group portraits and genre scenes at the Royal Academy from the 1840's until the early 1900's. This painting shows something of a rarity – the influence of contemporary French art in the 1870's on English painting. French painting was to the 19th century what Italian painting was to the Renaissance, yet hardly a trace shows up anywhere in English painting of the period. Generally Impressionism was misunderstood in England, signifying triviality, foreign emotionalism and lack of stability. While it was accepted that the French painters were indeed talented, the English believed they were squandering it: a loose handling of paint was considered to be synonymous with a loose way of life! Yet an occasional English picture does come near Impressionism at times and this scene of ladies in a garden could be taken for a Monet. Without the pressures of a client, critics or saleroom, Sant was able to work on this small picture for his own pleasure.

JOHN SINGER SARGENT

American 1856-1925

Carnation, Lily, Lily, Rose,

(1885-6)
Oil on canvas
68½×60½ inches (174×153.7 cm)
Tate Gallery, London

An expatriate American, Sargent moved in the circle of the Impressionists and in the 1880s began to paint landscapes that were overtly Impressionist in technique and approach. In 1884 he had scandalized visitors to the Salon with his *Portrait of Madame X* (1884) and Sargent left France for London. In the summer of 1885 he was recuperating after a boating accident in Broadway, an artists' colony on the River Avon, where his masterwork of plein-air painting *Carnation, Lily, Lily, Rose* was painted. The models for this painting were the sisters Dorothy and Polly Barnard and the picture took almost two years to paint because Sargent spent only a few minutes working on it each evening after sunset. As the summer turned into autumn, Sargent replaced the lily stalks and roses with artificial flowers. The painting's title comes from a popular song of the day but Sargent nicknamed the painting 'Darnation, Silly, Silly, Pose,' and it was purchased by the Tate Gallery soon after it was exhibited at the Royal Academy.

Claude Monet Painting at the Edge of a Wood, c. 1887

Oil on canvas
21¼×25½ inches (54×64.8 cm)
Tate Gallery, London

His reputation re-established with the success of *Carnation, Lily, Lily, Rose*, Sargent passed the summer of 1887 with Monet at Giverny. There, in addition to a profile study of Monet's head, Sargent portrayed his colleague at work at the edge of a wood as well as a companion piece, a view of him at work in his studio boat (National Gallery of Art, Washington DC). Sargent's reverence for Monet moved him to purchase four of his landscapes including *The Rock of Treport*. Monet, however, was later to deny that Sargent was ever an Impressionist, which in many ways is unjust, especially in relation to some of Sargent's works in the 1880s and 1890s. Nevertheless while Sargent's long thin strokes and the use of black in this portrait do indicate his independence from certain Impressionist techniques, Sargent's technique for painting large canvases out of doors was to be of use to Monet in his own large compositions.

GEORGES SEURAT

French 1859-91

Bathers at Asnières, 1883-84

Oil on canvas
79×118 inches (201×300 cm)
National Gallery, London

In his search for a method of rationalizing colors to create form, Seurat became deeply immersed in the color theories of Chevreul on the simultaneous contrast of color, the effect of juxtaposed colors, and the fact that each color can impose its own complementary on its neighbor. These ideas first found expression in *Bathers at Asnières* which was rejected by the Salon in 1884 but exhibited at the newly established Salon des Indépendants. This painting was by far the largest and the most ambitious project that Seurat had undertaken to date and amounted to a challenge to the Paris art world of the 1880s as well as the announcement of the arrival of a new and original talent. In addition to responding to contemporary developments in artistic practice, Seurat's painting also reveals his awareness of the long tradition of French art: the hieratic depictions of the resting figures, almost all of whom are seen in profile, was likened at the time to the work of Puvis de Chavannes, a classicizing artist renowned for his large-scale figurative works. Seurat's subject is however, uncompromisingly modern. The scene is the left bank of the river Seine looking toward Asnières, identifiable by the railway bridge, and in the distance, the smoking factory chimneys of Clichy. We are therefore, looking at an urban and industrial landscape. At the top righthand corner of the painting, just visible, is the corner of the island of La Grande Jatte.

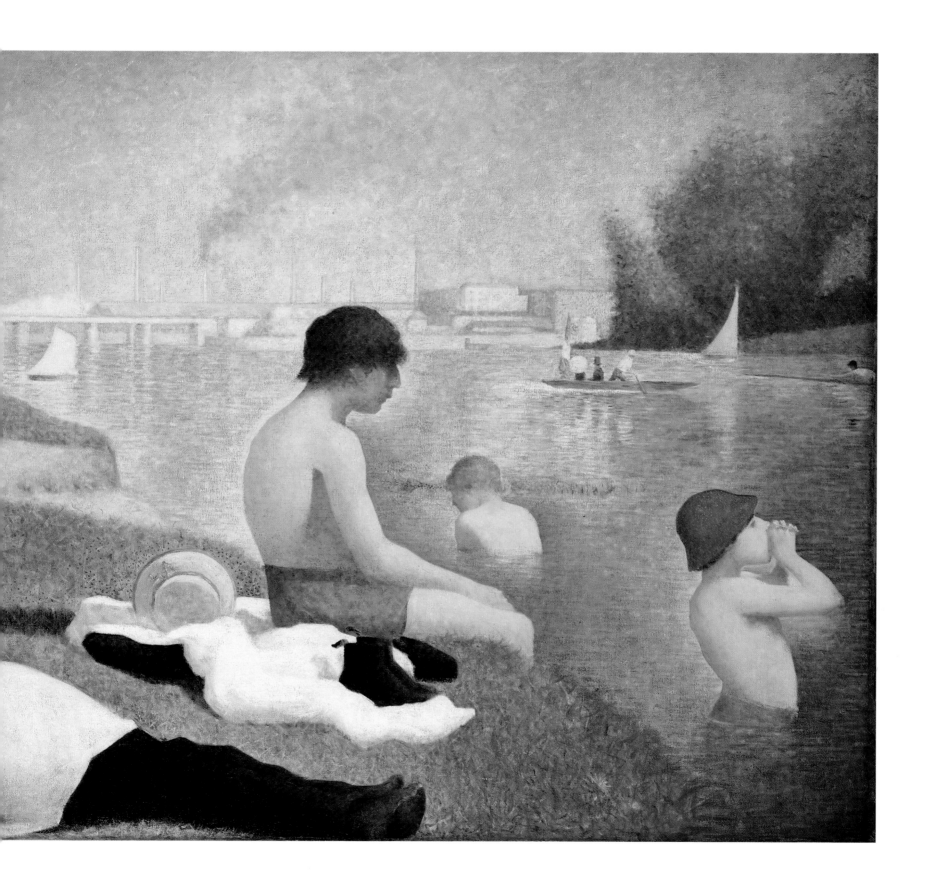

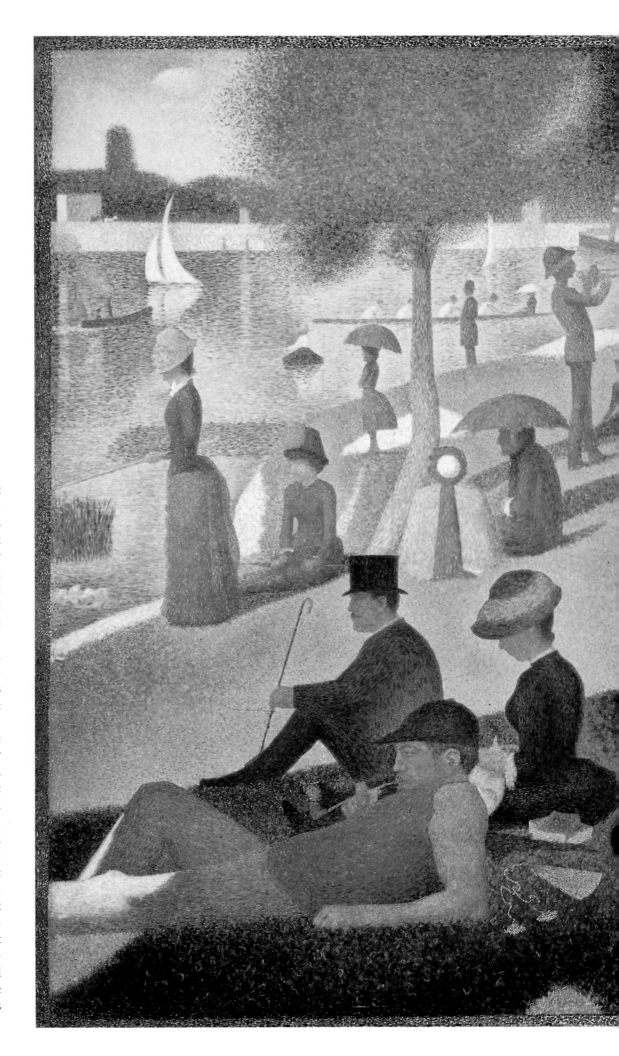

Sunday Afternoon at the Island of the Grande Jatte, 1884, 1884-86

Oil on canvas
82×121 inches (208×308 cm)
Art Institute of Chicago

More or less the same size as his *Bathers at Asnières, la Grande Jatte* is far more complex and was the first of Seurat's paintings to be painted in a completely pointillist technique. Some fifty figures, mostly women, are depicted strolling, resting, and relaxing on a Sunday afternoon on the island near the opposite bank of the Seine to where the *Bathers at Asnières* are located: in the top the railway bridge is visible. Seurat began work on this painting in 1884 (a date he was anxious to draw attention to as he included it in the painting's title) and his approach was more elaborate than in any other of his previous works. Some thirty panels, 25 drawings and three major studies were used as preparatory material. The painting caused a sensation when it was shown in 1886, firstly at the Salon of the Société des Independants and then at the last Impressionist exhibition. Pissarro was immediately impressed and wrote to his son Lucien: 'Seurat has something new to contribute which these gentlemen [his Impressionist colleagues] are not able to appreciate . . . I do not accept the snobbish judgments of 'romantic' Impressionists in whose interests it is to fight against new tendencies. I accept the challenge, that is all.' Pissarro did indeed accept the challenge and for a period he also adopted the pointillist style for his own paintings.

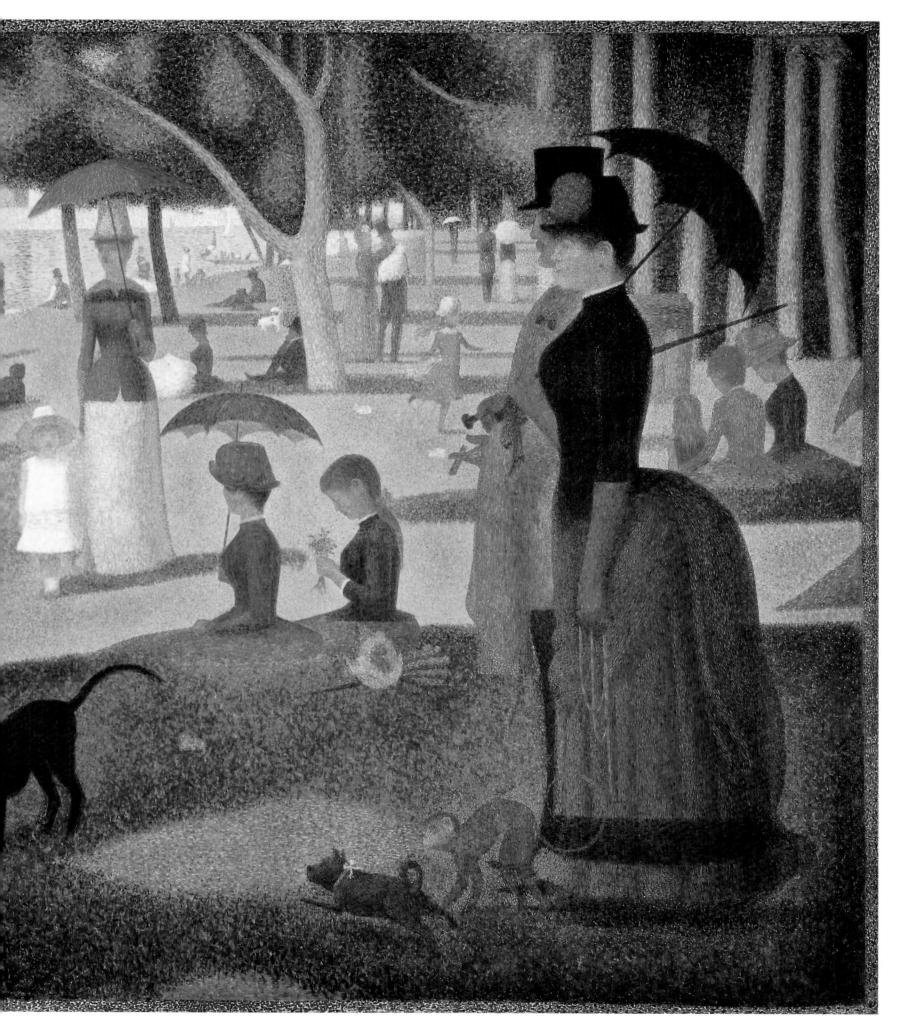

Le Pont de Courbevoie, 1887

Oil on canvas
18⅛×21⅝ inches (46×55 cm)
Courtauld Institute Galleries,
University of London

Like Asnières, Courbevoie was an expand-
ing industrial suburb of Paris in the 1880s.
As in the *Bathers at Asnières* Seurat had
painted a view of the River Seine looking
downstream at one of the newly con-
structed bridges connecting Paris with the
outer suburbs. Unlike the *Bathers* this
painting does not share the same subject
matter: only three isolated figures (two on
the river bank and one fishing from a jetty),
almost motionless, can be seen. In the dis-
tance two vague figures can be detected in
a small boat. The most remarkable feature
of this painting is its formal structure and
strictly organized composition in the play
of horizontal, vertical, and diagonal forms.

La Parade du Cirque, 1887-88

Oil on canvas
39⅜×59 inches (100×150 cm)
Metropolitan Museum of Art, New York
Bequest of Stephen C Clark, 1960

This picture was painted throughout the winter of 1887-88 and was shown at the Independants exhibition in 1888. The subject is a single trombone player performing outside in front of a group of four other musicians who are placed to the left of the stage. To the right, the conductor with his baton, is seen in profile being harangued by another performer. In the foreground various onlookers and members of the public form a line to gain entrance to the circus via the ticket booth at the extreme right. The subject was derived from the Cirque Corvi, part of a traveling fair which performed annually in Paris in the spring at the Place du Nation on the eastern edge of the city. Although it was essentially a working-class entertainment, the circus did attract a wider audience which Seurat indicates by the variety of headgear from working men's caps to top hats.

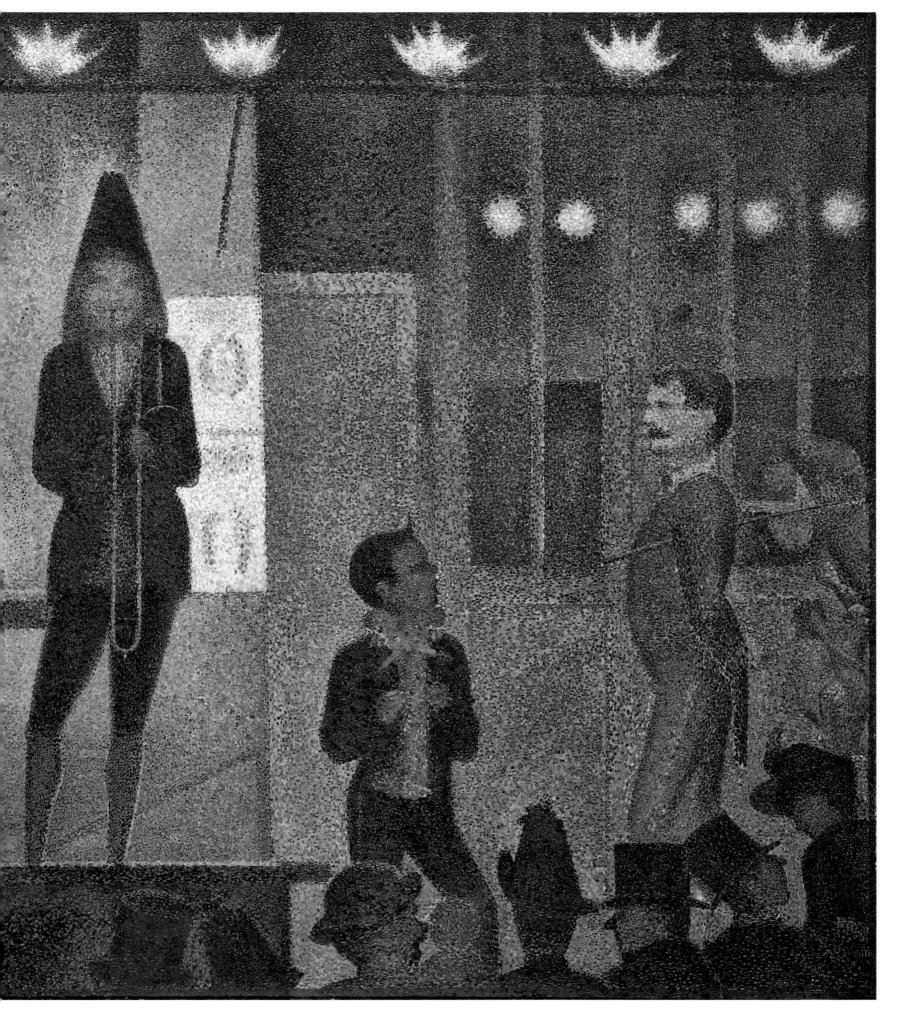

WALTER RICHARD SICKERT

British 1860-1942

Piazza San Marco, 1902-3

Oil on canvas
6¼×7⅞ inches (16×20 cm)
Laing Art Gallery, Newcastle-upon-Tyne

Born in Munich of mixed English and Danish descent, Sickert is the outstanding example of an artist on the fringe of Impressionism, friendly with many of its leading personalities while retaining his individualism. Sickert began his career as an actor but later became a student at the Slade School of Art under Alphonse Legros and then worked in Whistler's studio. In 1883 he went to Paris and there became friendly with Degas and derived from him an interest in depicting contemporary urban life. Like Degas, Sickert never painted in the open air but preferred to use preliminary drawings to create the basic structure of his paintings. More interested in people and city life and its architectural background than in landscapes, Sickert's views of Dieppe, Paris, and Venice went far in popularizing Impressionism in England.

PAUL SIGNAC
French 1863-1935

Gas Tanks at Clichy, 1886
Oil on canvas
26×32 inches (65×81 cm)
National Gallery of Victoria, Melbourne

Signac's well-to-do parents had originally intended their son to be an architect but eventually they agreed to him becoming a painter. Painting originally in the mainstream Impressionist style with a heavy dependence on Monet (to whom he always remained grateful for advice and support), Signac's membership of the Société des Indépendants brought him into contact with Seurat, whose newly formed doctrines and technique he absorbed to such an extent that for some time their works were almost identical in appearance. This painting, exhibited at the eighth Impressionist exhibition, is one of a series of urban landsapes of the area in and around Clichy and in which the emphasis is less on the people who lived and worked there than on the buildings. In his predeliction for such unpreposing motifs, as in this image of gas tanks, there seems to be nothing of an immediately picturesque character to attract the attention of a landscape artist. Signac in fact built on the tendency toward the banal and workaday that had already been identified by the Impressionists as suitable subject matter for painting.

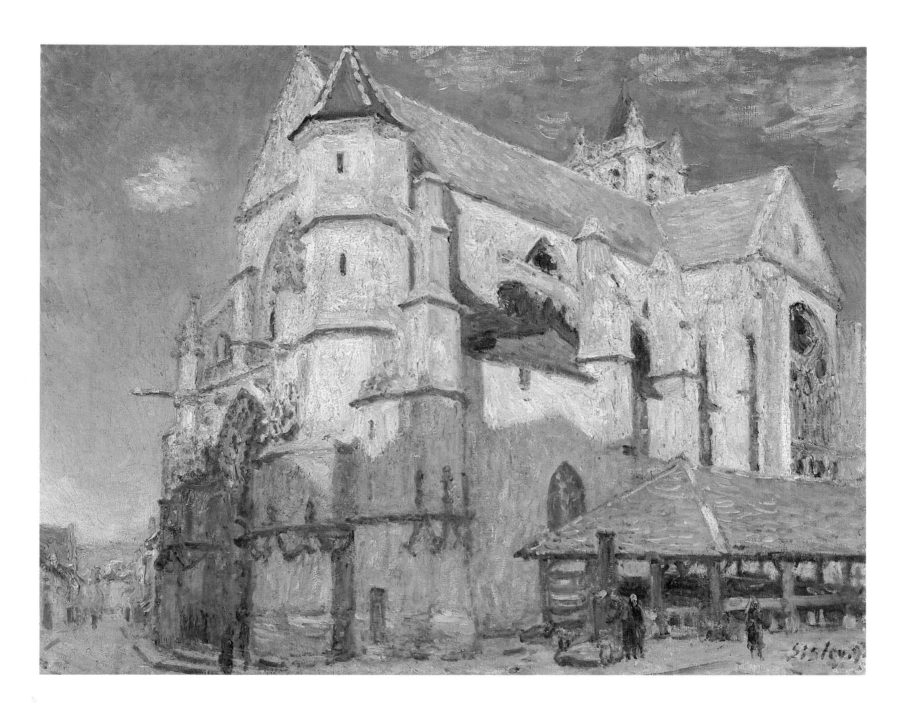

The Church at Moret, 1893

Oil on canvas
25½×36 inches (66×91 cm)
Musée des Beaux Arts, Rouen

In October 1883 Sisley moved from Veneux-Nadon to Moret, about 8 miles (13 km) from Fontainebleau and he was to remain in this region, painting its villages and landscapes, until his death in 1899. One of the houses he lived in was in the shadow of a church, situated on the corner of the rue du Château and the rue de Montmartre. In the last years of his life Sisley painted no less than twelve canvases all of which take the church as their central subject. Inevitably these paintings are compared with Monet's Rouen Cathedral series. But where Monet's paintings show more concern for the recording of a series of moments within the same painting thereby presenting a generalized effect, Sisley presents the church as seen in precise weather conditions and at specific times of the day, as if caught in a single moment.

Alfred Sisley

Lady's Cover, Langland Bay, 1897
Oil on canvas
Private Collection

CLARA SOUTHERN

Australian 1861-1940

An Old Bee Farm, c. 1900

Oil on canvas
26×44 inches (66×111.7 cm)
National Gallery of Victoria, Melbourne
Felton Bequest, 1942

Southern was a student at the Melbourne National Gallery School and also became associated with the Heidelberg School. In addition to the works of Whistler and tonal Impressionism, Southern greatly admired the works of Corot, particularly his establishment of relationships between figures and the landscape. Of the artists' camp that she established on the outskirts of Melbourne in 1908 she wrote that the group of landscape painters gathered there 'would come and go . . . I often think how Corot would have revelled in it.' Painted in the light of early morning or late afternoon, Southern depicts a humble weatherboard house on the crest of a hill below which a woman tends a number of beehives, the serenity of the scene enhanced by the muted palette.

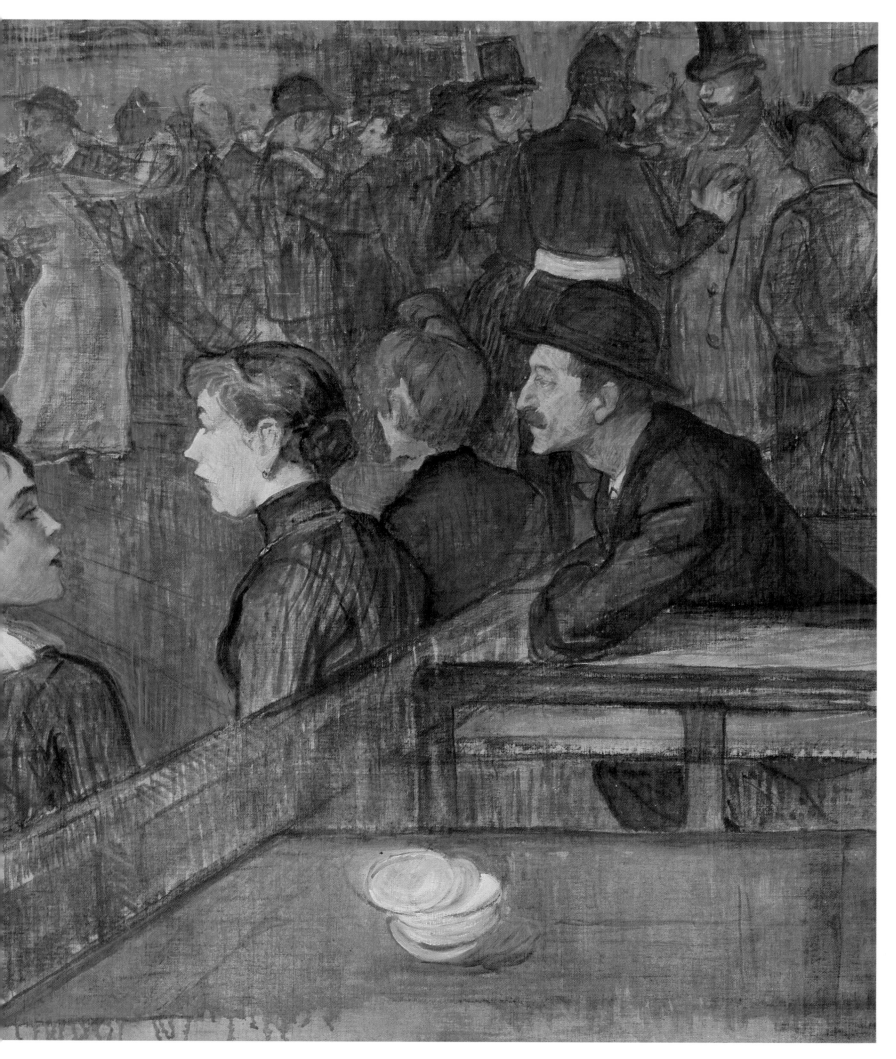

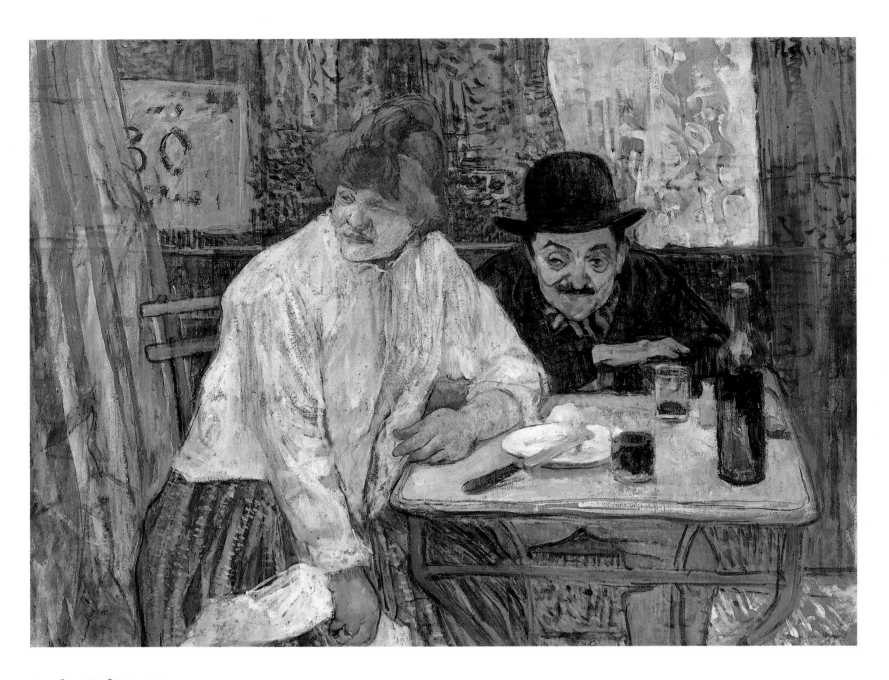

At the Café La Mie, 1891

Watercolor and gouache on paper
21×26¾ inches (53×68 cm)
Museum of Fine Arts, Boston

Since the mid 1880s Lautrec had been in-
terested in café and bar scenes and this
painting was his first important exhibited
work which shows a run-down wine shop
similar to the one featured by Zola in his
novel *L'Assommoir.* The man in the cafe is
Maurice Guibert, a champagne salesman
and friend of the artist. The unidentified
woman was possibly one of Guibert's
many mistresses. It is not known whether
this bar actually existed with the unusual
name 'La Mie' (The Crumb): Lautrec may
well have invented it to stress the degrada-
tion of those caught in the downward
spiral of alcoholism. In addition to photo-
graphs that Lautrec used to help develop
the composition, he would have found
precedents in the similar pair of drinkers in
Degas' *At the Café (L'Absinthe)* and in
Rafaëlli's *Absinthe Drinkers* which was ex-
hibited at the Salon in 1889 and uses a
similar frontal image of a run-down wine
shop.

Portrait of Dr Henri Bourges,
1891

Oil on cardboard mounted on panel
31×20 inches (79×50.5 cm)
Carnegie Museum of Art, Pittsburgh
Acquired through the generosity of the
Sarah Mellon Scaife family

At the Salon des Indépendants in early
1891, Lautrec, unannounced in the cata-
logue, at the last minute exhibited *At the
Cafe La Mie* and three portraits of male
friends. These images of upper-class men
shown next to the down-at-heel characters
at the cafe may well have been a deliberate
act by Lautrec to show his mastery in
depicting Parisian types. In this full-length
portrait of Henri Bourges pulling on his
gloves as he prepares to go out, Lautrec
places emphasis on the costume, pose, and
physiognomy of the doctor, so much so
that we often overlook the fact that the set-
ting is Lautrec's studio: at the bottom right
of the picture we see a number of canvases
and stretchers stacked against each other.

At the Moulin Rouge, c. 1894-95

Oil on canvas
48½×55⅜ inches (123×141 cm)
Art Institute of Chicago

This painting was Lautrec's last major
work based on the theme of the dance hall.
When the Moulin Rouge opened in 1889,
Lautrec had painted scenes of its interiors,
dancers, and audience and in 1891 he had
designed his first poster which was a com-
mission to advertise the star performer at
the Moulin Rouge, La Goulue. As so often
in Lautrec's works, there are strong auto-
biographical elements, particularly in his
choice of models. The bearded man to the
left is the writer Edouard Dujardin; the
woman with the pasty face is La Macarona;
the man with the moustache is photogra-
pher Paul Sescau, while the other seated
man is possibly Maurice Guibert. The
woman with the flaming red hair who has
her back to us may be Jean Avril, a dance
hall star and frequent model for Lautrec
and the woman who arranges her hair in
the mirror is La Goulue herself, accom-
panied here by La Mome Fromage (Miss
Cheese Tart). Behind the group at the
table, Lautrec represents his own dimin-
utive figure, absurdly sent up by the ex-
ceptionally tall figure of his companion,
Tapié de Céleyran, a degenerate medical
student and Lautrec's cousin. The figure
who dashes out of the picture at the lower
right is the English dancer, cafe-concert
singer, and notorious lesbian, May Milton.

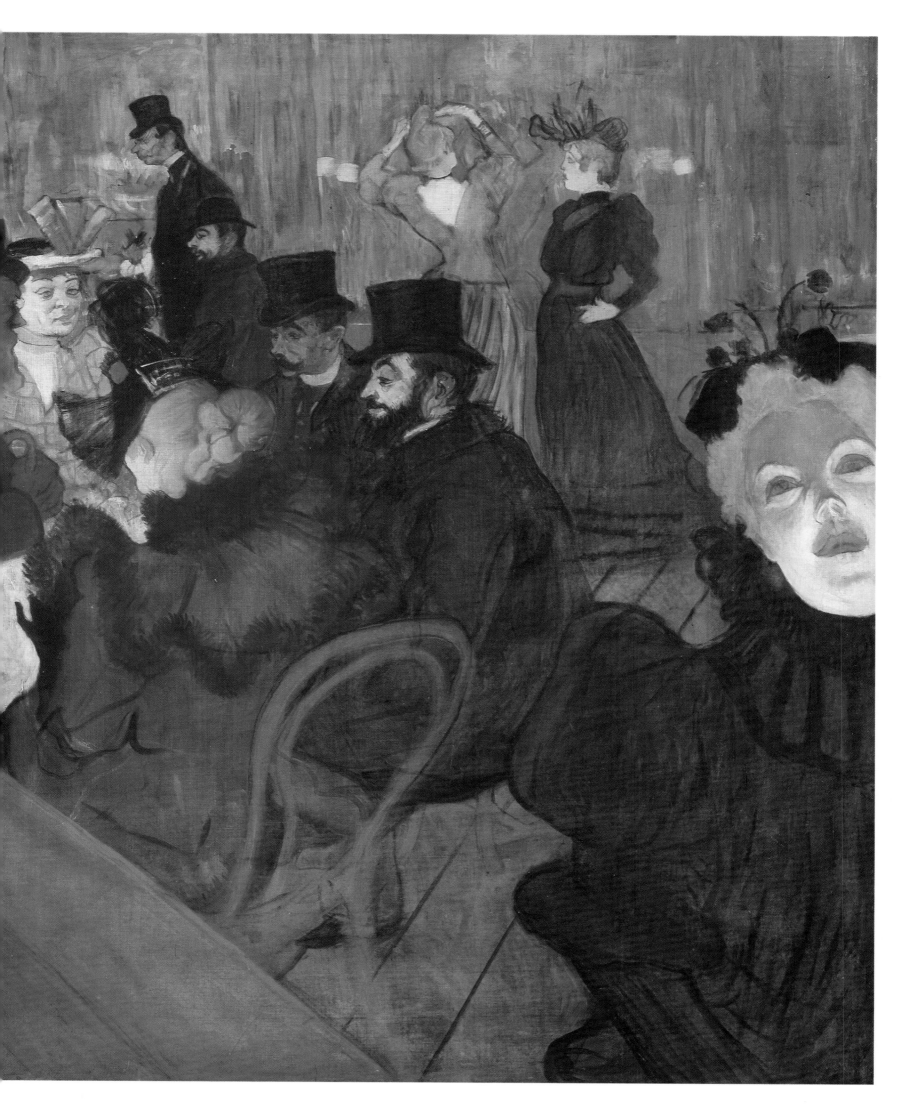

HELEN TURNER

American 1858-1958

Lilies, Lantern, and Sunshine,
1923
Oil on canvas
35×43 inches (88.9×109.2 cm)
The Chrysler Museum, Norfolk, Virginia
Gift of W B S Grandy

One of the notable American Impressionists Helen Turner began her artistic career when she moved from her native Louisiana to New York where she studied at the Arts Students' League and Columbia University. In 1910 she built a summer house at the artists' colony of Cragsmoor in the Hudson River Valley where she produced her trademark work of views of young women in simple but gracious interiors and gardens. In this painting, the scene is set on the porch of 'Takusan,' Turner's Cragsmoor home and the model who posed for both figures was Julia Polk, the daughter of another summer resident. This painting with its Chinese lanterns and background of flowers pays tribute to *Carnation, Lily, Lily, Rose* by Sargent who Turner met on one of her trips abroad. An expert gardener, Turner also cultivated the tiger lilies growing in the background and arranged in the vase on the table.

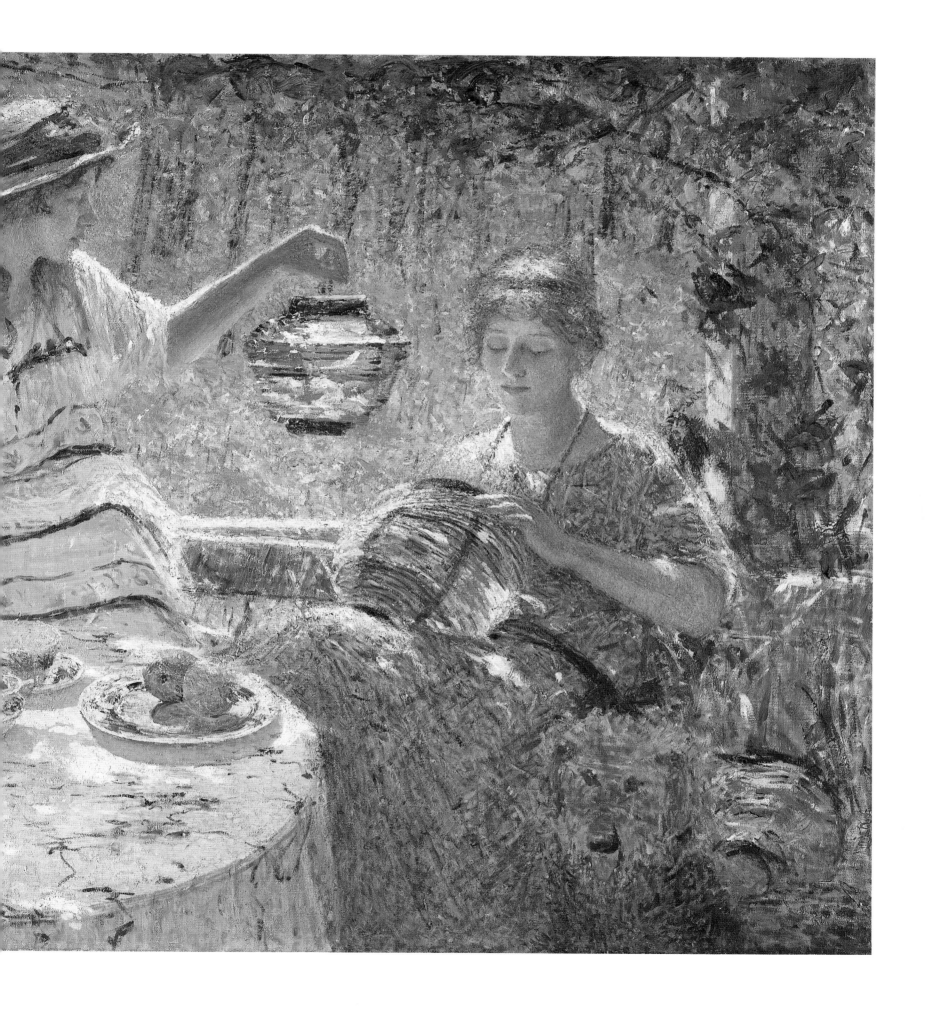

JOHN H TWACHTMAN
American 1853-1902

Meadow Flowers, c. 1890-1900
Oil on canvas
33¹⁄₁₆×22¹⁄₁₆ inches (84×56 cm)
The Brooklyn Museum, New York
Polhemus Fund

Twachtman had studied painting in Munich before studying at the Académie Julian in Paris from 1883 to 1885. In France he spent his summers painting in the countryside using a style influenced by

Whistler. On his return to America he moved to southern Connecticut and around 1889 bought a 17-acre farm in Greenwich, where, surrounded by the gentle landscape and encouraged by his

In Flanders Field Where Soldiers Sleep and Poppies Grow, c. 1892

Oil on canvas
58×104 inches (147.3×264.2 cm)
The Butler Institute of Art, Youngstown, Ohio

The boldness of *Poppies*, a sketchy earlier work derives from Vonnoh's awareness of Impressionist and Post-Impressionist trends and because it was intended as a study for this far more finished painting. The coarse brushwork has been refined into neater, more regular dabs of color to produce a painting that is both restrained and evocative of a sense of place. In his Impressionist paintings Vonnoh was, above all else, a colorist who, as an 1891 catalogue essay remarked: 'Worked with a definite purpose to interpret as directly and as simply as possible the Truths of Nature, not in the literal sense, but solely with reference to color.'

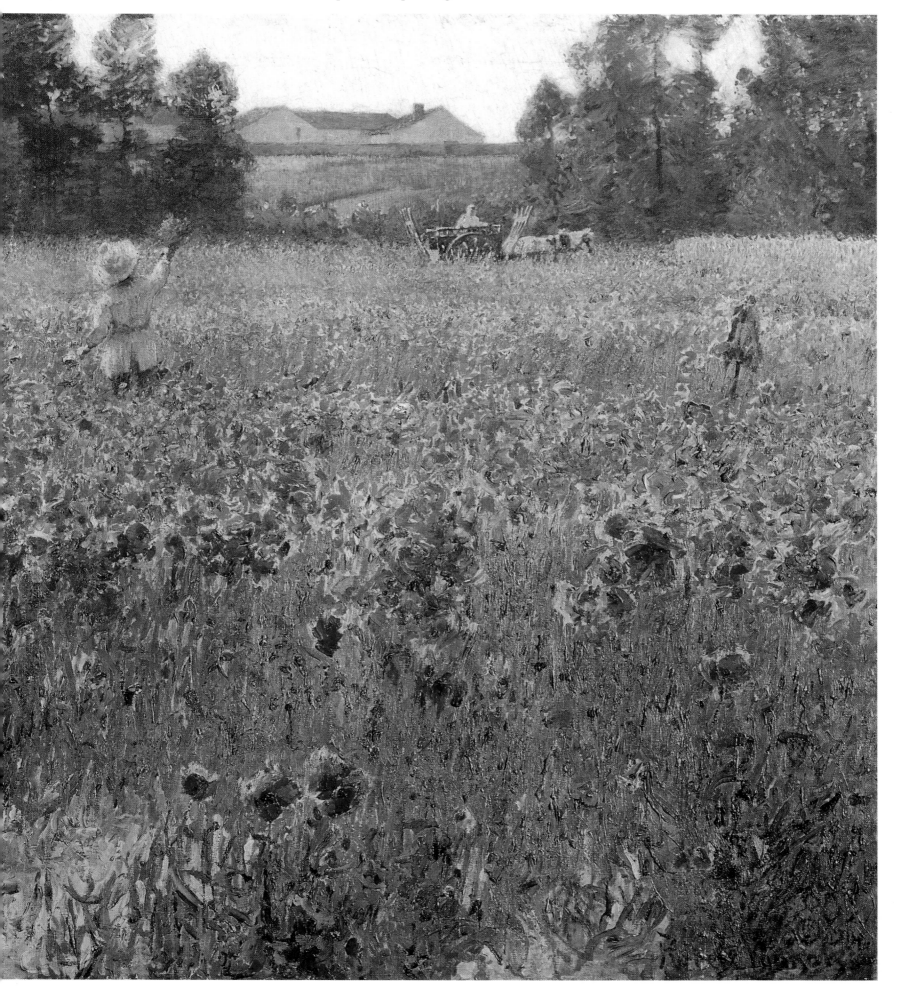

EDOUARD VUILLARD

French 1868-1940

Public Gardens, 1894

Two panels from a decorative scheme
Distemper on canvas
left panel: 7 feet × 34½ inches
(214.5×88 cm)
right panel: 7 feet × 36 inches
(214.5×92 cm)
Musée d'Orsay, Paris

Vuillard, like Bonnard, was a generation younger than the Impressionists and belonged to the Nabis, an artistic brotherhood formed in 1888 at the Académie Julian. Admiring the Impressionists, the Nabis rebelled against the style of photographic naturalism of their teachers and looked for influences in the primitive and decorative art forms of Egyptian, early Italian, and Japanese art. *Public Gardens*, a scheme of nine decorative panels, was designed to decorate the dining room of Alexandre Vlatasson, one of the editors of the art journal *La Revue Blanche*. The paintings use the theme characteristic of Parisian life, of children playing and nannies chatting under the trees in a park. Vuillard's concern to observe light effects of a bright summer's day echoes his Impressionist predecessors, notably such works as Monet's *Women in the Garden*. Vuillard however was more concerned than Monet in exploiting the decorative qualities of the subject in a more arbitrary way, reducing the figures to flat, simplified silhouettes and eliminating modeling elsewhere in the composition.

The Garden at Vaucresson, 1894

Oil on canvas
The Metropolitan Museum of Art, New York

Vuillard was on the whole more influenced by Degas, Odilon Redon, and Gauguin than by the Impressionists as a whole, but there are indications throughout his work that he had studied the Impressionists' works and his subject matter is closely related to theirs. His garden scenes owe much to the early paintings of Monet – *Under the Trees* is once again derived from *Women in the Garden*. Vuillard seems to have been particularly attracted by the striped and spotted fabrics in Monet's painting as well as to the use of dappled sunlight as a decorative device. In general though, Vuillard's somber and more detached art is one of suggestion rather than description.

J ALDEN WEIR
American 1852-1919

The Red Bridge, 1895
Oil on canvas
24¼×33¾ inches (61.6×85.7 cm)
The Metropolitan Museum of Art, New
York
Gift of Mrs John A Rutherford, 1914

Weir trained at the National Academy of
Design and after 1873 in Paris at Gérome's
atelier and the Ecole des Beaux-Arts where
he became an accomplished figure painter.
With a limited tolerance of avant-garde art
Weir described the third Impressionist ex-
hibition as 'Worse than the Chamber of
Horrors.' On his way back to New York he
stopped in London to visit Whistler who
he described as a 'snob' and his paintings
'mere commencements'. Despite this ap-
parent distaste, Whistler's paintings seem
to have left their mark on Weir, but the
credit for his eventual orientation toward
Impressionism belongs to his friends
Theodore Robinson and John Twachtman.
Weir's Impressionist canvases of the 1890s
have a distinct surface of thick but evenly
brushed paint, and though his color ranges
across the spectrum, the colors are kept at
an equal density which results in the over-
all tonal unity of his works. At his wife's
family home in Wyndham, Connecticut,
Weir discovered that an attractive wooden
bridge had been replaced by an iron struc-
ture, that once painted red, gave him the
opportunity to explore firstly, the effects of
red against its complementary color green,
secondly to juxtapose industry with
nature, and thirdly to update and west-
ernise a Japanese print in his collection,
Hiroshige's *Maple Trees at Tsuten Bridge* (c.
1834).

232

JAMES MCNEILL WHISTLER

American 1834-1903

Symphony in White, No 2
The Little White Girl, 1864

Oil on canvas
30×20 inches (76.2×50.8 cm)
Tate Gallery, London

The woman in this painting was the Irish beauty Jo Hiffernan who became Whistler's long-term mistress and frequent model. The title of this works comes from the first portrait of 1862 which was exhibited at the Salon des Refusés in 1863, when the critic Paul Mantz proclaimed it a 'Symphony in White,' a description which Whistler appropriated for his further white-on-white canvases. In this second portrait of Jo Hiffernan, she is dressed in white and is posed against the mantlepiece and mirror of Whistler's London house and we are provided with two views of her features. Swinburne, whose poetic homage to the painting was affixed to the original frame wrote: 'I watch my face and wonder/At my bright hair.' With unusual praise and generosity, Whistler declared that Swinburne had made: 'A rare and graceful tribute from the poet to the painter – a noble recognition of the work by the production of a nobler one.'

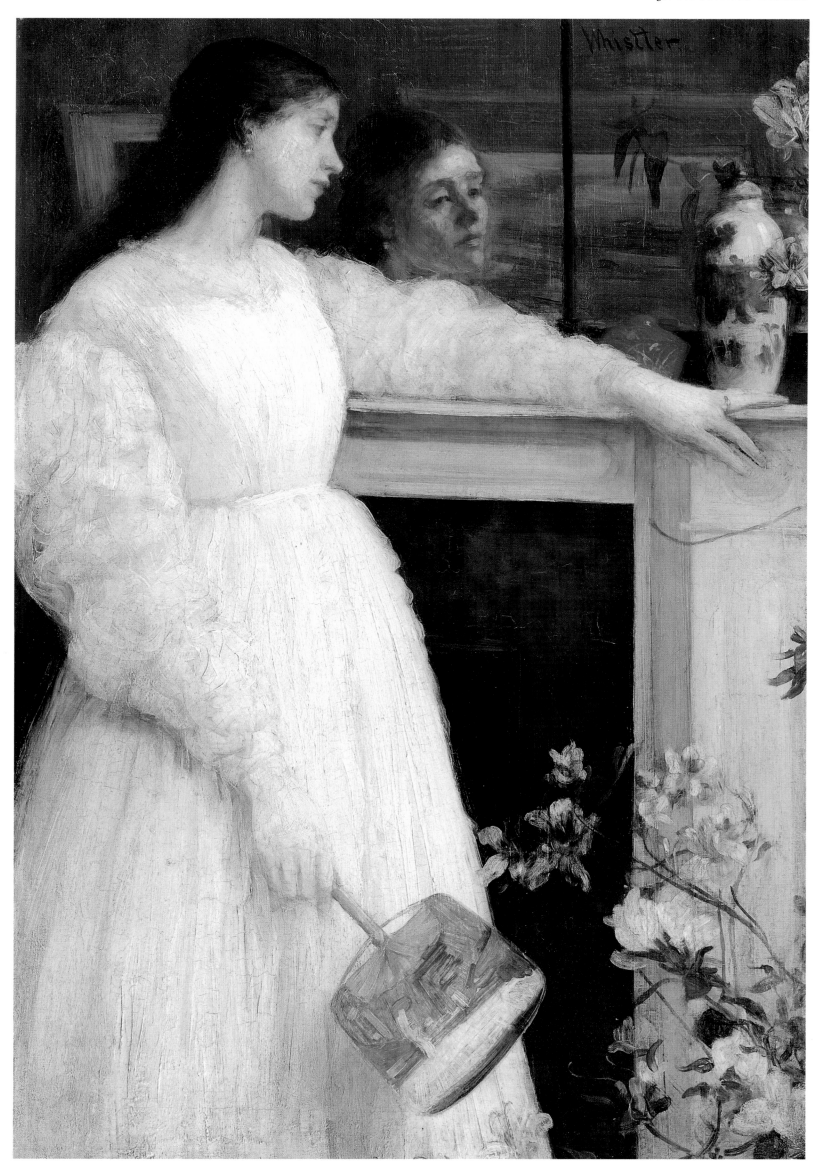

Nocturne in Black and Gold: The Falling Rocket, c. 1875

Oil on oak panel
$23^{45}/_{64} \times 18^{3}/_{8}$ inches (60.2×46.7 cm)
Detroit Institute of Art
Gift of Dexter M Ferry, Jnr

Nocturnal subjects were ideal for Whistler: the issues for which he had no patience – atmospheric and linear perspective, clarity of detail, distinctions between form and background, horizon and sky – became irrelevant. His technique of painting with pigments thinned to the consistency of inks, of rubbing out areas with rags and then repainting, here conveys the sense of moving, layered shadows. This painting of fireworks in Cremorne Gardens on the Thames was the centerpiece of Whistler's 1878 lawsuit against the critic John Ruskin who had written: 'I have seen and heard much Cockney impudence before now, but never expected to hear a coxcomb ask two hundred guineas for flinging a pot of paint in the public's face.' Throughout the trial Whistler entertained the court with his wit but won a Pyrrhic victory: he was awarded damages of one farthing and went bankrupt over legal expenses.

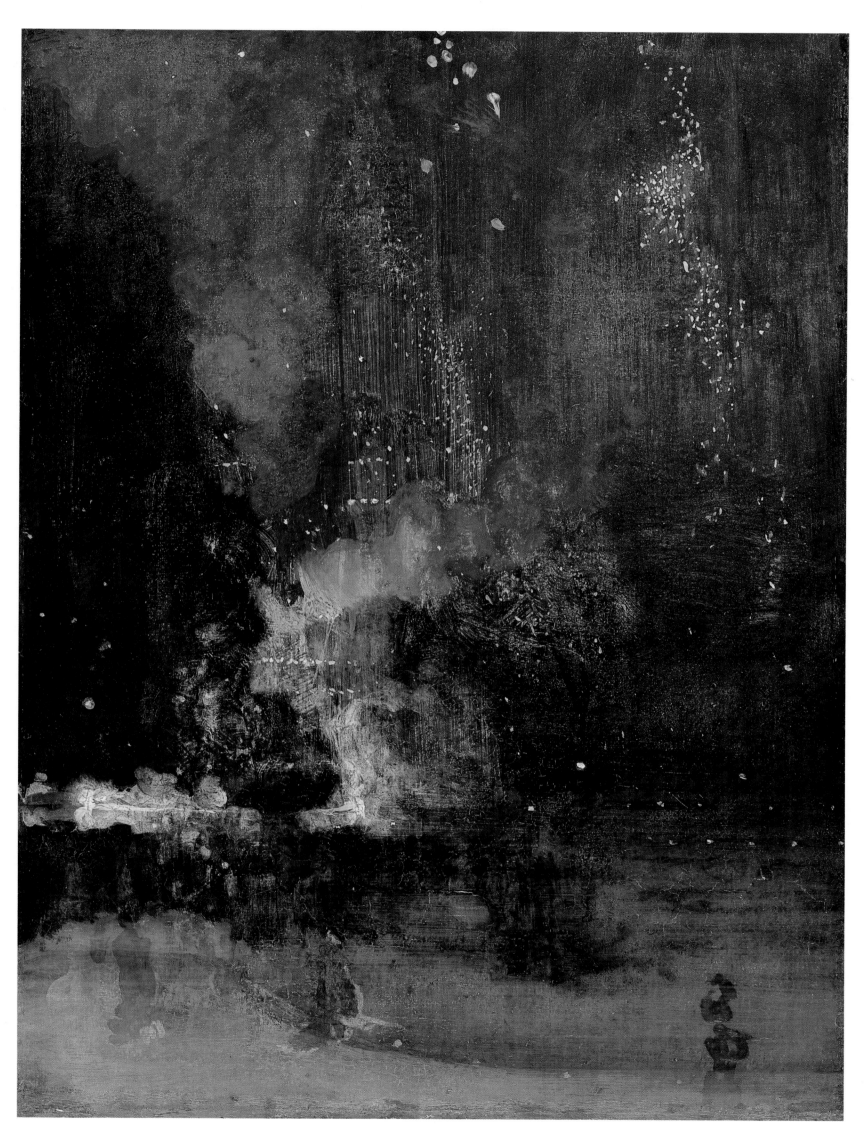

Index

Acknowledgments

The publisher would like to thank Martin Bristow who designed this book, Ron Watson, the indexer, and Aileen Reid, the editor. We would also like to thank the following institutions, agencies, and individuals for supplying the illustrations:

Agnew and Sons, London/Bridgeman Art Library: page 116
Archives of American Art, Smithsonian Institution, Washington DC: page 21 (below)
Art Gallery of New South Wales, Sydney: pages 43, 62-63 (Purchased 1888), 166 (Purchased 1921)
Art Institute of Chicago: pages 46 (Charles H and Mary F S Worcester Collection), 53 (Robert A Waller Fund), 98 (Joseph Winterbotham Collection), 115 (Louise B and Frank H Woods Purchase Fund in Honor of the Art Institute of Chicago's Diamond Jubilee), 156 (Gift of Marshall Field), 194-195 (Helen Birch Bartlett Memorial Collection), 218-219 (Mr and Mrs Lewis Larned Coburn Memorial Collection), 220, 222-223 (Helen Birch Bartlett Memorial Collection)
Australian National Gallery, Canberra: page 64
Benalla Art Gallery, Victoria: pages 212-213
Bibliothèque Nationale, Paris: page 11 (below), 13 (above)
BPL: pages 6, 9 (below), 12 (both), 19 (above)
Brooklyn Museum, New York: page 226 (Polhemus Fund)
Butler Institute of Art, Youngstown, Ohio: pages 228-229
Carnegie Museum of Art, Pittsburgh: page 221 (Acquired through the generosity of the Sarah Mellon Scaife Family)
Christie's, London/Bridgeman Art Library: page 65
Chrysler Museum, Norfolk, Virginia: pages 224-225 (Gift of W B S Grandy)
Connaught Brown, London/Bridgeman Art Library: page 165
Cooper-Hewitt Museum, New York: page 112 (Gift of Charles Savage Homer)
Courtauld Institute Galleries, London: pages 59, 126-127, 175, 196-197
Detroit Museum of Art: pages 84-85 (Detroit Museum of Art Purchase, Picture Fund), 138-139 (Founders' Society), 237 (Gift of Dexter M Parry, Jnr)
Dreyfus Foundation, Basil: pages 160-161
Courtesy of the Fogg Art Museum, Harvard Unviersity Art Museums, Gift: Mr and Mrs F Meynier de Salinelles: page 30
Galleria d'Arte Moderna, Rome/ Bridgeman Art Library: page 153

J Paul Getty Museum, Malibu: page 16
Glasgow Museums: The Burrell Collection: pages 58, 70-71
Hill-Stead Museum, Farmington, Connecticut: page 83
Kitakyushu Muncipal Museum, Japan: page 69
Kunsthalle, Hamburg: pages 118-119, 125
Laing Art Gallery, Newcastle-upon-Tyne: pages 117, 200-201
Location Unknown/Bridgeman Art Library: page 114
Malden Public Library, Malden, Massachusetts: page 34
Collection Marqués de Villamizar/Bridgeman Art Library: page 51
Collection of Mr and Mrs Paul Mellon, Upperville, Virginia: page 80
Metropolitan Museum of Art, New York: pages 72-73 (Bequest of Mrs Harry Payne Bingham, 1986), 90 (George A Heard Fund, 1966) 99 (Bequest of Sam A Lewisohn, 1951), 167 (Gift of George A Hearn, 1907), 198-199 (Bequest of Stephen C Clark, 1960), 232-233 (Gift of Mrs John A Rutherford, 1914)
Metropolitan Museum of Art, New York/ Bridgeman Art Library: pages 67, 231
Milwaukee Art Museum: page 47 (Gift of the Milwaukee Journal Company in Honor of Miss Faye McBeath)
Musée des Beaux-Arts, Caen: page 1
Musée des Beaux-Arts, Lyon: page 2
Musée des Beaux-Arts, Rennes: page 94
Musée des Beaux-Arts, Rouen: page 209
Musée Eugène Boudin, Honfleur: page 10 (below)
Musée Fabre, Montpelier: page 29
Musée Marmottan, Paris: pages 10 (above), 134-135, 141
Musée d'Orsay, Paris/Réunion des Musées Nationaux: pages 6-7, 13 (below), 14 (below), 15, 19 (below), 20, 32-33, 54, 55, 74, 77, 82, 122-123, 131, 136-137, 149, 154, 155, 169, 178-179, 206-207, 230
Musée du Petit Palais, Geneva: pages 44-45, 103
Musée Saint-Denis, Reims: pages 162-163
Courtesy, Museum of Fine Arts, Boston: pages 35 (Gift of Charles A Coolidge Family), 140, 158, 208, 216-217 (Bequest of David B Kimball in memory of his wife Clara Bertram Kimball)
National Gallery, London: pages 76, 120-121, 130, 133, 142-143, 144-145, 192-193
National Gallery of Art, Washington DC: pages 11 (above; Rosenwald Collection), 17 (above; Chester Dale Collection), 38-39 (Ailsa Mellon Bruce Fund), 52 (Chester Dale Collection), 104-105 (Chester Dale Collection Loan), 150 (Chester Dale Collection), 151 (Chester Dale

Collection), 172-173 (Chester Dale Collection)
National Gallery of Victoria, Melbourne: pages 184, 202-203, 214-215
National Gallery of Scotland, Edinburgh: pages 79, 96-97
National Museum of Wales, Cardiff: pages 56-57
Neue Pinakothek, Munich/Artothek: page 124
New Britain Museum of American Art, New Britain, Connecticut: page 185 (Gift of A W Stanley estate)
Norton-Simon Art Foundation, Pasadena: pages 146-147
Ny Carlsberg Glyptothek, Copenhagen: page 93
Oskar Reinhart Collection 'Am Römerholz,' Winterthur: pages 170-171
Pennyslvania Academy of the Fine Arts: pages 48-9 (Joseph E Temple Fund), 113 (Bequest of J Mitchell Elliott), 227 (Joseph E Temple Fund)
Philadelphia Museum of Art: page 159
Phillips Collection, Washington DC: pages 110, 180-181, 204-205
Portland Art Museum, Portland, Oregon: pages 176-177
Private Collection, London: pages 88-89
Private Collection/Bridgeman Art Library: pages 41, 210-211
Pushkin Museum, Moscow: pages 128-129
Richard Natkiel: page 8
Rijksmuseum, Amsterdam: page 41
São Paulo Museum of Art: page 183
Sheldon Memorial Art Gallery, University of Nebraska, Lincoln: 107 (Beatrice D Rohman Fund)
Roger-Viollet, Paris: pages 9 (above), 14 (above)
Smith College Museum of Art, Northampton, Massachusetts: page 111
Tate Gallery, London: pages 157, 186-187, 188-189, 190-191, 235
Terra Museum of American Art, Chicago: pages 40, 91 (both © Daniel J Terra Collection)
Thyssen-Bornemisza Collection, Lugano: page 81
Toledo Museum of Art, Toledo, Ohio: pages 60-61 (Gift of Arthur J Secor), 102 (Gift of Florence Scott Library)
Vincent van Gogh Foundation/National Museum, Vincent van Gogh, Amsterdam: pages 18, 101
Von-der-Heydt Museum, Wuppertal: page 100
© Vose Galleries of Boston, Inc: pages 86-87
Wadsworth Atheneum, Hartford, Connecticut: page 174 (Bequest of Anne Parish Titzell)
Worcester Art Museum, Worcester, Massachusetts: page 109 (Theodore T and Mary G Ellis Collection)
Yale University Art Gallery, New Haven, Connecticut: pages 36-37 (Gift of Walter Bareiss, BA 1940)